A Celebration of
MARINE ART

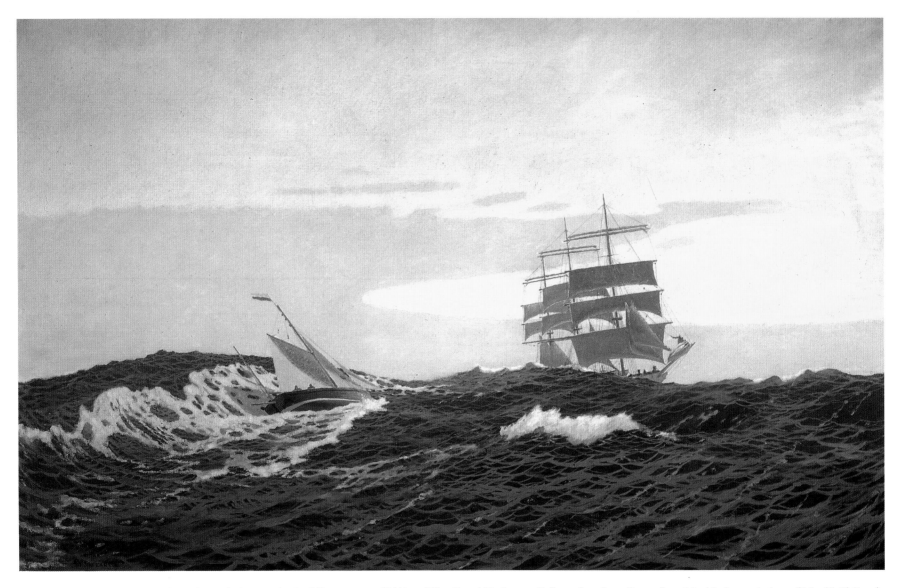

Charles Pears, R.O.I., S.M.A. 'Falmouth Approaches'. Oil on canvas, 31½in x 50in. Royal Exchange Gallery, London. Reproduced by kind permission of Mr. Noël Brack.

A Celebration of
MARINE ART

Sixty Years of the Royal Society of Marine Artists

B B **Bounty**
Books

*To marine painters, past and present; members
of the Royal Society of Marine Artists, non-
member exhibitors and lay members, and the
enthusiastic public who have supported our
exhibitions; this book is dedicated*

First published in Great Britain in 1996 by Blandford, a Cassell imprint.

This updated edition published in 2005 by Bounty Books, a division of
Octopus Publishing Group Ltd, 2–4 Heron Quays, London E14 4JP

ISBN: 978-0-753711-39-2

A CIP catalogue record for this book is available
from the British Library

Printed and bound in China

Contents

Acknowledgements

This book provides a comprehensive account of the one hundred and seventy individuals who have been members or associate members of the Royal Society of Marine Artists since its founding, together with, in most cases, illustrations of their work. The first edition, which also forms the most substantial part of this edition, involved a considerable organisational and research effort by the original Publishing Committee, whose members were Roy Cross, Kenneth Denton, Terence Storey, Colin Verity and John Worsley. Much essential groundwork, and constant encouragement, was freely given by the then President, Mark Myers. With an equal energy and dedication, the additional material needed to create the second edition was produced by the Working Group of 2005, whose members were Lorraine Abraham, John Groves, and David Howell. Here is the place for the Society to thank the members of both the Publishing Committee and the Working Group for their work; not forgetting many other individual members of the Society, a decade apart, who have helped greatly throughout.

In creating the greater part of the book we gratefully acknowledge the help and the support given to us by the following individuals and organisations:

The staff of the Ferens Art Gallery; Robert Cotton, for photographing many of the paintings and sculptures; John Deston at the Mall Galleries, for providing us with a home and an unfailing welcome; Kate Marchant; John Menasakanian for some valuable research; James Taylor; Roger Hadlee of the Royal Exchange Gallery; the staff of Sotheby's picture library; Oliver Swann of the Tryon Gallery; and Jennifer Wood of the Imperial War Museum Art Department. Not least, of course, has been the contribution made by the many relatives and friends of past members, who have generously given their permission to reproduce works, much useful information, and their best wishes for the book; we ask them to forgive us for not mentioning them all by name.

We have made strenuous efforts to trace the surviving owners of copyright of every piece that appears; however, in a few cases the search has been unsuccessful. In these cases we have taken the decision to reproduce the paintings anyway, believing that the artists' reputations and the completeness of the record are best served by the appearance of their work in this comprehensive survey. We apologise to any copyright holders whom we have failed to contact in this way, assure them of our good intentions, and invite them to contact the Society, where their information will be very welcome. In other cases we have failed, within our publishing deadline, to trace any extant works by certain artists. Again we apologise for these unavoidable omissions. The members of the Publishing Committee and the Working Group, drawing upon the collected wisdom of the whole Society, have done their best.

Geoff Hunt P.R.S.M.A.
Co-ordinator, Publishing Committee, 1995
Chairman, Working Group, 2005

Foreword
by The Countess Mountbatten of Burma

Having taken a lively interest in the Royal Society of Marine Artists for many years, latterly as an Honorary Member, I welcome this comprehensive account of the Society's history and work.

Writing this Foreword is rather like opening the annual Exhibition (as I did in 1986); both book and Exhibition present many fine pictures in a wide variety of styles and subjects. Perhaps at first glance it is difficult to find a connecting link between them all – far more difficult than in a gallery full of portraits or landscapes – but the link is there all the same. It is the love of the sea that breathes through all these works.

The society has represented much of what is best in marine painting for sixty years. I wish the members well as they embark upon the next sixty.

Mountbatten of Burma

The Countess Mountbatten of Burma, C.B.E, C.D., J.P., D.L.

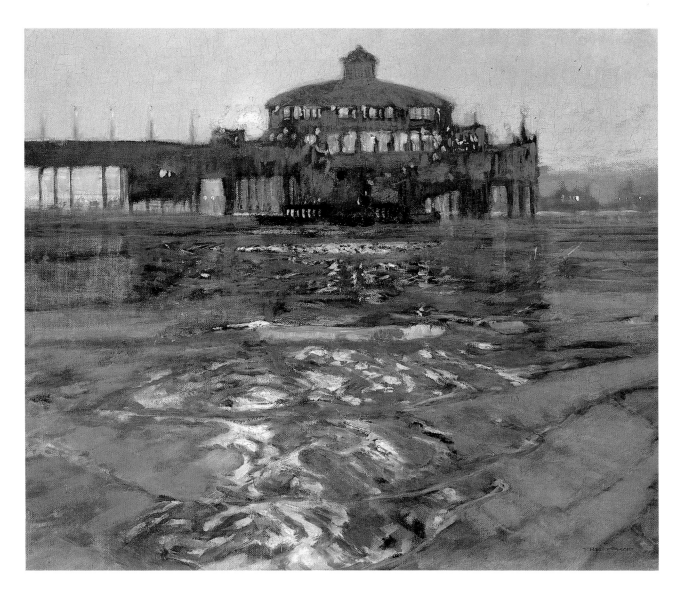

Borlase Smart, S.M.A. 'Plymouth Pier at Night'. Oil, 25in x 30in. From the collection of Plymouth City Museum & Art Gallery. By kind permission of Mr Brian Smart.

Introduction

We are delighted to present the second edition of this book, exactly ten years after the first, in time to commemorate the sixtieth anniversary of the R.S.M.A. This edition has been expanded by sixteen pages to include all sixteen Members and six Associate Members who have been elected since 1995, and the earlier text has been revised and updated. The Society's work consists of celebrating the sea in all its aspects. We have flourished for sixty years, and the next sixty will be just as good; for our inspiration, the sea, is inexhaustible.

The first edition carried a very fine Introduction by the then President, Mark Myers. Unfortunately space does not permit the whole of this to be reproduced, but the following extracts form an equally appropriate introduction to the new book.

Geoff Hunt, President

From the Introduction to the first Edition
by Mark Myers, President 1993 - 1998

The Society came into being in 1939 to encourage the practice and appreciation of marine art in Britain, a maritime nation with a long tradition in this field. It sought to establish a focal point where artists could gather and regularly exhibit to the public the best of contemporary marine painting, drawing, prints and sculpture. It aimed to educate and to serve a large and appreciative audience by making a special place for the genre among the country's cultural institutions.

Fifty years on from the Society of Marine Artists' Inaugural Exhibition of 1946, Britain may seem in many ways a different country, but marine art still has an important place in the national psyche and the R.S.M.A. can be proud of its part in fostering this. It has kept contemporary marine art of the highest standard consistently in the public view, displaying more than 13,500 works by nearly 1,500 member and non-member artists in its annual, regional and overseas exhibitions. Many thousands of people have enjoyed this addition to the nation's cultural life. The Society has shared its artistry in other ways as well. It has educated the public through members' talks and demonstrations, has encouraged growing talents in the field and has inspired the foundation of similar societies across the seas. Marine art has gained an increasingly international following in recent years, and the Society has played an active role in these developments. In 1966 the S.M.A.'s efforts were recognised through the granting of the title 'Royal Society of Marine Artists' by her Majesty the Queen.

In 1996 we celebrated the fiftieth anniversary of our inaugural exhibition with the publication of this book, a tribute to the talent and dedication of all the Society's members over the years. Their number has included nearly all the 'biggest guns' in twentieth-century British marine art as well as some lesser-known but equally accomplished artists, with many a great 'character' among them. All have a place in this book, which includes many works published here for the first time, and which sheds new light on the vitality and variety of this centuries-old art form today.

Looking back over the list of previous Presidents of the Society is a humbling experience for a 'new boy' like myself, with only twenty-one years' membership. How much better it seems, therefore, to let the personalities who led the Society for so many years speak in their own words about the concerns and the meaning of the Society in their own times.

'The R.S.M.A. has evolved a number of harmless little rituals over the years,' wrote Keith Shackleton in 1978, 'and the Foreword in this catalogue is a good example... It is the President's only opportunity in a twelvemonth, to set down whatever ephemeral rubbish may enter his head, with neither let nor hindrance nor reference to any committee. My predecessors made it varied and stimulating, and the custom has always appealed to me if only for the moral responsibility it puts on Members, not to elect Presidents who might garnish the catalogue with obscenity or indiscretion.'

Here then is a bouquet of such Presidential Forewords picked from the catalogues of past exhibitions

Foreword 1947

The Society of Marine Artists, founded in 1939, has now reached its second Annual exhibition.

Since the pronounced success of the inaugural exhibition, opened by the Rt. Hon. A.V. Alexander, and held in this gallery, the Society finds itself one of no small importance, thus justifying the prophecy of those who advocated its foundation.

As a medium for reminding the country that ships and the sea are a part of Great Britain's heritage, it has a mission apart from depicting the beauty of these things. By expressing the great part men play, and the large concerns which reach out to far off lands, it surely has a wide potentiality.

This in its fullness needs co-operation, and I suggest that no ship in this country should be launched without one of the artist members of the Society being invited to see it. During the wars some of us were given opportunities of seeing the Royal Navy at work, and I feel that the Society should be given similar opportunities during peace time, at Naval operations, and other Naval occasions. I do not think a single artist, for instance, was officially present at the Naval Review on the Clyde this year. What a loss that it was not recorded! That no picture of it is found upon these walls! Shipping lines too, pay large sums for publicity; so surely it is asking little that they should co-operate by inviting a representative of this Society to be present when appropriate occasions in their affairs arise.

In making this appeal I am thinking of the artists who have little opportunity of getting to sea.

The Society welcomes its numerous lay members to the present Exhibition. The ballot for the paintings which each lay member is hopeful of winning will take place on the opening day.

Now, about the works of the members of the Society of Marine Artists. Are we keeping up our standard? Is this an even better show than the last? I think it is, but it is for you, the reader, to decide.

In these days we must all try to keep the upper TEN-dencies, for there is much that is working downwards.

Are we going to have utility everywhere? Is the new board-room to have no uplift, no sign of the thing well done, no help to the imagination? Surely a board-room is where that stimulus is needed.

I anticipate a great revival of art appreciation, and complete understanding of its necessity as a reaction from austerity.

Charles Pears, President

Foreword 1973
'The Captain's Cabin'

A year or two ago I was commissioned to paint an oil painting of a 'giant tanker'. She was berthed at Milford Haven, and I travelled down to visit her with three ex-tanker captains whose company I very much enjoyed.

It was a lovely, warm, sunny, calm morning when we stepped aboard the 'leviathan', and the vast space of the deck seemed to resemble in no way the deck of a ship. But there *was* a mast and far away a structure which was evidently the bridge. This we approached and climbed up to the captain's cabin. Here the captain welcomed us most amiably, and his wife was an excellent and generous hostess. Our needs lacked nothing, and the cool drinks were more than acceptable. But a curious thing happened. No sooner did we enter the cabin than each one of us visitors retired into his shell, and the easy companionship which had developed between us shrunk into its shell too. Only when thinking about this later did I begin to unfathom the reason why. The captain knew the purpose of my visit and, knowing that I was an artist, said that he would welcome my opin-

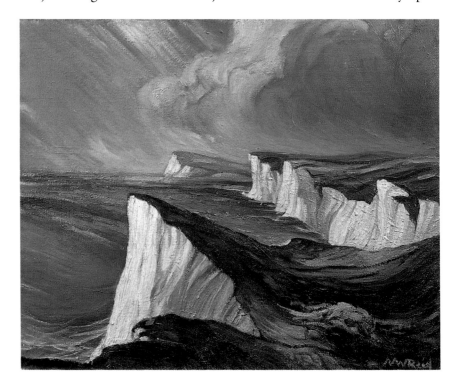

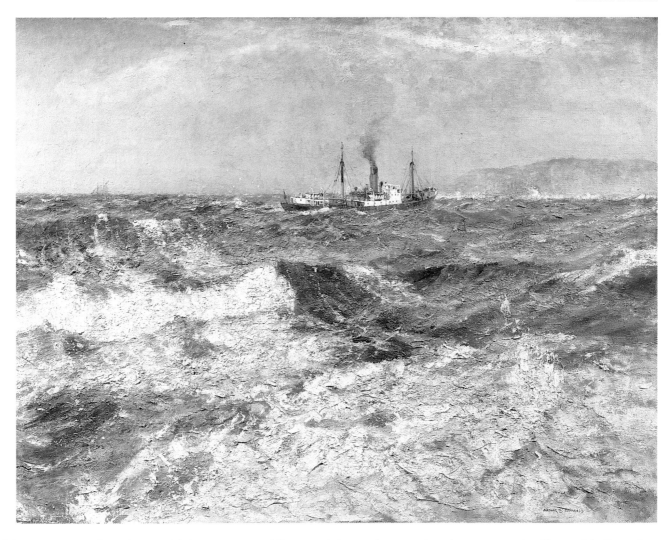

Left: Nina Winder Reid, R.S.M.A.
'Chalk Cliffs'. Oil, 18in x 22in.
R.S.M.A. Diploma collection.

Right: Arthur Burgess, S.M.A.
'High water on the bar'. Oil, 31in x
41in. R.S.M.A. Diploma Collection.
By kind permission of Stephen Bartley.

ion concerning a picture which had been presented to him in Tokyo, where the ship had been built. When I saw the picture I was horrified and experienced a physical revulsion, and, since he had asked my opinion, I told him so. He exclaimed, 'Thank goodness! I thought there was something wrong with *me*! Steward, take this and lock it up in the strong-room along with the other horror!' And turning to us said, 'How do you think I would get a wink of sleep with that hanging on the bulk-head at the foot of my bunk?'

The captain's reactions to the picture were significant. I believe they reflected the reason why our previous friendliness had suddenly evaporated. Everything in the captain's cabin was unattractive and rigid. The decor was brown and depressing. This was not the captain's fault. He had to accept what was provided for him, and I wondered that he was as cheerful as he was.

I believe people are not generally aware of how an angry, depressing or discordant decor, and unattractive furnishings, pictures and ornaments can have deleterious effects and can irritate the nerves and even create dishar-

mony in the home. And this applies very much to hospitals, where the drab decor does nothing to accelerate the patients' recovery.

It is the policy of the R.S.M.A. to reject works which we consider distortionate or disturbing. Our object is to produce and exhibit pictures which will induce harmony rather than disharmony. It is our hope that those who look at our pictures and, better still, possess them, will derive happiness from the experience of viewing them, and an even greater happiness from the fact of possessing them.

Claude Muncaster, President

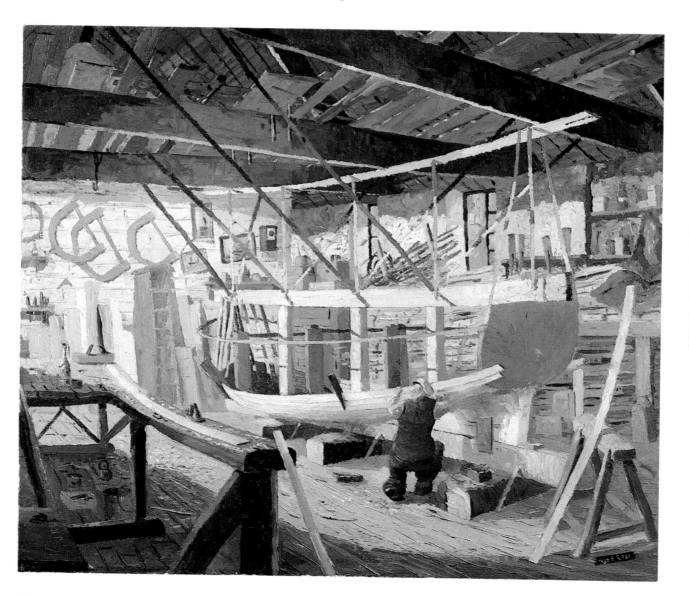

Left: Hugh Ridge, R.S.M.A. 'Mr Cothey builds his last boat'. Oil, 28in x 34in. R.S.M.A. Diploma collection.

Right: Charles Simpson, R.S.M.A. 'The Herring Season, St. Ives'. Reproduced by courtesy of Whitford & Hughes, London/Bridgeman Art Library, London.

Foreword 1975

'The object of the Society shall be to promote and encourage Marine Art in any form and its recognition as an important element in the artistic life of a maritime nation.' Thus ended the foreword to last year's catalogue – Rule 2 of our founder's statement of purpose of the R.S.M.A.

This is the 30th Exhibition, and the 'important element' seems to have increased in stature over the years to a burning need – a need for escape.

Art and the sea have always gone hand in hand to offer their separate brands of escape when needed. The open ocean in a workable boat is a world that knows no bounds. With brushes to hand and a surface to paint on, there are prospects of a gentler and more accessible adventure which in its way is just as alluring, just as free – escape of the mind.

Many great people have found this panacea and reaped its rewards. Competence has little to do with it, but trial has everything; trial and purpose and perhaps a pinch of courage, sustained by hope. And the reason it is more important now than it was in our founders' day is the sad but simple truth that we now have more to escape from and therefore a little further to go.

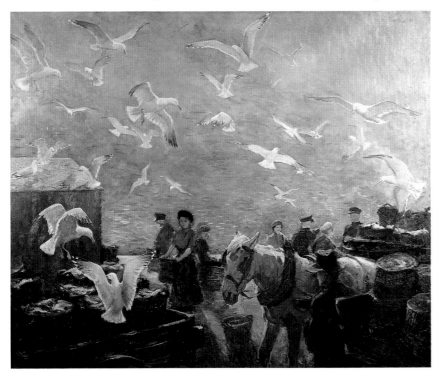

When our selection committee sits before each year's exhibition, this understanding is in everybody's mind. There is a certain reverence for the work of others using the well-worn routes because each of us has tried it and known its joys and frustrations in slightly differing ways. Judgement is the wrong word – art can be assessed only by the totally flexible parameters of personal taste. The committee therefore 'accept' pictures they 'like'. They reject a lot they like too because there is not room enough on the walls, and they exercise the discretion necessary for a society of artists, but artists who have set themselves within the confines of an exacting subject.

There will always be conflict between the two ideals. Each selector will sit tight or raise an approving hand by a personal tip of the scales. Sometimes an impassioned plea from a minority will sway enough votes for acceptance – or it may just fail. There are occasions of unanimous agreement – for or against. There will be discussion, even vehement debate, but the result, warts and all, will be democratic.

Artists must pay heed to standards of technique and creativity, but seamen must be excused for voting against a full-blooded masterpiece if it happens to display a green light on the port side or a squared-off spinnaker on a fervent beat to windward. Such things happen regularly – in paint; and the problems of their acceptance is the price, if one may call it that, of being *Marine* Artists.

I believe that the enduring strength of such a group lies in the blend of the two criteria in the work submitted each year. Some are from established painters in other fields who complete an occasional picture that meets the 'Marine' terms of reference. But most are from amateurs who feel the need to paint for the intrinsic joy of the exercise.

They are escapers by way of art and the sea, seeking out their own 'important element' in the artistic life of a maritime individual. The results of each and every search, hung or not, will always be more than welcome to this Society.

Keith Shackleton, President

Foreword 1979

Over the last thirty years or so my predecessors have written on such diverse subjects that they leave me little new to say. But I feel I must report on the Society. Despite difficult times, or perhaps because of them, it is in excellent health, with many people aspiring to membership. Even so we miss greatly

those senior members who can no longer play their active part in our affairs, and sympathise with their (far worse) handicap of being unable to paint. We do not forget them, or their grand help over so many years.

Marine art has a history as long as any other branch, and much longer, I suspect, than most people realise. Scandinavian Long Boats feature in rock carvings of 3500 B.C., and the murals and ceramics of all the ancient civilisations show marine artists and designers at work.

The more recent value of this art is well recognised. The Van de Velde partnership served both the Dutch and British national interests brilliantly, and thereafter the marine artist's work was seen to be of increasing importance to all seafaring nations. This was the only means by which the populace could be told about national activities afloat; and the capacity to observe and draw was until recently, and perhaps still is, a regular part of sea-officers' training. Twice in this century the marine artist's skills have been used to camouflage ships; to try to upset, or even prevent, altogether, the enemy's attack.

So we've had our varied uses, and seemingly still have, for today as never before people on holiday are experiencing the sea, either sailing on it, diving into it, or just looking at it; so some begin to notice marine art for the first time.

David Cobb, President

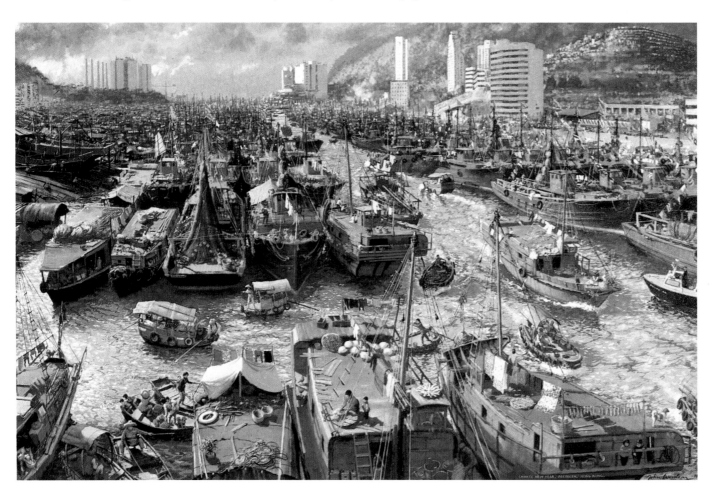

John Worsley, R.S.M.A.
'Floating City – Aberdeen, Hong Kong, at Chinese New Year'. Oil, 40in x 50in. In the collection of the Hong Kong and Shanghai Banking Corporation.

Keith Shackleton, R.S.M.A., S.W.L.A.
'South from New Zealand'. Oil, 24in x
36in. Buller's Albatross, one of the
smallest of the 'Mollymawks' breeds
only on Solander and Snares Island.
Permanent collection of Leigh Yawkey
Woodson Art Museum, Wisconsin,
U.S.A.

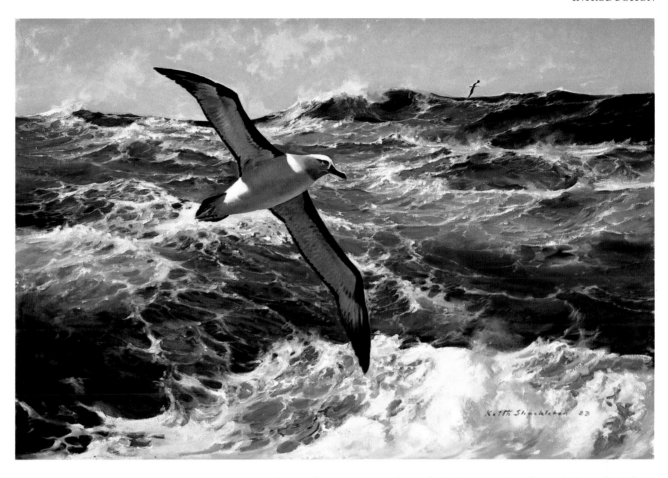

Foreword 1988

As you open this catalogue and are about to view our visual offerings for 1988, I hope you will anticipate an hour or even more of pleasure and will not be disappointed.

We present a considerable variety and a tradition of over forty years of quality marine painting, which does not hold rigidly to just ships, although they are naturally the main purpose of our being.

The word 'marine' evokes a thousand related thoughts... sailors, ships, wind, storms, beaches, birds, fishes, dolphins... on and on down to perhaps even plankton and diatoms (although the latter will not be much in evidence on our walls!)

This wide compass and its depiction requires knowledge, discipline, good drawing, good colour and, above all, observation and the emotion essential to good art.

For sailors and those fond of things maritime, a ship must look like a ship, and its parts must look functional.

In sailing ships masts are thick and strong to withstand full forces; likewise shrouds, stays and blocks, whereas other lines like halyards and sheets need not have the same tensile strength and therefore are more slender... all this the good sea painter should know, and his pictures should show it.

These practical matters often restrict the marine artists who may wish to paint freely, emotionally and with gusto, and the marrying of the factual

with untrammelled artistic freedom is, in my opinion, one of the hardest accomplishments for the marine painter to attain.

So, as you view our exhibition, I hope you will find our paintings interesting, exciting, evocative and appealing, and if, as I also hope, you should purchase one or more for your delight, they will also have the proverbial quality of being 'liveable with' for years to come.

John Worsley, President

Foreword 1993

In this age where built-in speedy obsolescence is very often the prime factor of production, it is reassuring to feel that one's work and the output of our Society is potentially long lasting. Paintings survive longer than we do; the clever little car sticker slogan 'A dog is not just for Christmas', while not having the touching companionship of man's best friend to equate with, similarly applies to a painting. So, while we all like to think of our painting as giving lasting pleasure, we perhaps tend to relate to our own flimsy allotted span and not to the true perspective of artwork life.

One of the earliest representations of a shipwreck, for instance, appears on a ceramic of the 8th century B.C. showing an upturned boat with fish and crew members in the water. It is fascinating to consider that the artist probably thought much the same and no more than we do when we sketch today's oil rig or tanker disaster, and he most certainly would not have envisaged it to be of note in the 20th century A.D.

Times change; shipping and fashion alter our subject matter; maybe we do not indulge in as much deep-sea activity as we used to; but I don't think any of us can escape from the 'Must go down to the seas again' bit.

I believe our Society will be long-lasting with no built-in obsolescence. So with this in mind I hope that you will find in our exhibition something that will give a lifetime pleasure and – who knows? – may last until the 25th century A.D.

Terence Storey, President

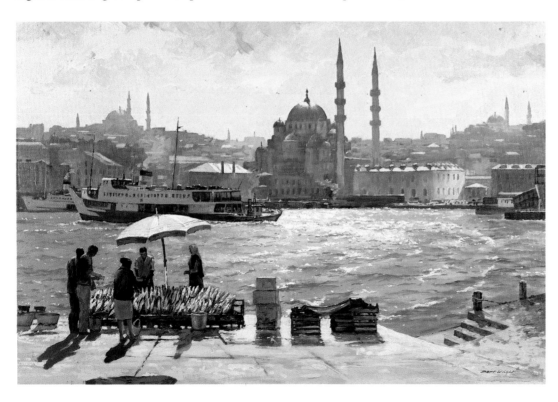

Bert Wright, R.S.M.A., F.R.S.A.
'Golden Horn, Istanbul'. Oil, 25in x 35in. The busy waterfront of Istanbul seen in the evening light from the fish market. Collection: Artist's studio.

THEMES IN MARINE PAINTING

Marine painting covers a diverse range of subjects, and marine painters interpret those subjects in many different ways. The Society has therefore always represented an enormous variety of work. What is our common ground? Article 3 of the Society's Rules provides the answer:

'The objects of the Society are to promote, maintain, improve and advance the education of the public by the encouragement of the study and practice of the fine and applied arts... with particular but not exclusive reference to the sea, to the seashore and to marine and maritime subjects of whatsoever nature and by the recognition of such works of art as an essential feature of the artistic life of a maritime nation.'

But perhaps it is simpler to say that we, like so many other people, are all of us mad about the sea. We stand spellbound by the shining water.

The following pages illustrate the work of the Society in all its diversity, taking four of the major themes that occupy our attention. Each of the four articles is written from a personal viewpoint; each serves as the focus for a gallery of pictures.

This selection of paintings conveys better than any description the scope and strength of the Society's work in its first sixty years. We hope you will enjoy them.

Geoff Hunt

Sail
by Mark Myers, P.P.R.S.M.A.

Sail is one of the great themes in marine art, and in the Society's exhibitions. This is hardly surprising, given the attractiveness of the subject for the artist and its undying popularity with the public. Why it should be so popular I won't attempt to say, but in this article we will have a look at the other side of the coin – the importance sail has had in the lives and work of some of the Society's members.

'Sail' covers a multitude of types, of course, not just the square riggers that many people first think of when the topic arises. All around the world sailing craft can be found in infinite variety, from Amsterdam *aaks* to Zanzibar *zaruks*. Here at home we have scores of types from sailing dinghies to deep-water sailing ships. Indeed, far from being a dead or dying technology, sail proliferates around our shores as never before within the history of the Society. Pleasure sailing has expanded hugely in the more affluent post-war years. Old craft have been preserved and many restored to sailing condition, while international gatherings of 'old gaffers' and 'tall ships' continue to grow in size, frequency and popular appeal. Here are subjects aplenty for artists to draw and paint!

There is an intrinsic beauty in sail that gives it as much power to move an artist to paint as it has to shift a hull through the water. It also offers a wealth of compositional and tonal possibilities which the marine painter finds hard to resist. There is, too, a great symbolic value in sail as an emblem of man's age-old quest to understand and use the elemental forces that surround him.

The different ways in which the Society's artists of sail have approached their subject is interesting, I think. Some have been led by love of subject into teaching themselves to paint in order to express it; others have applied their artist's training to the pictorial potential in sail. Some have taken a broad view, painting the passing scene or interpreting their past experiences in a way that placed the sailing vessel naturally within their sights. Some have been fascinated by a particular type of craft or the vessels associated with a certain stretch of coast, returning again and again to their muse.

Some have enlisted scholarship to their observations and experience in order to paint reconstructions of period ships and waterfronts long vanished. Many artists have used more than just one approach, of course. Career artists especially have gone down several of these paths in a lifetime's pursuit of their calling.

Yachts and Yachting

A good beginning to a survey of the Society's contributions to the art of sail can be made with a look at yachts and yachting. So many members have been involved in this type of sailing that it is difficult to give each one due mention, but there is no problem in deciding where to start. Charles Pears, the Society's founder and first President, was one of the keenest sailing yachtsmen imaginable, dividing his time between cruising the North Sea and Channel and working in his studio in London. He used his yacht *Wanderer*, an engineless ten-tonner which he kept for nearly forty years, as a floating studio, sketching wherever he went and what vessels he saw along the way. Pears' output covered every sort of craft, sail and steam, including sailing yachts of all sizes from dinghies to J-Class racers.

Norman Wilkinson and Arthur Briscoe were also dedicated yachtsmen and undoubted leaders in their field of art. Briscoe's contribution to the launch of the Society was crucial but cut all too short by his death in 1943. His oil and watercolour portraits of yachts were superb, and he sketched avidly while cruising in a succession of his boats, most notably the 1908 gaff cutter *Golden Vanity*, which he owned for more than twenty years. Wilkinson's brilliance as yacht portraitist was recognised by royal patronage and by his appointment as Honorary Marine Painter to the Royal Yacht Squadron in 1919. In his thirties he owned the *Wild Rose*, a twelve-ton Falmouth Quay Punt, but sailed on board friends' boats after she was lost at the end of the First World War, in other hands than his.

Some other early members well known for their yachting pictures were Montague Dawson, Frank H. Mason, Cecil King and Harold Wyllie. We

shall return to them all in another context, but mention should be made here of Cecil King's appointment as Honorary Marine Painter to the Royal Thames Yacht Club and Harold Wyllie's similar position with the Royal Victoria Yacht Club at Ryde.

David Cobb's work will be familiar to long-standing readers of the yachting press. He was brought up in a sailing family and, inspired by acquaintance with Charles Dixon, taught himself to paint. Since then he sought every opportunity to sail in and depict 'everything, of any period, that floats'. He began painting professionally just after the war, living in an old cutter alongside at Newlyn and cruising in her in the summer. Some time later he came across, and purchased, Briscoe's *Golden Vanity*, basing her on the Solent, near which he still lives. Fid Harnack's story is similar, although he had the backing of an art school education at the start of his career. Like Cobb, he sailed avidly, keeping a small gaff sloop at West Mersea. He illustrated for the yachting press and painted yachts with feeling, as can be seen in his R.S.M.A. Diploma Work, 'Cruising'. John Davies was another of this breed, a watercolorist of yachts, ships and seascapes, long-time boat owner and seasoned member of the Royal Ocean Racing Club. Peter Wood also painted yachts with great sympathy and with the understanding gained from cruises in his small cutter, *Falcon* .

One member who made a speciality of yacht portraiture early in his career is Deryck Foster. Fired with a boyhood love of sailing, he worked for years as a commercial artist before achieving independence on the strength of his yachting commissions. His sea time has been varied, taking in racing and cruising yachts, sail-training schooners and a stint in the Yarmouth Lifeboat. Geoff Hunt's yachting subjects also brought him early recognition, although he did not specialise in them alone. An interest in the ships of Nelson's day was stimulated while cruising in the Admiral's wake through the Mediterranean on board his own sloop, *Kipper*.

Two of the Society's most eminent current members are noted for their yachting pictures. John Worsley and Keith Shackleton have both undertaken important commissions to paint yacht portraits and premier international races. Each has good sailing experience: the former as a racing and cruising man and the latter as a champion International 14ft. racer and crewman in four winners of the Prince of Wales's Cup. John Worsley has been much involved in successive America's Cup challenges, painting the contenders from their tank-testing stage through to their final races.

Working Sail

Working sail – the bawleys and barges, schooners and smacks once so common around the coast – has given inspiration and subject matter to a host of members. At the time of the Society's foundation there were several regions where these types survived. Among the founder members there were many with clear memories of Victorian times, whose early sketchbooks showed the whole panoply of sail that earned its living then. Nowadays there is less working sail 'in harness', so to speak, but many types do survive and sail with enthusiasts rather than cargoes to pay their bills.

Those inveterate cruising yachtsmen we have mentioned before usually took note of any working sail they came across, at sea or in port. They left a rich legacy of work depicting working craft at home or across the Narrow Seas, where they were found in plenty.

Peter Anson's driving interest was in fishing craft, fishing ports and fishermen themselves. He claimed to have visited nearly every fishing harbour on the British and Breton coasts and sailed with English and Scottish fishermen in almost every type of vessel. He sketched these things tirelessly, using many of his line drawings and watercolours to illustrate a succession of books.

Other members have had more widely ranging tastes for working sail. Stuart Beck has grasped at every chance to study, sketch and, if possible, sail in a great variety of vessels. His commercial art career left little free time for this, but his determination to know and paint the sea and ships has overcome great odds to win him sea time in some classic sailing types. Captain Roger Fisher also had to wait until retirement from a busy naval and legal career before taking up marine painting full-time. He had a deep interest in old British sailing types as well as the contemporary scene. There are many others: Alan Simpson with his love for coastal sail; Leslie Watson, a Yorkshireman with a background in herring drifters and cobles; Josiah Sturgeon, an architect with a painter's eye for working craft; Aileen Elliott; and Sybil Mullen Glover, to name but a few.

Far away from home waters, John Worsley has studied and painted Chinese junks and Arab dhows. Harry Heine, a Canadian member, has used his flowing watercolour style to paint the sailing craft and visiting square-riggers in British Columbian waters. Fritz Goosen is a Dutch member who has studied and painted the wealth of traditional sailing types still to be found in the Netherlands.

The Thames has inspired a good number of our artists, as might be expected given the Society's London home. Londoners before the last war had the chance of finding large square-riggers in the docks, as well as barges, smacks and bawleys on the river. These were the sparks that fired the talents of Norman Janes, who sketched the big windjammers visiting the port in the 1920s and 1930s. Rowland Hilder came to London as a small boy, became entranced by its surging river traffic between the wars, and returned to this

subject again and again throughout his career. Growing up in Blackheath at the same time, Edward Wesson found inspiration for his first subjects in the passing ships and barges. Another Londoner, Eric Thorp, found constant interest and subject matter in the river craft. In 1947 he helped to found the Wapping Group of artists, painters of the Thameside scene who have included many members of the Society over the years. There is no room to name them all, but some, such as Trevor Chamberlain, Gordon Hales, Dennis Hanceri and Bert Wright, still paint the sailing barge with great feeling.

The lower Thames estuary and East-Coast rivers have their champions too. Vic Ellis was celebrated for his paintings of all types of East-Coast craft, sail and steam, past and present. He was born on Canvey Island and taught himself to paint at the age of ten, developing his skills as an artist and sailor of the very finest sort. Hugh Boycott-Brown settled in Suffolk after an extensive art background, painting landscapes and seascapes, barges and smacks in a broadly Impressionist style. He too was a keen and lifelong sailor, first in dinghies and later in larger boats. Kenneth Denton also includes landscape and seascape in his range. His penchant for painting the sailing barges and 'old gaffers' still to be found afloat stems from his early days in Kent, where he studied the river traffic of the Medway and trained as an artist. Another who celebrated the sailing barge in his work was Peter Carter, a Londoner with a long background in engineering. He was a self-taught artist, and in his marine work added Brixham trawlers to his repertoire after moving down to Devon. East-Coast working sail also appears in the work of less specialised artists such as Sydney Foley, Raymond Leech, Robert King and Michael Norman.

Large sailing ships have been a comparatively rare sight in British waters within the Society's lifetime, but it is a curious fact that there are more of these in active commission now than there were at the end of the war. Most of the early members we have mentioned painted them with an authority that came from long familiarity in the pre-war years, and to this list we should add the names of George Bradshaw, Arthur Burgess, Rowland Fisher and Claude Muncaster.

Claude Muncaster is rather a special case, for he followed the sea in his youth, gaining sea time in the *Favell*, *Olivebank* and other big ships, which he used in his work as a painter. This intimate acquaintance with deep-water sail (including a Cape Horn passage) enabled him to paint deck scenes of sailing-ship seamen at work, a seldom-studied subject but one at which Briscoe, too, excelled in his paintings, etchings and drypoints. Briscoe, Harnack and Peter Wood all grabbed a passage in the Finnish 'onker' barques before the last war. David Cobb put in time aboard the West-country topsail schooner *Elizabeth Drew*.

Nearly all the large sailing ships at sea today are sail training vessels, and many of them offer the opportunity to sign up for a week or two on board. Stuart Beck did just this in the *Astrid* at the age of 87! Terence Storey, Roger Fisher and Deryck Foster have all been to sea in one or both of the Sail Training Association's schooners and have painted their experiences. Each of these artists, together with Leslie Wilcox, Eric Thorp and others, has enjoyed the large congregations of 'tall ships' at festivals and races and made them the subjects of their paintings.

In addition to the training ships, there are a few other square-riggers still at sea in the form of replicas and film ships. Peter Wood, John Groves and I have been involved with them and have made use of these experiences in our paintings.

Historic Sail

Marine historical painting is a discipline with very deep roots in the history of marine art, for the depiction of ships and events not personally witnessed by the artist was common among medieval painters and carvers and continued in the works of many of the greatest marine painters of the British scene, from Vroom through Turner to the war artists of our own time. It is also a discipline that calls for more than just picture-making skills, for the true worth of an historical painting depends as much upon the quality of the artist's scholarship as it does upon his or her painting ability. In addition to a sound knowledge of the shipping of different periods and cultures, the historical painter has need of a keen eye for wind and weather and its effect on different types of ships, familiarity with basic and historic seamanship, an understanding of historic architecture, costume, cartography, signalling, naval tactics and so forth, and – most importantly – a good imagination.

An undoubted master of the genre among the Society's founders was Lieutenant-Colonel Harold Wyllie. He inherited much of his father W. L. Wyllie's ability as a painter and etcher, as well as something of his style, but he concentrated more closely on historical subjects throughout his career. He researched prodigiously into the history of sail, particularly the sailing warship, and as a result his paintings carry great authority. Wyllie's feel for the shape of ships, for the proportions of hull, masts and rigging, and for old-fashioned seamanship was, in my opinion, unmatched in his time.

Several of Wyllie's contemporaries in the Society's early days were noted for their historical works. Bernard Gribble, Patrick Jobson, Cecil King, Leslie Wilcox and Stanley Rogers all had fine reputations and highly individual styles. Gribble loved scenes with people to the fore, as did Leslie Wilcox, who had a special flair for busy, theatrical sea pieces, beautifully composed and painted. Cecil King was a great scholar on the subject of marine flags and

a keen naval historian. Both he and Wilcox wrote and illustrated books on sea subjects, as did Stanley Rogers and Norman Wilkinson.

Two of the best known of the earlier members were Montague Dawson and Frank H. Mason. Dawson is now remembered chiefly for his exuberant paintings of clipper ships, which dazzled the public and made him a very wealthy artist indeed. In his earlier work he painted naval scenes, yachts and square-riggers with wonderful presence and atmosphere, but his popular success with the clippers and other period pieces led him later into a more romantic, sensational style. His work remained supremely painterly, however, particularly in the way he handled seas and skies. Frank Mason's pictures of 'wooden walls', sailing barges and coasters were very widely reproduced in books and in the press. He was a prolific artist, and many of his attractive, freely painted oils and watercolours can be found in today's art sales.

Peter M. Wood and Chris Mayger were fine draughtsmen and accomplished historical painters. As a boy with good access to the London River and its docks, Peter Wood drew and painted ships compulsively, then underwent a good art training. After the war he joined the film industry as a technical adviser on ships, making sets and models and fitting out ten full-sized sailing ships in the course of his career. He also played a part in the design of the *Nonsuch* ketch, a replica of a seventeenth-century vessel in which I served for a couple of years. Chris Mayger had a long career in commercial art before setting out as a freelance, where he could concentrate on the marine subjects that had come to fascinate him. Chris was fond of dramatic subjects, which he handled in a crisp, highly realistic style.

John Stobart is a gifted painter whose interest in period shipping was developed with remarkable success through a fortunate contact with a New York gallery in 1965. This soon encouraged him to move to the United States, and it was there that he began to produce the large, beautifully composed and painted historic port and river scenes for which he is so well known today. Roy Cross has also concentrated successfully upon the American market. Initially inspired by Dawson's work, he branched out from commercial and aviation art to become a specialist in late eighteenth- to mid-nineteenth-century ships and port scenes and period yachting subjects

The current R.S.M.A. membership includes a good leavening of historical painters: Derek Gardner, John Groves, Geoff Hunt, Ronald Dean,

Roger Desoutter and myself, together with Roy Cross mentioned above. While this is a higher proportion of fellow spirits than would perhaps have been found in the Society's early days, it may be worth noting that recent advances in maritime scholarship, nautical archaeology and historical naval architecture, and the proliferation of such material in print and on video, has put a great deal more information within one's grasp than was the case fifty years ago.

Derek Gardner began painting professionally after training as a civil engineer. Entirely self-taught, he mastered the techniques of oils and watercolours and researched extensively into eighteenth- and nineteenth-century sailing ships and naval actions. His battle pieces and pleasing ship portraits have won him a great reputation at home and overseas. John Groves and Geoff Hunt followed a solid art training with careers in commercial art. Both have had a lifelong interest in the sailing ship and can paint the vessels of many periods with brilliance, vitality and precision. John Groves also excels in pastel work, and his great ability with figure drawing is used to good effect in deck scenes of shipboard work and life. Geoff Hunt worked as an illustrator, art editor and book designer before settling into painting full time. A painter of contemporary as well as historic shipping, his work has become widely known on book jackets to admirers in many countries.

Ronald Dean and Roger Desoutter tend to focus more on the shipping of the late nineteenth and early twentieth centuries. Ronald Dean is well known as a watercolorist with an abiding interest in merchant sail. This medium complements his careful draughtsmanship, giving his compositions of ships and port scenes colour, life and charm. Harbour scenes and ship portraits also appear frequently in the work of the oil painter Roger Desoutter, who, like Dean, developed his technique as a painter in the course of a full-time business career.

As for myself, an early passion for sailing ships led me into marine art and sustains me today. I trained as an historian but taught myself to paint, managing a few good years' sea time in small square-riggers when such jobs came along in my youth. Historical painting keeps me anchored pretty firmly in my studio now, but, like many of the artists we have met in this short survey, I paint all kinds of ships and boats and steal away on board them when I can.

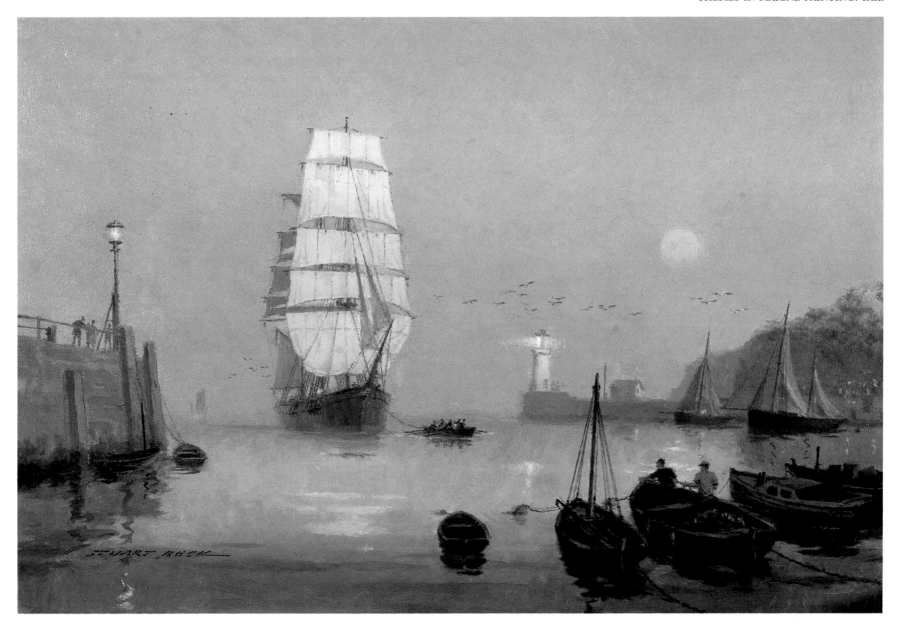

Stuart Beck, R.S.M.A. 'Not a breath'. Oil, 20in x 30in. A becalmed sailing vessel being towed by rowing boat the last half mile or so into harbour. Collection of J. G. Reed Esq.

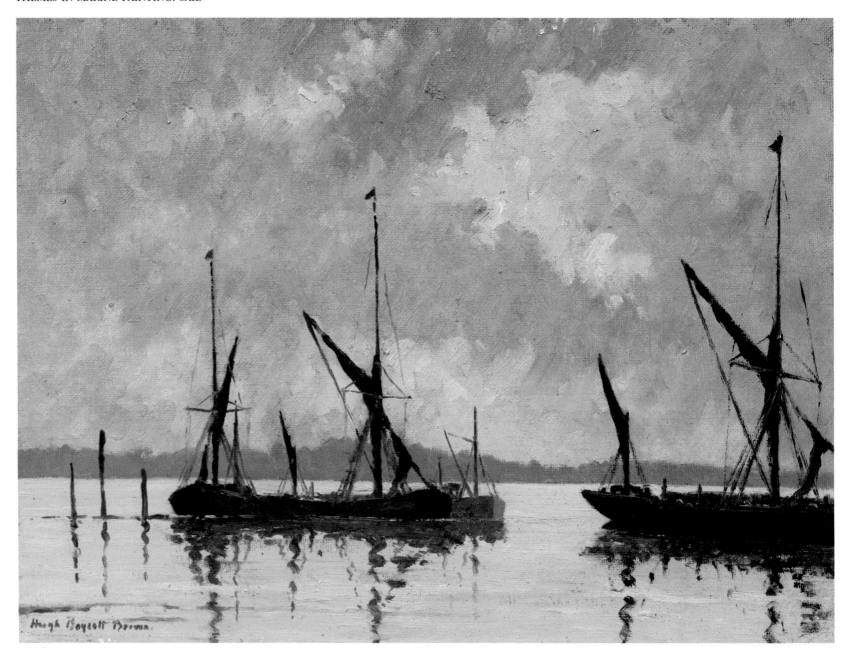

Hugh Boycott-Brown, R.S.M.A. 'Approaching storm, Pin Mill, Suffolk'. Oil, 12in x 16in. R.S.M.A. Diploma Collection.

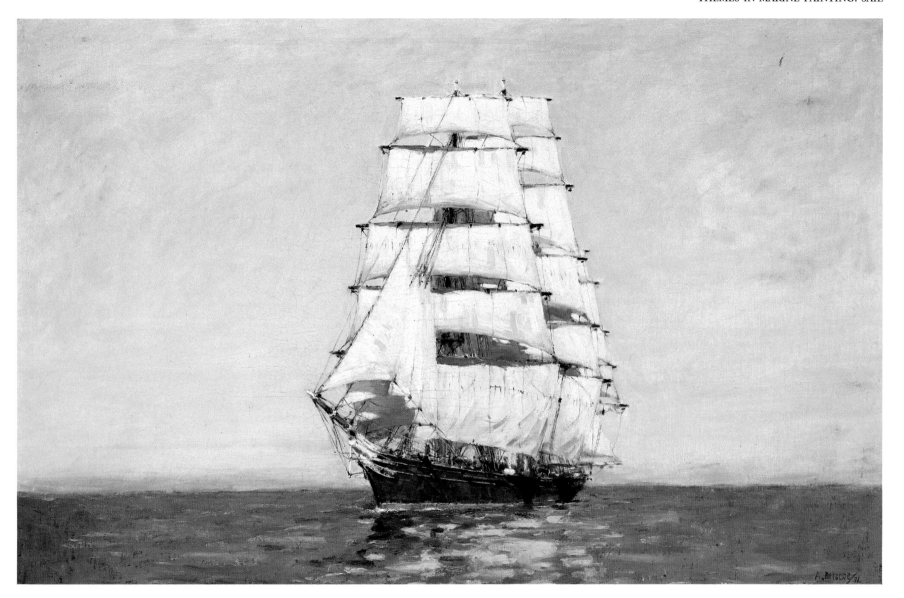

Arthur Briscoe. 'The *Cutty Sark*'. Oil, 26in x 40in. Reproduced courtesy of Sotheby's.

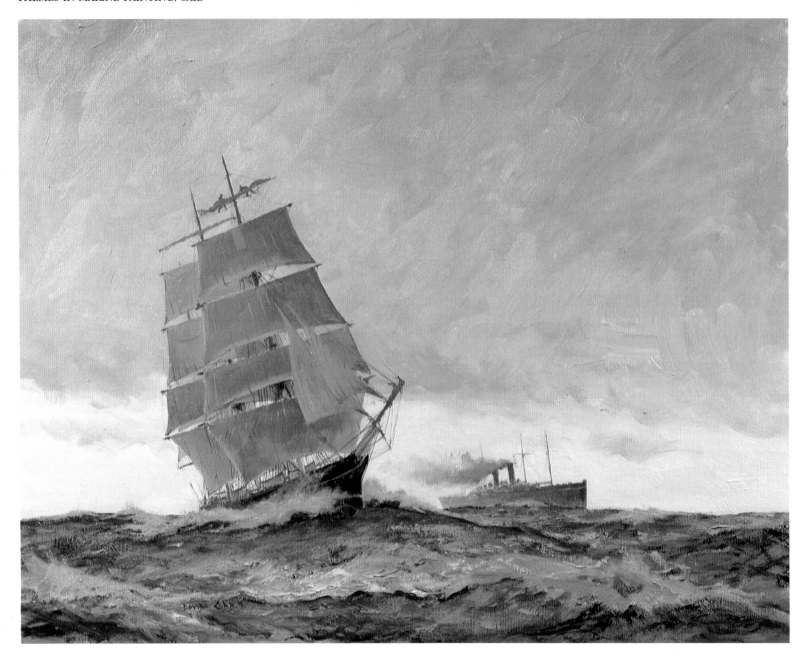

David Cobb, R.O.I., R.S.M.A. '25th July, 1888: *Cutty Sark*'s win over S.S. *Britannia*'. Oil, 24in x 30in. R.S.M.A. Diploma collection.

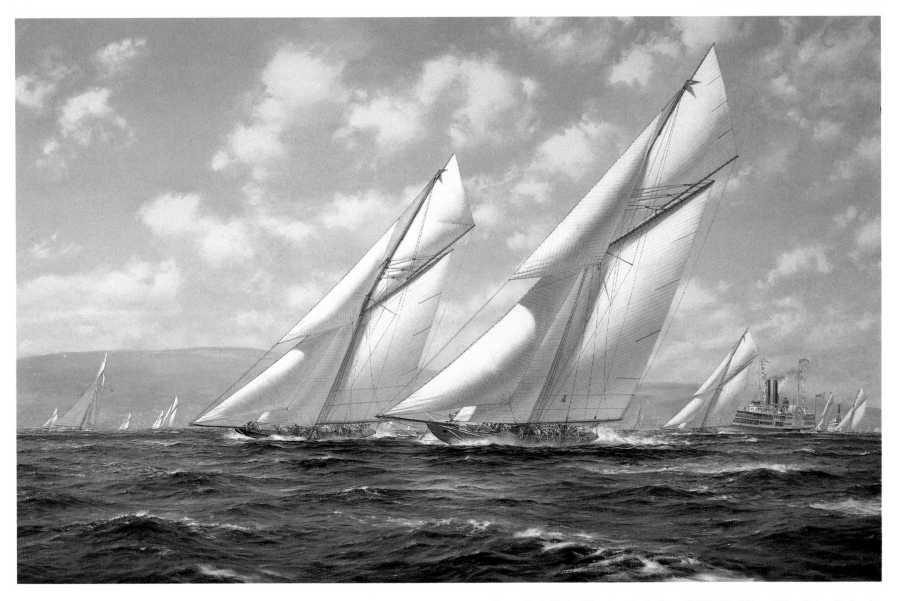

Roy Cross, R.S.M.A. 'The America's Cup, 1901'. Oil, 32in x 50in. *Columbia* battles with *Shamrock II* in the 1901 event, close racing which persuaded Sir Thomas Lipton to challenge again for the 1903 event. Private collection.

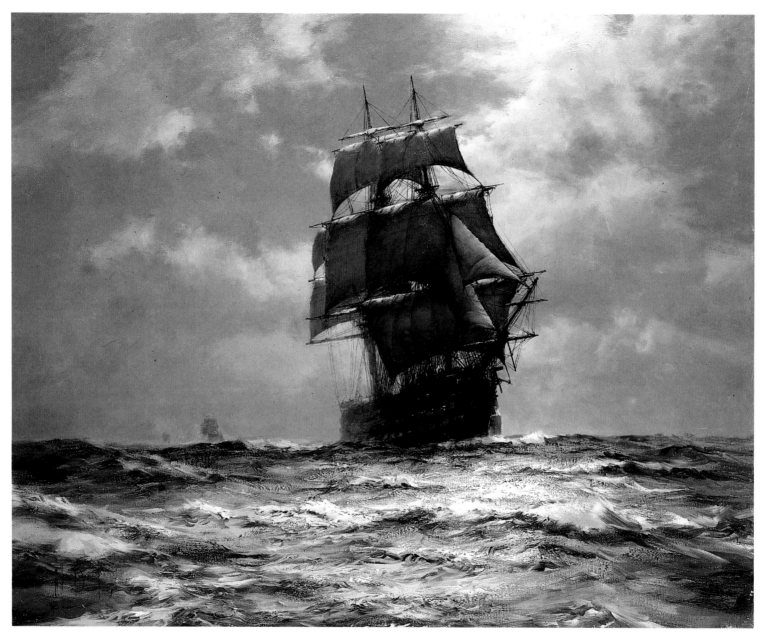

Montague Dawson, R.S.M.A. 'Sea Guardian – HMS *Victory*'. Oil, 40in x 49½in. By permission of the Trustees of the estate of the late Montague Dawson. Reproduced by courtesy of Sotheby's.

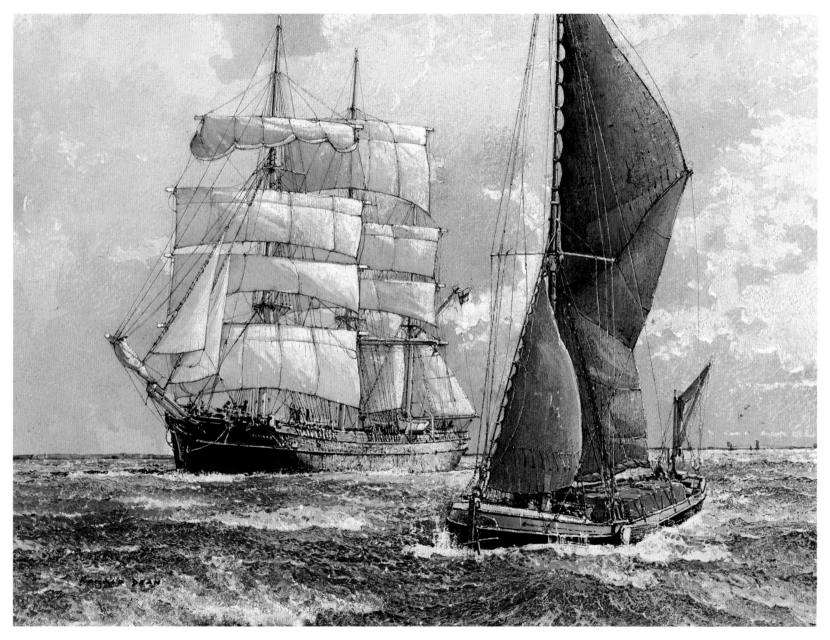

Ronald Dean, R.S.M.A. 'Firewood barque and sailing barge'. Watercolour and gouache, 12in x 16in. The Finnish barque *Alastor* sailing into the Thames during the mid-1930s. Collection Jan Peterson Esq., Gothenburg.

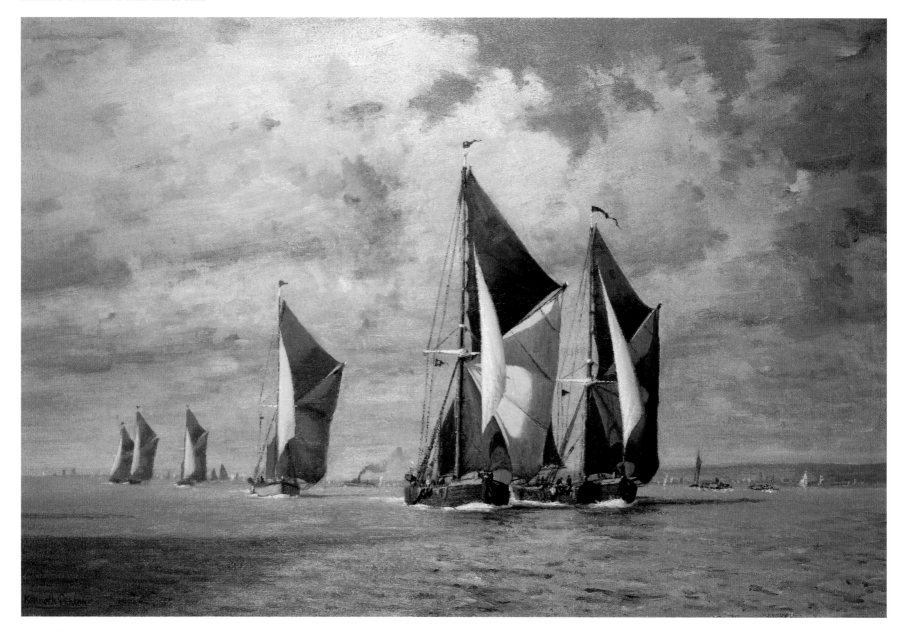

Kenneth Denton, R.S.M.A., I.S.M.P., F.R.S.A. 'Racing to the Medway buoy'. Oil on panel, 20in x 30in. The annual Barge Race on the River Medway. The leading barge has a new mainsail, which must be used and stretched prior to painting with Red Ochre, fish oil and sea water mixture. Private collection.

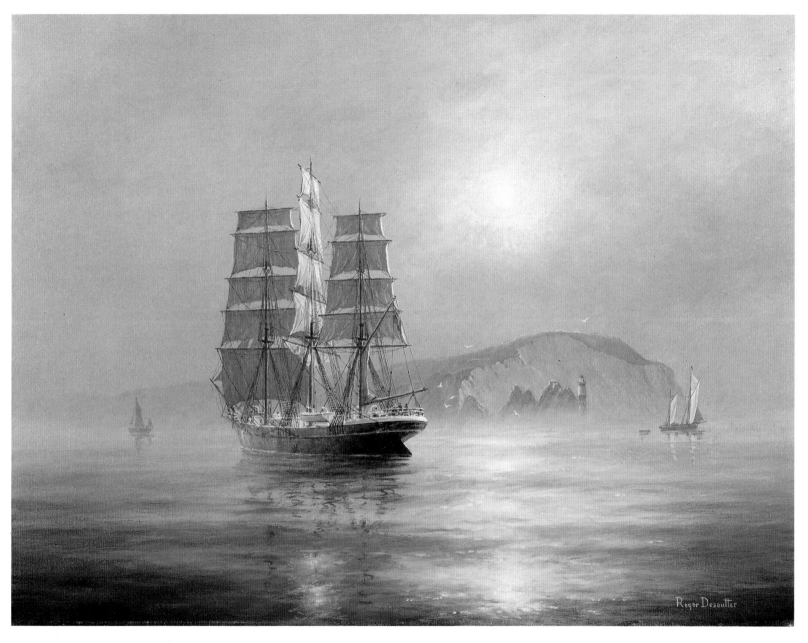

Roger Desoutter, R.S.M.A. 'Hove-to off the Needles'. Oil, 22in x 29in. On a winter morning, a three-masted barque lies hove-to, as the rising sun disperses the sea mist. Collection: Artist's studio.

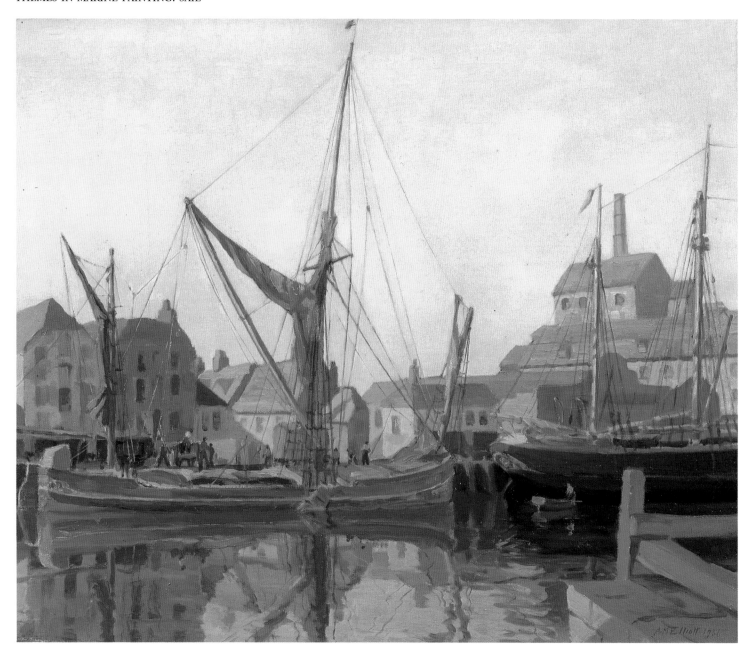

Aileen Elliott, R.S.M.A. 'Quayside, Poole'. Oil, 20in x 24in. R.S.M.A. Diploma Collection.

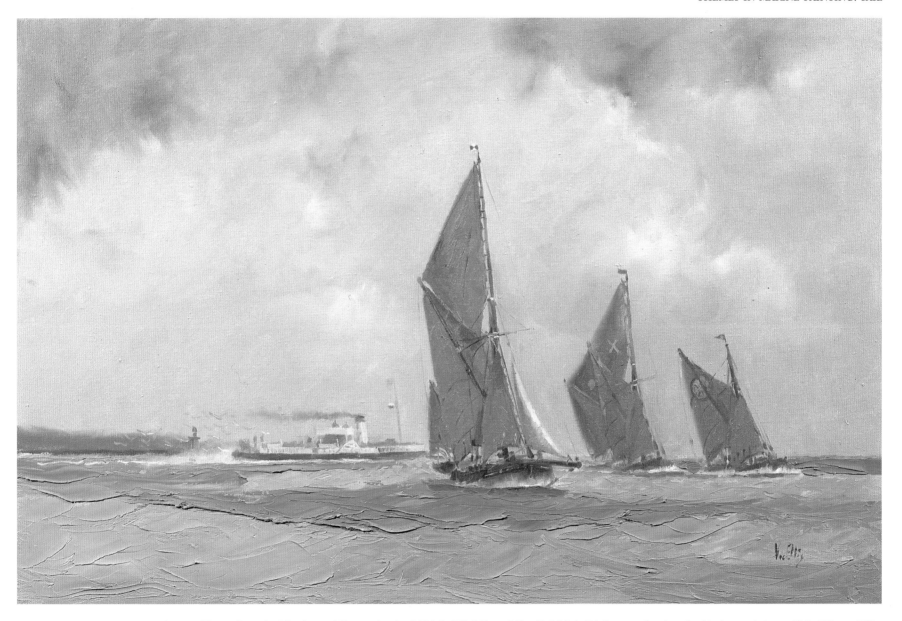

Victor Ellis, R.S.M.A. 'The lower Thames in the 1930s'. Oil, 20in x 30in. R.S.M.A. Diploma collection, by kind permission of Mrs Wynne Ellis.

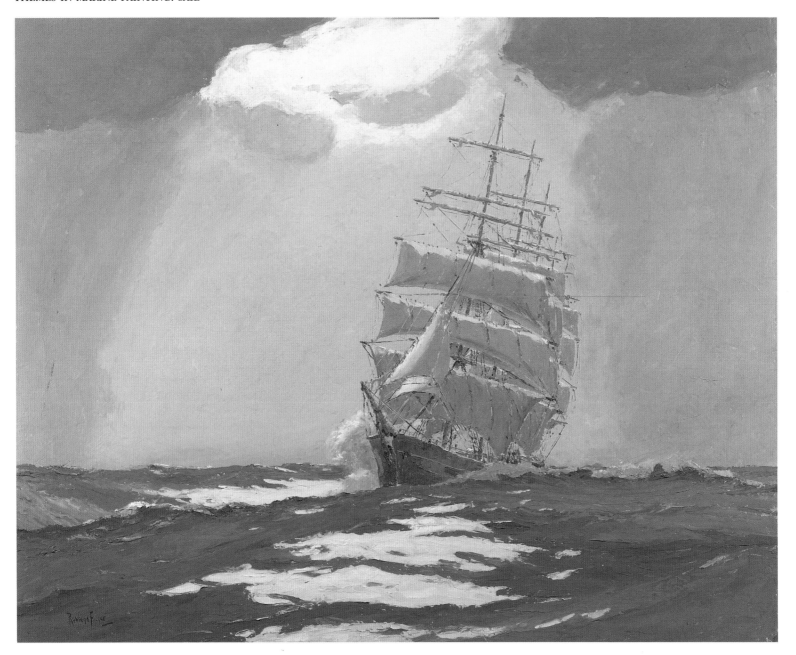

Rowland Fisher, R.S.M.A., R.O.I. 'A rough passage/stronger blow coming'. Oil, 40in x 50in. R.S.M.A. Diploma collection.

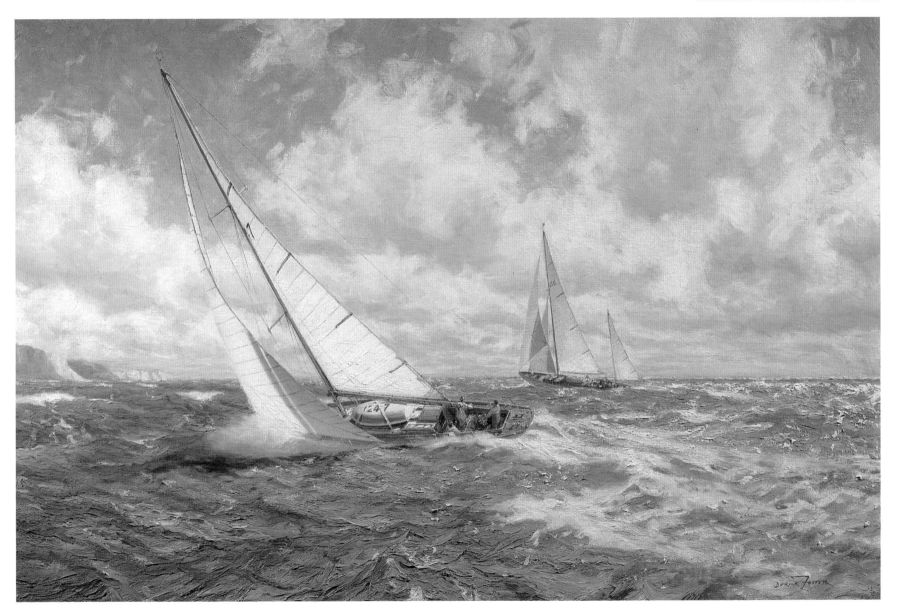

Deryck Foster, R.S.M.A. 'Offshore racers'. Oil, 26in x 40in. R.S.M.A. Diploma collection.

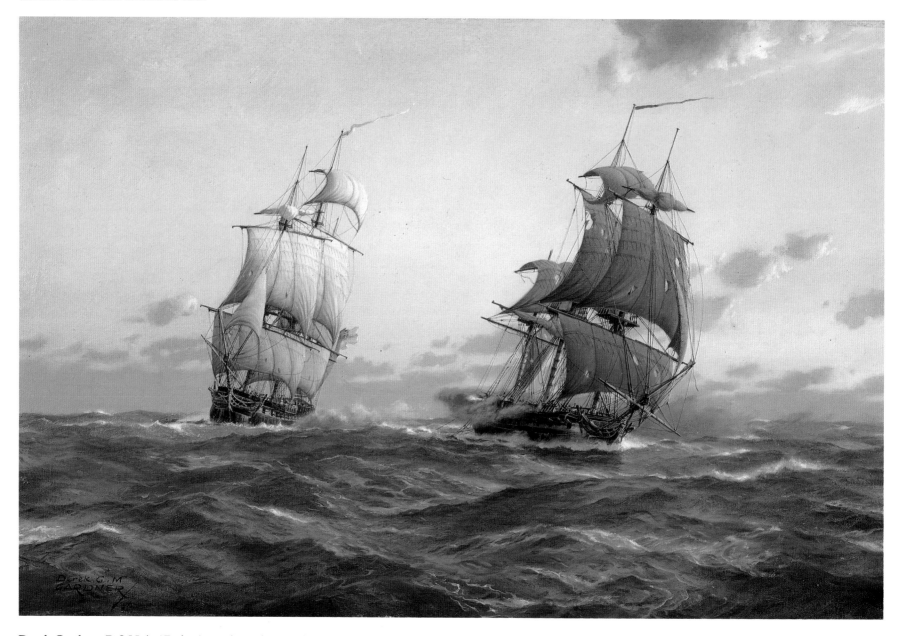

Derek Gardner, R.S.M.A. '*Endymion* and *Bacchante*, 25th June 1803'. Oil, 16in x 24in. Private collection in Australia.

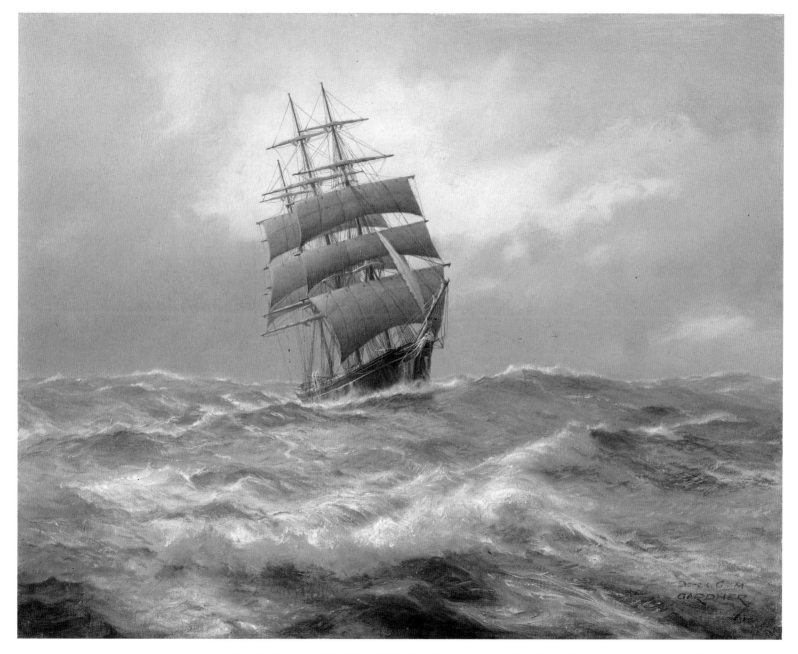

Derek Gardner, R.S.M.A. 'High Seas. The tea clipper *Leander*'. Oil, 14in x 18in. Private collection in U.S.A.

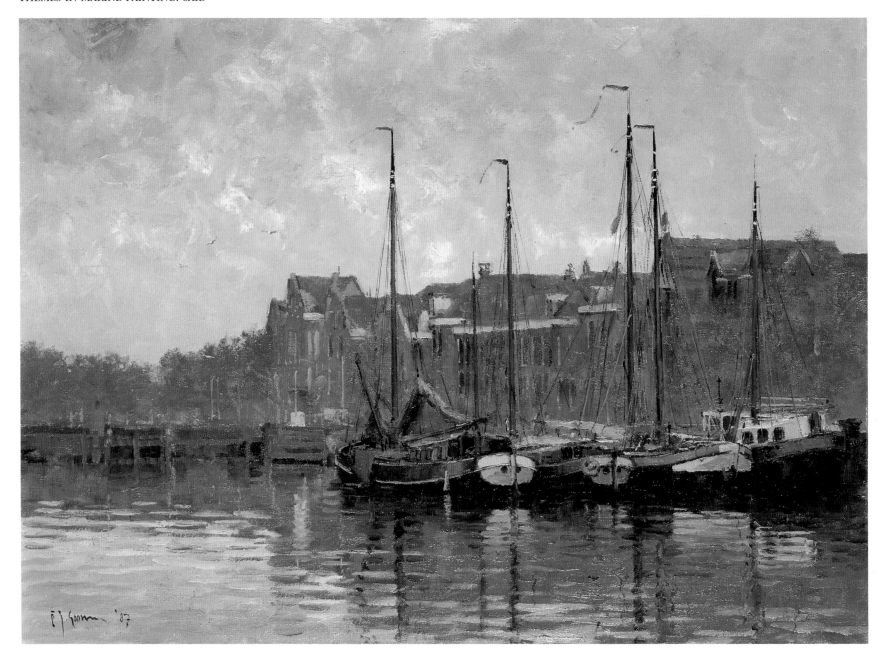

Fritz Goosen, R.S.M.A. 'Barges at Muiden'. Oil, 50cm x 70cm. By courtesy of Oliver Swann Galleries.

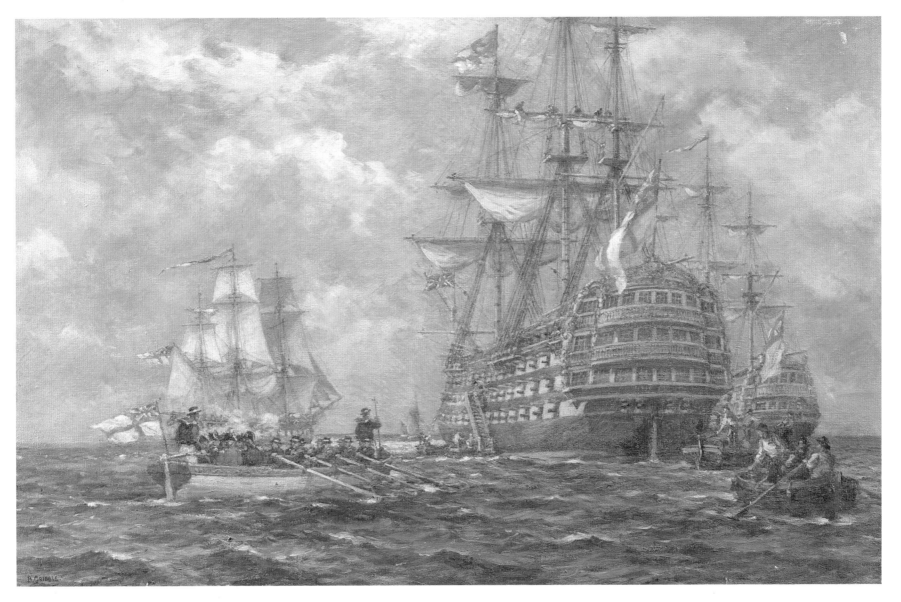

Bernard Gribble, S.M.A. 'Nelson boarding the *Victory* at Portsmouth'. Oil, 22in x 34in. R.S.M.A. Diploma collection.

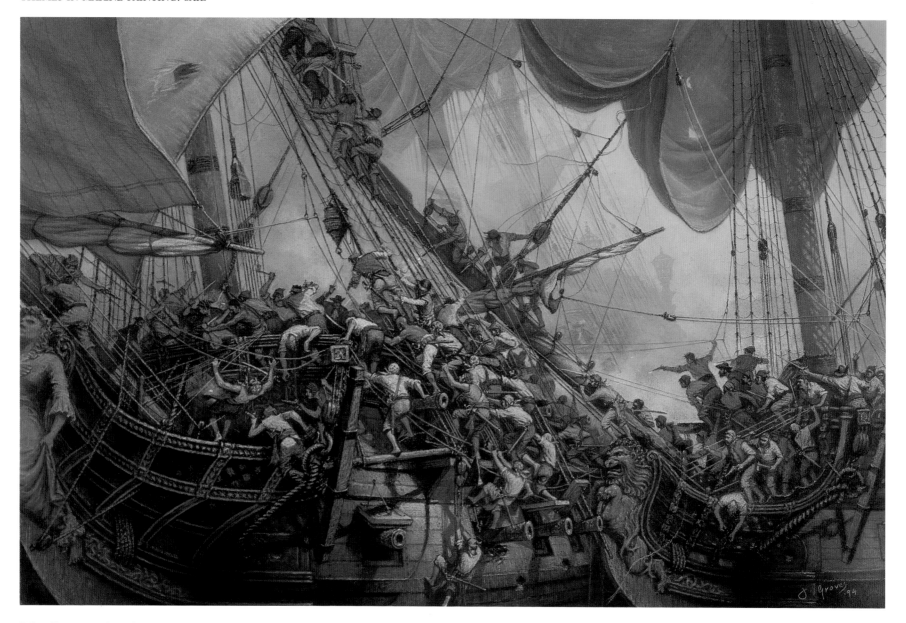

John Groves, R.S.M.A. 'The taking of the French Guinea-man by Captain Edward Teach, alias Black-Beard buccaneer'. Pastel, 20in x 30in. From 'Lives of the Most Notorious Pirates' by Captain Charles Johnson.

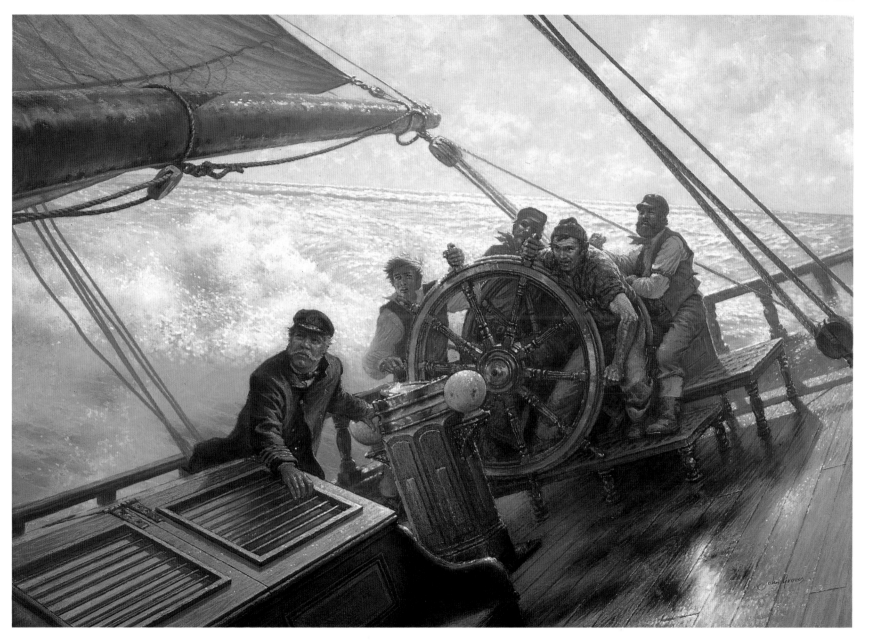

John Groves, R.S.M.A. 'Strong wind on the port quarter'. Pastel, 20in x 30in. Full sail in a strong wind and good weather; showing the intensity and concentration of handling a sailing vessel at maximum speed.

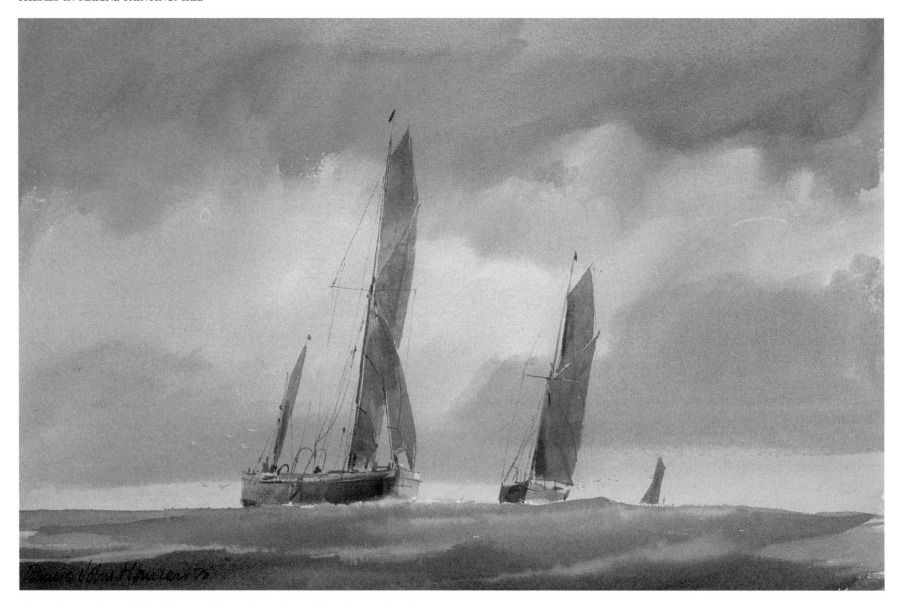

Dennis Hanceri, R.S.M.A. 'Barges'. Watercolour, 10in x 14in. Private collection.

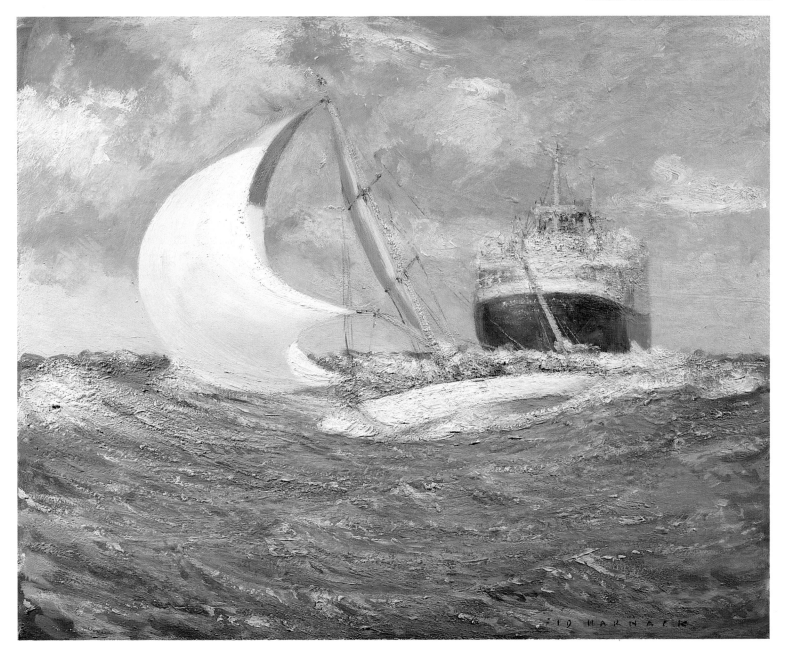

Frederick Harnack, R.S.M.A. 'Cruising'. Oil. R.S.M.A. Diploma collection.

Harry Heine, R.S.M.A., F.C.A., C.S.M.A. '*Nippon Maru* at Ogden Point'. Watercolour, 20in x 28in. Sail training vessel *Nippon Maru* at Ogden Point Dock, Victoria, British Columbia. Collection of Mr & Mrs Barry Philbrook.

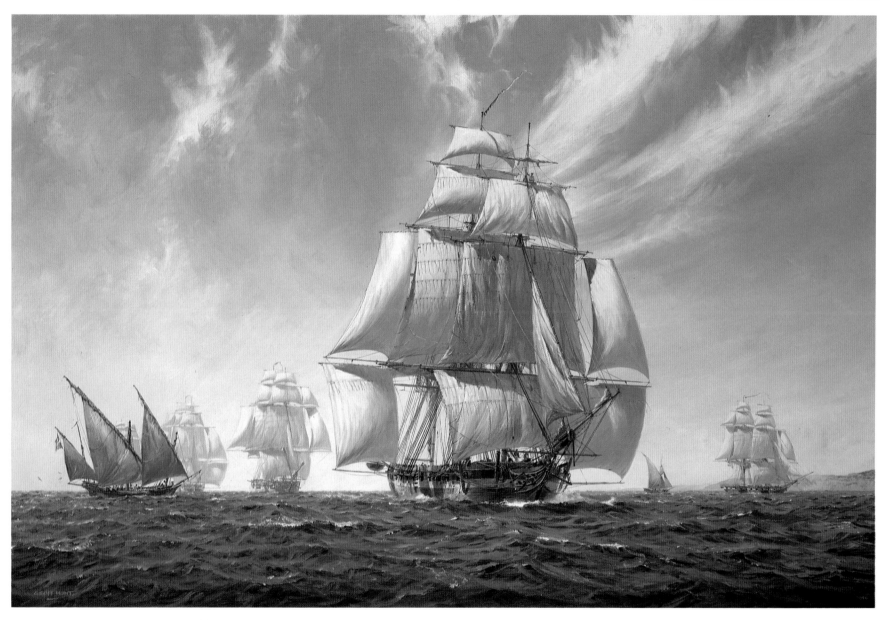

Geoff Hunt, R.S.M.A. 'Mediterranean deployment: U.S.S. *Ontario* leading Decatur's squadron, 1815'. Oil, 18in x 27in. Artist's collection.

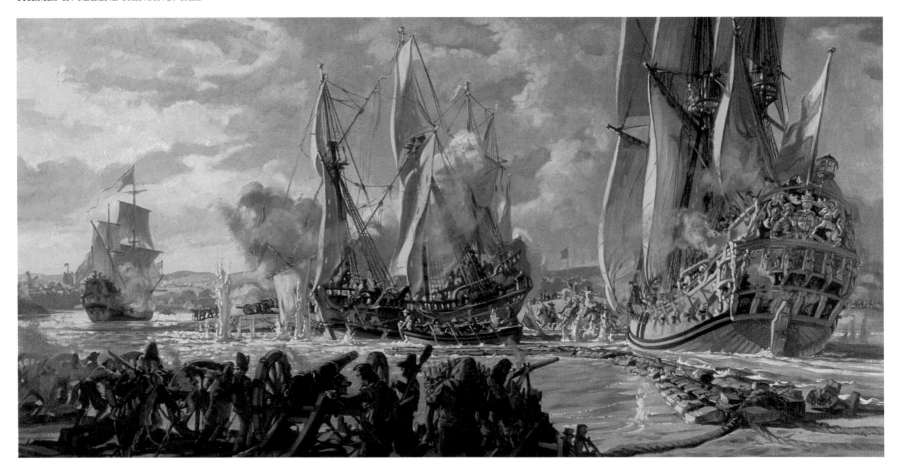

Pat Jobson, R.S.M.A. '*Mountjoy* breaks the boom at Londonderry'. By kind permission of Mr Harry Patton.

Claude Muncaster, A.R.W.S., R.W.S., R.B.A., R.O.I., R.S.M.A. 'South Pacific Blow'. Oil. Collection of Mr John Scott. By kind permission of the Trustees of the Claude Muncaster Estate.

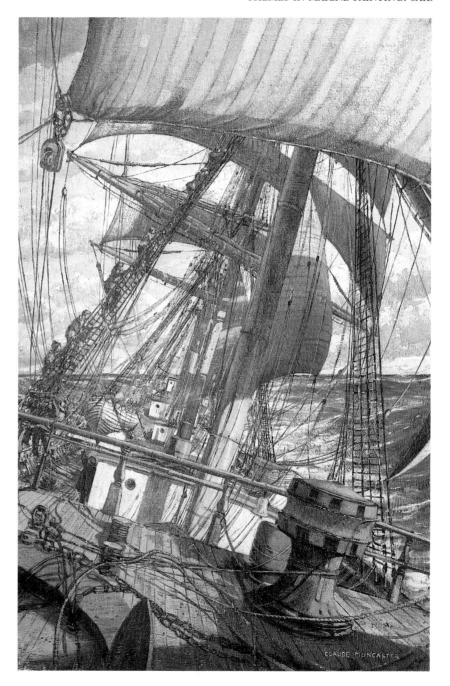

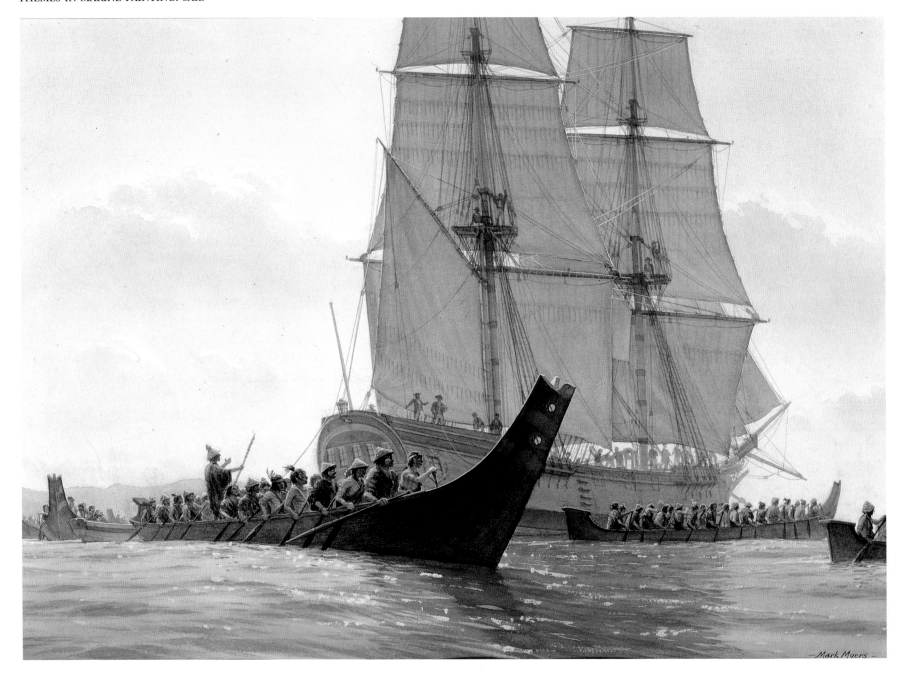

Left: Mark Myers, R.S.M.A., F/A.S.M.A. '"The simple melody of nature": the *Felice* circled by Makahs, June 30, 1788'. Watercolour, 22in x 30in, 1995. John Meares' *Felice Adventurer* was an early participant in the fur trade on the wild North West Coast of America. The painting's title comes from a passage in Meares' *Voyages* describing how an expected skirmish with the fierce Makah people off Cape Flattery was suddenly resolved when they burst into a song of welcome. From the collection of Mr & Mrs Robert Alexander.

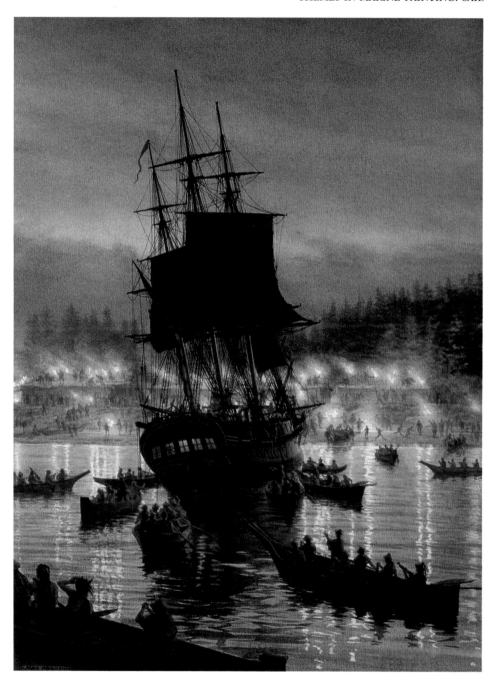

Right: Mark Myers, R.S.M.A., F/A.S.M.A. '"A most horrible drumming": the captured *Boston* in Friendly Cove, March 22, 1803". Watercolour, 30in x 22in, 1991. The American ship *Boston* was attacked and her crew massacred by the natives of Nootka Sound while on a fur trading voyage. The life of the ship's English armourer was spared in order to sail the ship to Friendly Cove, where her arrival was greeted by a night of wild celebration. The title comes from John Jewett's account of these events and of his three years' captivity among the Nootkans. From the collection of Dr. and Mrs Wayne Pazina.

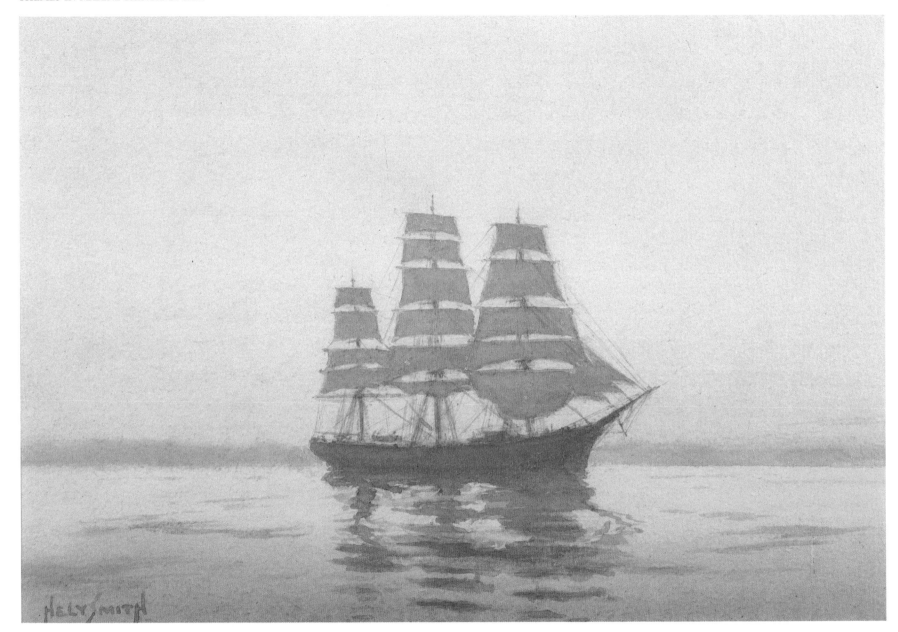

Hely Smith, R.B.A., R.B.C., S.M.A. 'In calm waters'. Watercolour, 6½in x 9½in. By courtesy of the David Cross Gallery, Clifton, Bristol.

John Stobart, R.S.M.A., A.S.M.A. 'London: moonlight over the Lower Pool'. Oil. By courtesy of Maritime Heritage Prints.

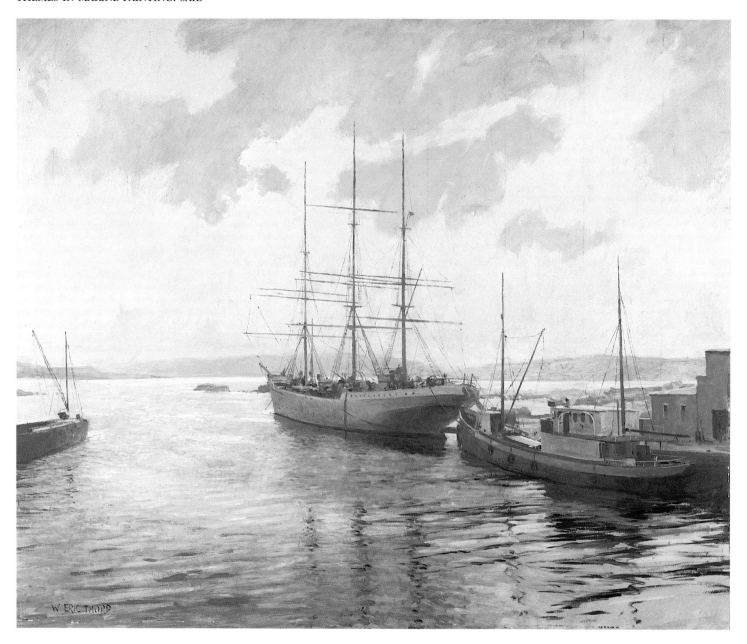

W. Eric Thorp, R.S.M.A. 'Training ships at Kristiansand, Norway'. Oil, 29in x 35in. R.S.M.A. Diploma collection, by kind permission of Mr John Thorp.

Leslie Wilcox, R.I., R.S.M.A. 'Start of the Tall Ships race, 11 August 1962'. Oil, 30in x 57in. R.S.M.A. Diploma collection.

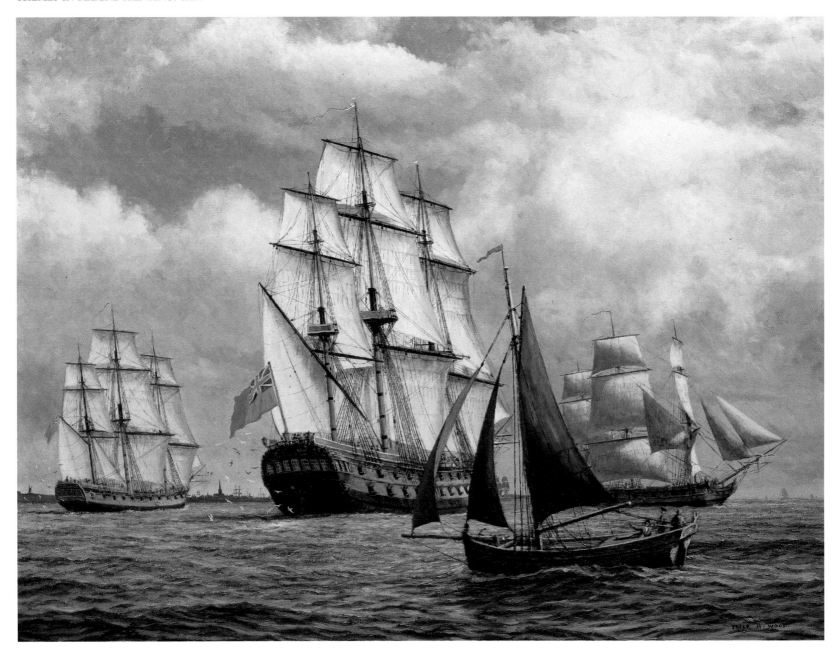

Peter Wood, R.S.M.A. '18th Century Ships in a Light Breeze'. Oil. By kind permission of Mrs Ursula Wood.

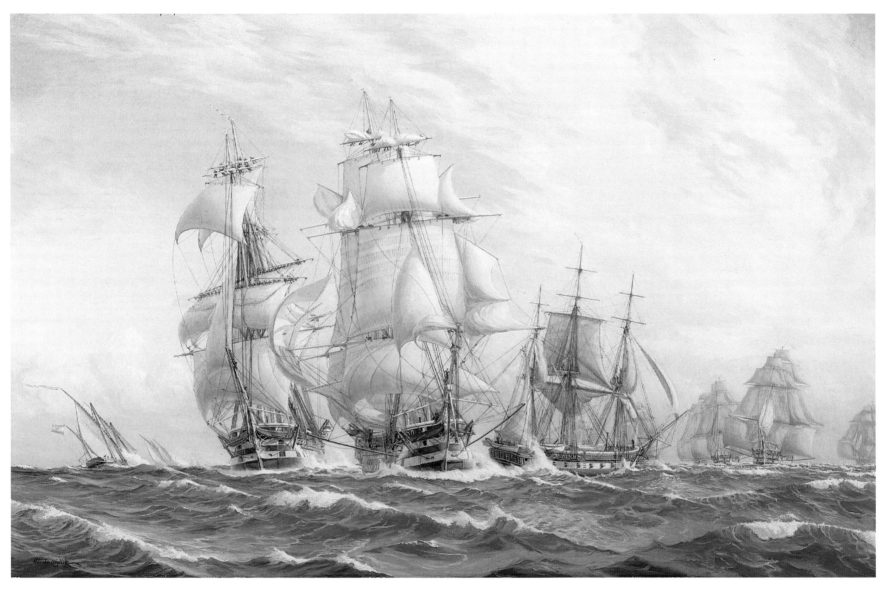

Harold Wyllie, R.S.M.A. 'Sailing trials of the Channel Fleet, 1847'. Oil, 38in x 60in. R.S.M.A. Diploma collection.

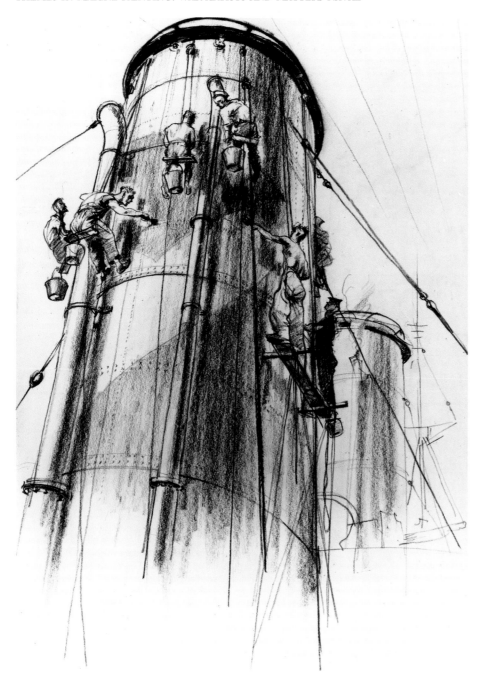

John Worsley, R.S.M.A. 'Funnel Party'. Charcoal pencil, 20in x 15in. HMS *Devonshire*, Indian Ocean 1942. Imperial War Museum collection.

War Artists and Matters Naval
by John Worsley, P.P.R.S.M.A.

In general there would seem little to equate art and artists with the deplorable and violent activities of warfare.

War makers, humble sailors, soldiers and airmen behave and obey their commanders and usually, but not always, have small concern about the arts. Why should they? As an art student in the middle 1930s and a modest earner from Fleet Street illustration in 1938–9, I believed when joining the Royal Navy in September of that year that my chosen art life had probably come to an end. But I realised we had to fight that dreadful war. An amusing naval aphorism I collected early in my service was that war life seemed to be 5 per cent terror and 95 per cent boredom (the percentages might vary according to one's view). However, I found, surprisingly, that the new life provided time to enjoy the pleasure of continuing to draw and paint. As a young midshipman (five shillings a day and gin at two old pennies per tot) I did have time to draw sailors and things marine, which was a delightful change from starting out to make an early living as a young artist.

Having spent the first three years of the war as a junior officer (midshipman, sub-lieutenant, lieutenant, R.N.V.R) in various ships – an armed merchant cruiser (sunk November 1940), destroyers and a cruiser – and during this time contributing regularly to Sir Kenneth Clark's current war art exhibitions at the National Gallery, I returned from a year in the Indian Ocean (H.M.S. *Devonshire*) to find that my next 'ship' was to be appointed as an official war artist on the staff of the Commander-in-Chief Mediterranean, based at Malta, as from July 1943. I had now joined the ranks of the few 'official' naval artists with the pleasing freedom of being able to join any ship or operation I thought boded well for depicting the Mediterranean war. I was now the youngest 'official' war artist and felt honoured to have joined the ranks of such renowned painters as Charles Pears, Muirhead Bone, Norman Wilkinson and others.

As this book is essentially a history of our Royal Society of Marine Artists during its first fifty years, the subject of war artists must be limited to those painters whose work was concerned with ships and sea. However, although our R.S.M.A. did not exist during the 1914–18 war, there are fine examples of marine war pictures of that time, mostly in the Imperial War Museum at Lambeth. Many of these paintings were by artists who subsequently became founder members of the Society.

A short summary of these would therefore seem to be appropriate before moving on to the 1939–45 conflict, when most of our war pictures were made and our Society was conceived. During the First World War one of the concepts considered for employing artists was that they should be used for what we now call 'propaganda' purposes under Government direction. A second and more marine area was for the design of ship camouflage. Those were the days before Asdic* and radar and if a ship was painted with what was called 'dazzle' design it was much more difficult for an enemy submarine or surface vessel to calculate the ship's speed and direction in order to achieve a successful attack. One of our Society's renowned founder members, Norman Wilkinson (in 1917 a lieutenant-commander in the R.N.V.R.) was one of the pioneers of dazzle painting and probably the first man to think of the idea. In his fine book *A Brush With Life* he describes his first ideas and tussles with naval bureaucracy, and his final triumph. The book also presents some excellent photographic examples of his first designs and the ships painted with them, together with other drawings.

During the 1939–45 war, however, the development of Asdic and radar made camouflage less significant, these modern scientific tools enabling enemy ships' positions, speeds and directions to be calculated with accuracy. In 1939 the Imperial War Museum, although possessing many interesting and fine works by prominent painters of First World War events, neglected to focus much attention on organising any official or serious employment of artists to record the momentous proceedings that were to unfold during the next six years.

It was then that Sir Kenneth (later Lord) Clark entered the scene. At 36, he was Surveyor of the King's Pictures and Director of the National Gallery, and a man of influence, wealth and great art knowledge. He was aware that the Ministry of Information was not particularly intent on bringing the arts into its sphere of activity apart from using artists for propaganda and camouflage purposes, and was not particularly concerned with the idea of a serious pictorial record of the war. Sir Kenneth, by now an employee at the Ministry of Information, by dint of hard manoeuvring managed to set up

* Asdic: from 'Allied Submarine Detection Investigation Committee' (now known as 'Sonar').

a new body named the War Artists Advisory Committee (W.A.A.C.) with himself in the chair and a Mr. O'Rourke Dickey (a serious painter in his own right) as Secretary, and with modest funds at its disposal to employ artists. He first invited Muirhead Bone, of First World War painting fame (which satisfied the Imperial War Museum), to join. Other artists, including Henry Moore, John Piper, Anthony Gross and Eric Ravilious, subsequently joined the organisation.

One of Clark's aims was to endeavour to assist prominent painters in continuing to exercise their skills by depicting happenings during the conflict instead of perhaps wasting their lives by being forced into one of the services and possibly being killed.* Exhibitions were shown at the National Gallery throughout the war.

Amidst the works of his official artists, Sir Kenneth Clark kindly exhibited some of the pictures of naval happenings and sailors that I, as a junior R.N.V.R. officer, found time to illustrate. Before leaving for my C-in-C Staff Malta post I was instructed by Admiral Sir William James, who was in charge of organising war correspondents and stray creatures such as naval war artists, that as I was the youngest of the breed I was not to sit on my bottom in Malta but was to get 'in amongst it', to which I responded rather too enthusiastically. After depicting landings at Sicily, Reggio and Salerno and other rumpuses, I was taken prisoner by the Germans.

At first I had a curious psychological block, causing me to regard myself more as a spectator or referee who, of course, was immune from the dangers of battle. I soon realised my mistake. Having arranged a nice watercolour board plus paints, water pot, etc., on the small bridge of an anti-aircraft landing craft crossing the Straits of Messina to Reggio, we were attacked by dive-bombers. The pompom guns on each side of the bridge opened up – result: board, paints, water pot and everything all 'went for six'. Henceforth I was convinced that the only way to proceed in future was to make drawings (with copious notes on colour and so on) and then retire to a more peaceful location to paint them. Cameras in those days were relatively rare and not encouraged by the services, unlike today, when cameras are everywhere in the hands of courageous correspondents. They produce wonderful pictures, but with no particular *comment*; if he is to produce a worthwhile picture, the artist must unfortunately be there, observing and commenting, alongside the sailors and soldiers suffering the 'bangs', 'pops' and slaughter.

Members of our Society were not, of course, the only marine war artists, but I have listed here the members who represent us with their pictures of war at sea.

* The above is only a brief account of how the W.A.A.C. came to be formed.

We in Britain are now at peace and have generally been so for a surprising fifty years, although I am told there are as many as 65 small wars being conducted around the world at the present time. We still have warships, although considerably reduced in numbers, and I would make the curious and perhaps piquant comment that during the 1939–45 war naval ships had portholes and open bridges, and when the 'action stations' button was pressed the whole ship's company donned anti-flash gear, 'tin hats', life-jackets and so on before hurrying on deck (except for the engine-room men) and peering seawards for the enemy; and, of course, the bridge activity was equally active. Today's warships have no portholes, bridges are covered against nuclear fallout and when action is imminent the whole ship's company hurries below, closing hatches and proceeding to their below-deck stations to man highly technical electrical devices. It is a strange contrast.

Yet warships have lost none of their power to fascinate. The above-deck structures of a modern warship, in my thinking, are far more interesting than most idle contemporary sculpture, and the fact that it all has a practical purpose adds to its attraction.

May our R.S.M.A. members continue to draw and paint Naval ships because, I suggest, they are more interesting than the monster tankers and container ships.

Artists of Naval and Wartime Subjects*

DAVID COBB (1921–) was an R.N.V.R. lieutenant in the 1939–45 war and served mostly in motor torpedo boats; he latterly made a fine record of the Falklands conflict, and the Gulf War.

CHARLES CUNDALL, R.A., (1895–1971) made many fine marine war paintings as well as some for the R.A.F.

MONTAGUE DAWSON (1895–1973) is renowned mostly for his magnificent big square-rig sailing ship pictures, but also for sea battles and naval activities. (See the section concerning Sail.)

RICHARD EURICH, R.A., (1903–92) painted many fine pictures of naval warfare and activity.

ROGER FISHER, C.B.E., D.S.C., (1919–92) was elected to the R.S.M.A. in 1983. As a regular naval officer, (Captain (S) R.N.) he painted few works during the war (1939–45) produced good naval paintings subsequently for our exhibitions.

FRANCIS RUSSELL FLINT (1915–76).

FRANK MASON (1876–1965).

* Other war artists were Sir Muirhead Bone, George Davis, Pamela Drew, Cecil King, Charles Norton, Leopold Pascal, John Platt and Frank Wootton. See Directory section.

CHRIS MAYGER (1918–93). Apart from his regular contributions to the Society's exhibitions, he was well known for his fine, evocative book jacket covers for the sea stories of Douglas Reeman over many years.

CHARLES PEARS (1873–1958), founder and first President of the Society. Many good examples of his work showing the war at sea can be seen in the Imperial War Museum and National Maritime Museum.

NORMAN WILKINSON, C.B.E., (1878–1971) was renowned during the First World War for his 'dazzle'-painting designs for ship camouflage. Many examples of his exciting paintings of the 1939–45 war can be seen in the Imperial War Museum and National Maritime Museum, as well as in other municipal galleries.

JOHN WORSLEY President of the Society from 1983 to 1988. Much work in the Imperial War Museum and National Maritime Museum and municipal galleries showing drawings and paintings of wartime life at sea and in a naval prisoner-of-war camp in Germany. Creator of the successful dummy naval officer escape device 'Albert R.N.'

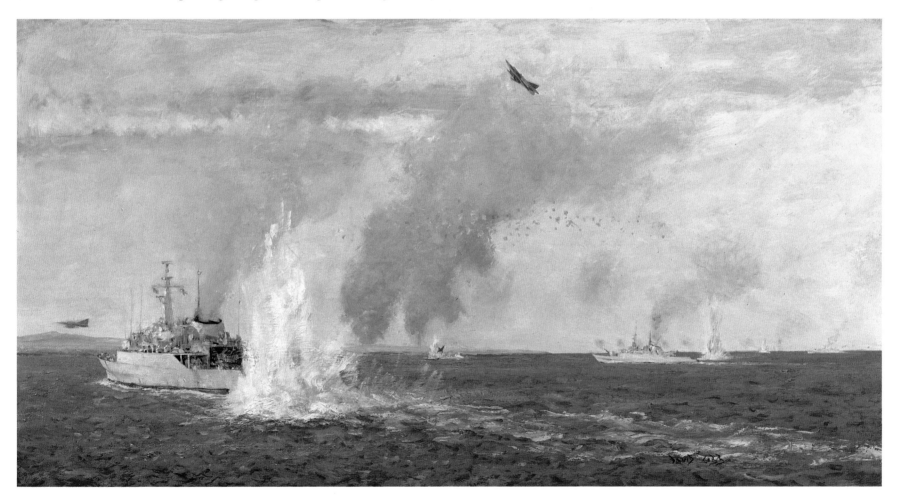

David Cobb, R.O.I., R.S.M.A. 'Bombardment of Port Stanley Airstrip, 1 May 1982'. Oil, 16in x 30in. H.M. Ships *Alacrity*, *Glamorgan* and *Arrow* bombarding Port Stanley Airstrip during the Falklands campaign, 1982. By courtesy of the Royal Naval Museum, H.M. Naval Base, Portsmouth

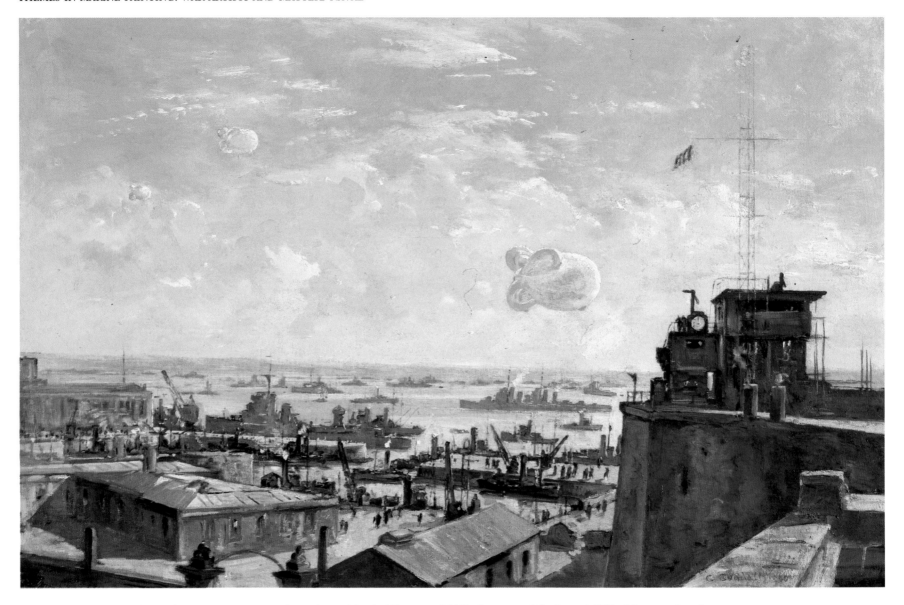

Charles Cundall, N.E.A.C., A.R.W.S., R.B., R.W.S., R.A., R.S.M.A. 'Sheerness 1940'. Courtesy of the Imperial War Museum, London.

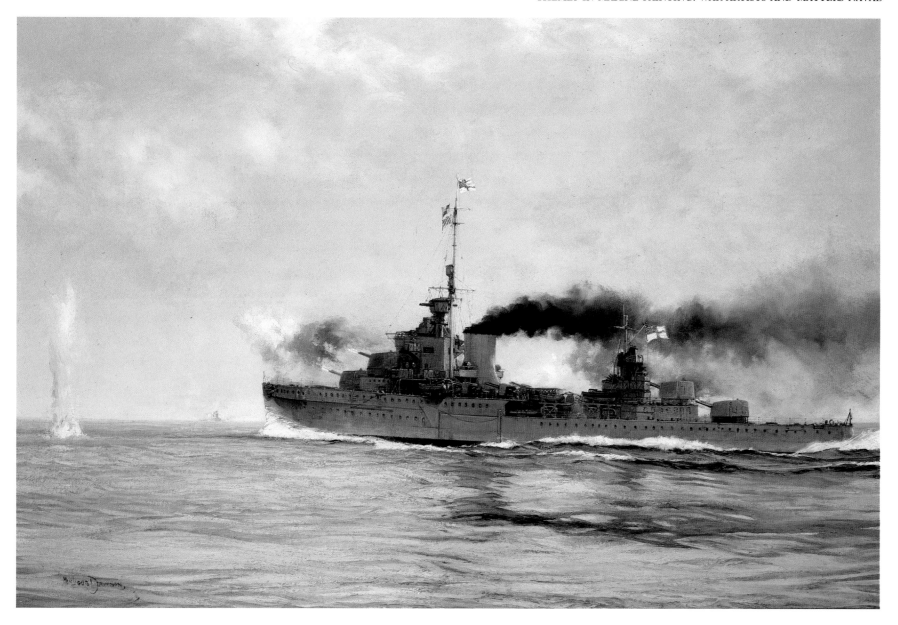

Montague Dawson, R.S.M.A. 'Well done *Ajax*, battle of the River Plate'. Oil, 28in x 42in. By permission of the Trustees of the estate of the late Montague Dawson. Reproduced by courtesy of Sotheby's.

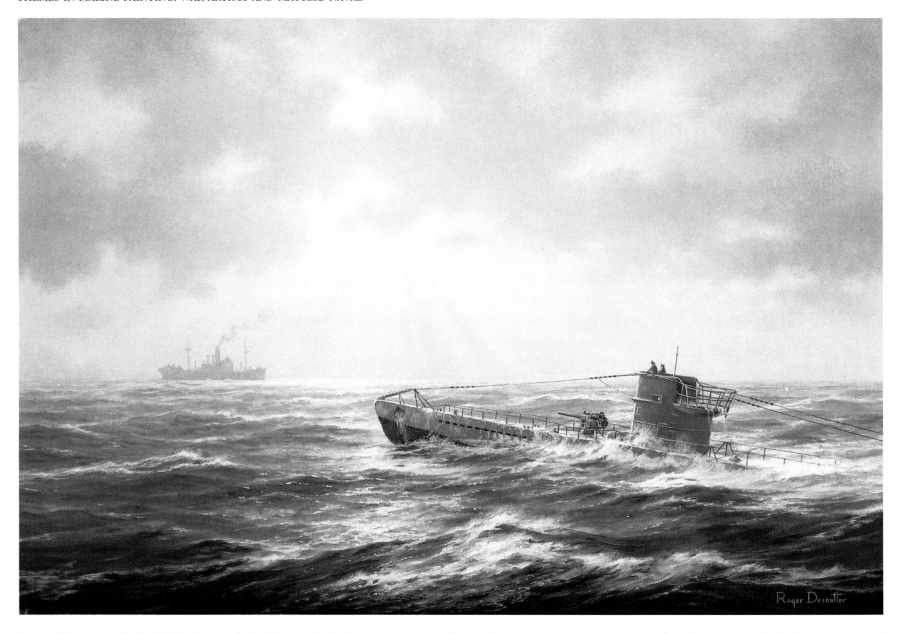

Roger Desoutter, R.S.M.A. 'The Straggler'. Oil, 20in x 30in. A German U-Boat, all torpedoes spent, surfaces to attack a small merchant ship which has become separated from the convoy. Collection: George Makris Esq.

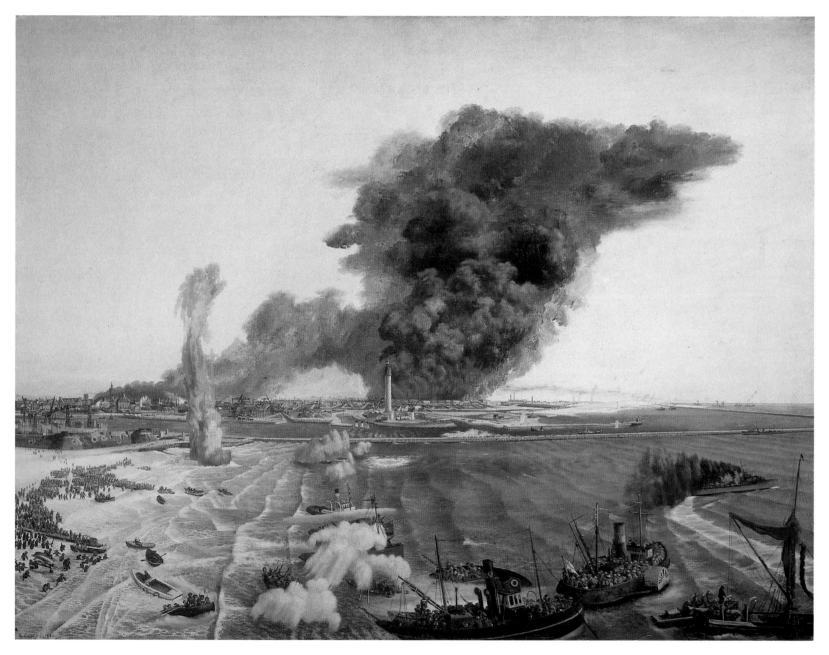

Richard Eurich, R.A., N.E.A.C., Hon.R.S.M.A. 'Withdrawal from Dunkirk, June 1940'. Oil, 30in x 40in. By courtesy of the National Maritime Museum, Greenwich.

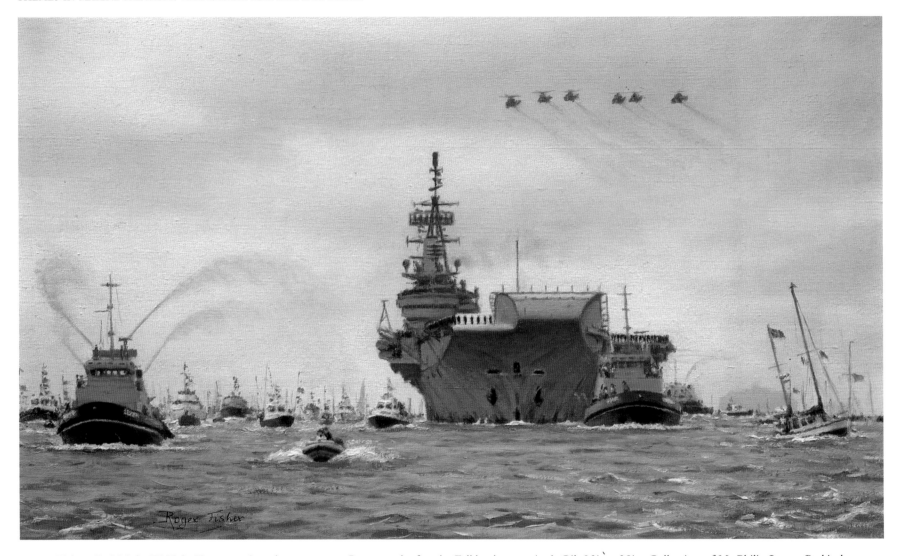

Roger Fisher, R.S.M.A. 'H.M.S. *Hermes* – triumphant return to Portsmouth after the Falklands campaign'. Oil, 12in x 20in. Collection of Mr Philip James. By kind permission of Mrs June Fisher.

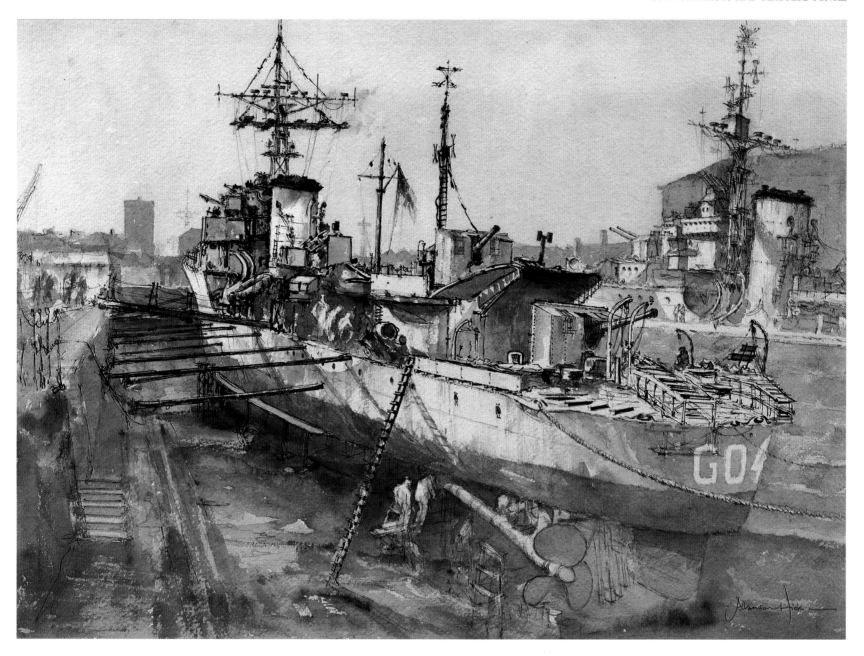

Allanson Hick, R.S.M.A. '*Onslaught*'s new shaft'. Watercolour, 12in x 20½in. R.S.M.A. Diploma collection, by kind permission of Sandy Chamberlain.

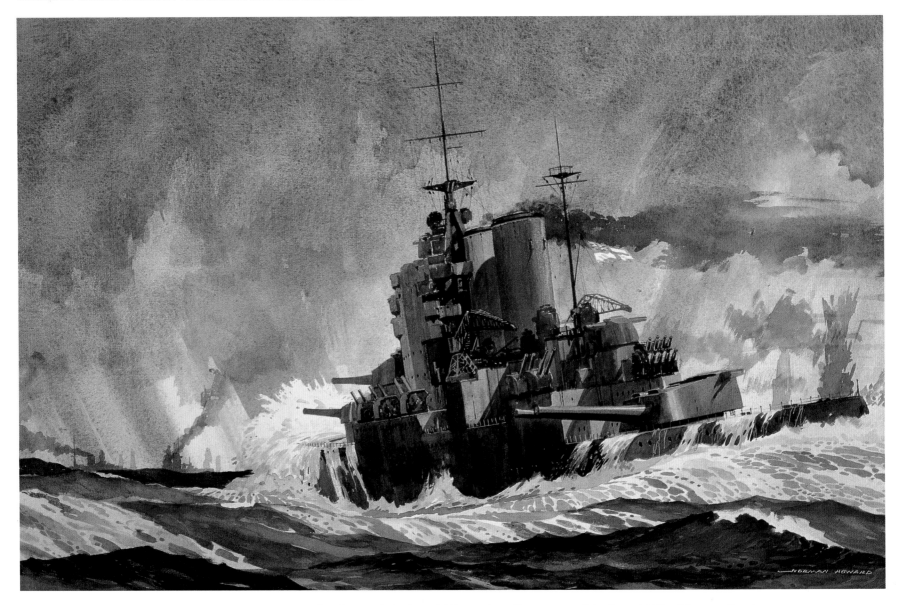

Norman Howard, S.M.A. 'HMS *Renown* engaging the *Scharnhorst* and *Gneisenau*'. Watercolour. By courtesy of the Imperial War Museum, London.

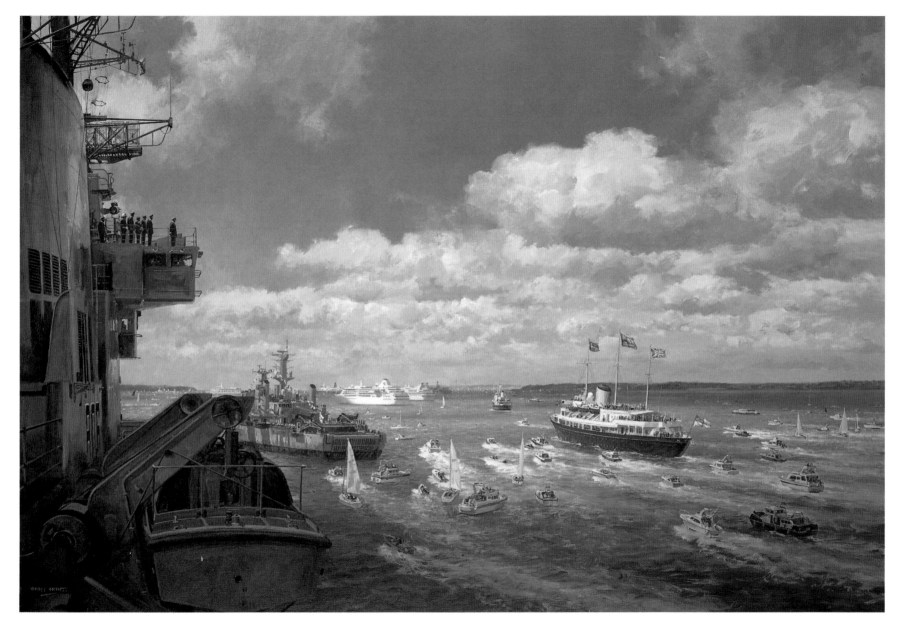

Geoff Hunt, R.S.M.A. 'HM Yacht *Britannia* reviewing the D-Day commemorative fleet, Spithead 1994, seen from HMS *Illustrious*'. Oil, 24in x 36in. Painted from sketches, notes and photographs taken while aboard HMS *Illustrious* on the day. Artist's collection.

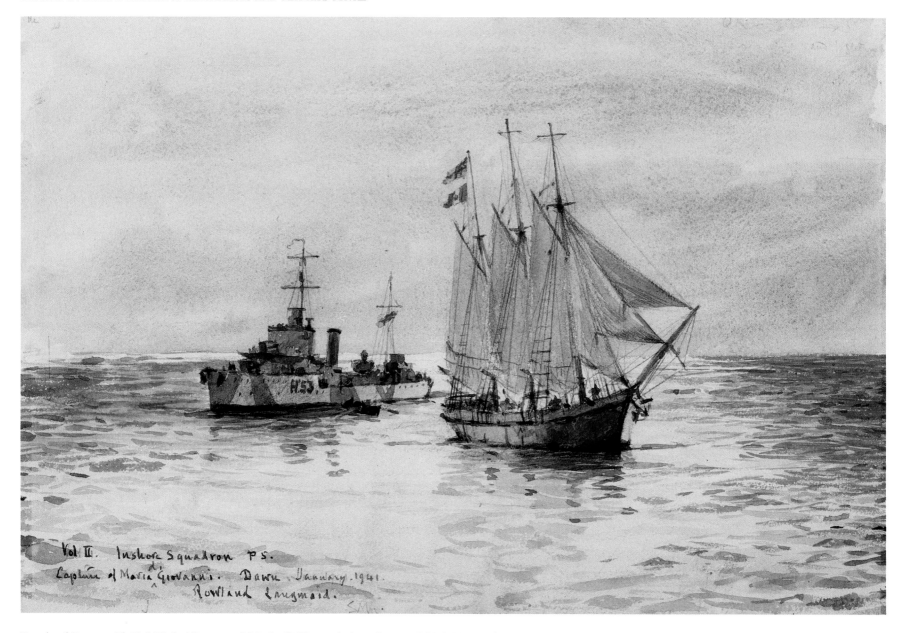

Rowland Langmaid, R.S.M.A. 'Capture of *Maria di Giovanni*, dawn January 1941'. Watercolour, 24cm x 34cm. © Crown Copyright. Ministry of Defence Art Collection.

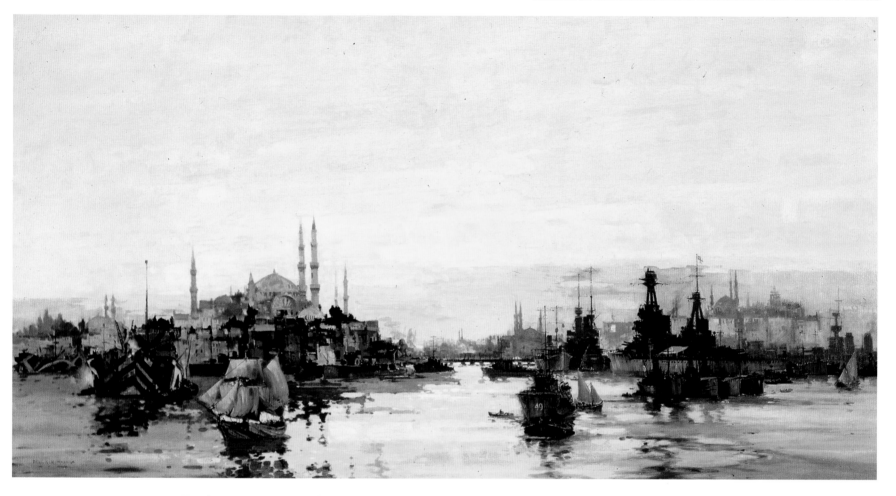

Frank Mason, R.I., R.B.A., S.M.A. 'The Allied fleet and shipping at Constantinople'. By courtesy of the Imperial War Museum, London.

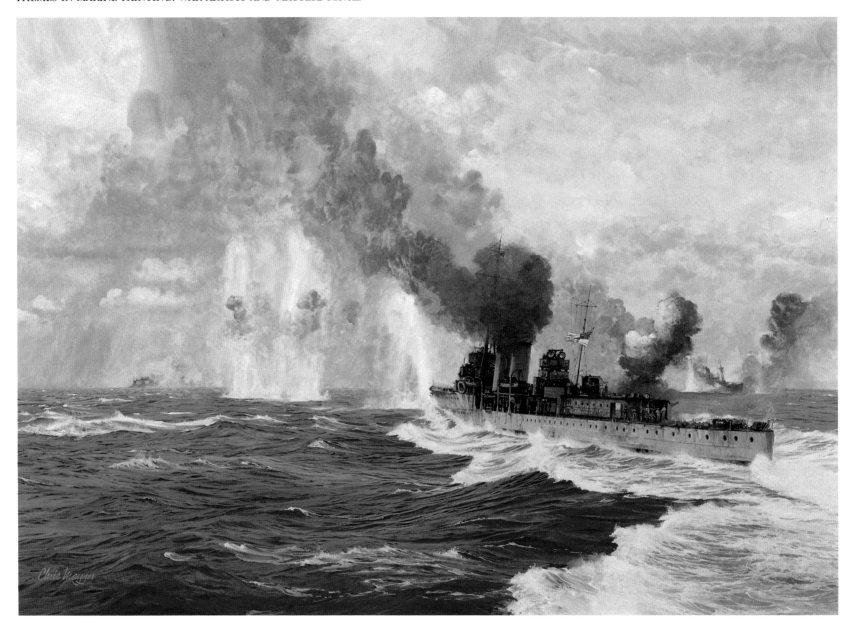

Chris Mayger, R.S.M.A. 'The *Dauntless*'. Gouache, 24in x 27in. R.S.M.A. Diploma collection.

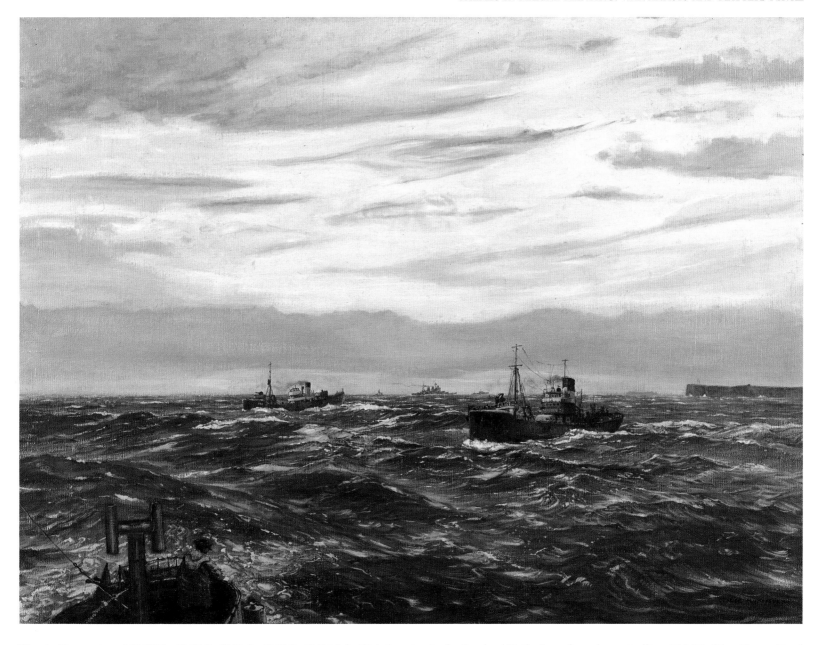

Claude Muncaster, A.R.W.S., R.W.S., R.B.A., R.O.I., R.S.M.A. 'Gale brewing in the Pentland Firth: Armed trawlers patrolling, H.M.S. *King George V* and accompanying destroyers cruising'. Oil, 30in x 40in. R.S.M.A. Diploma collection, by kind permission of the Trustees of the Claude Muncaster Estate.

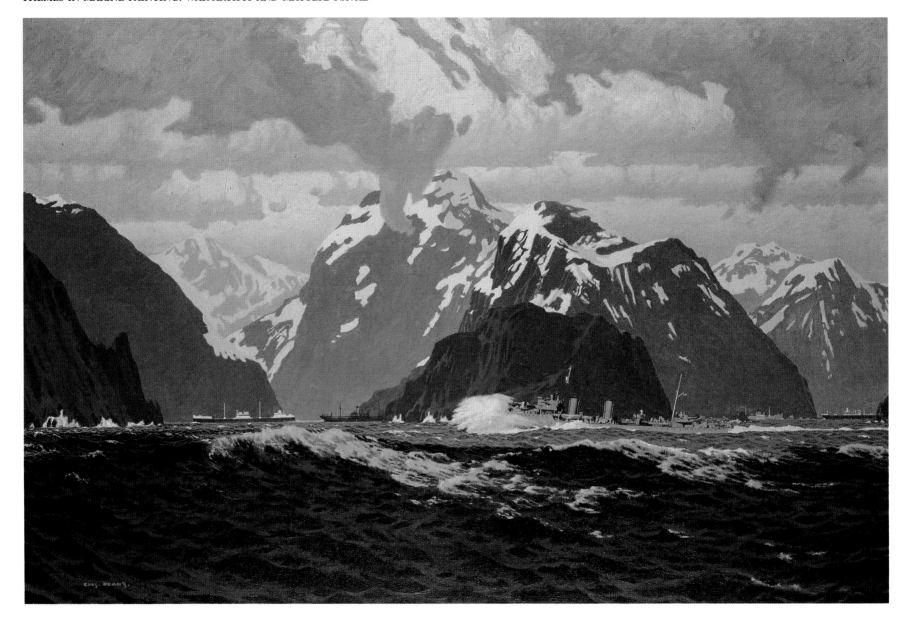

Charles Pears, R.O.I., S.M.A. 'The Norwegian Coast, Spring 1940'. By courtesy of the Imperial War Museum, London, and Mr Noël Brack.

John Platt, R.S.M.A. 'Convoy arriving off St Anthony lighthouse, Falmouth.' Oil, 36in x 24in. By courtesy of the National Maritime Museum, Greenwich.

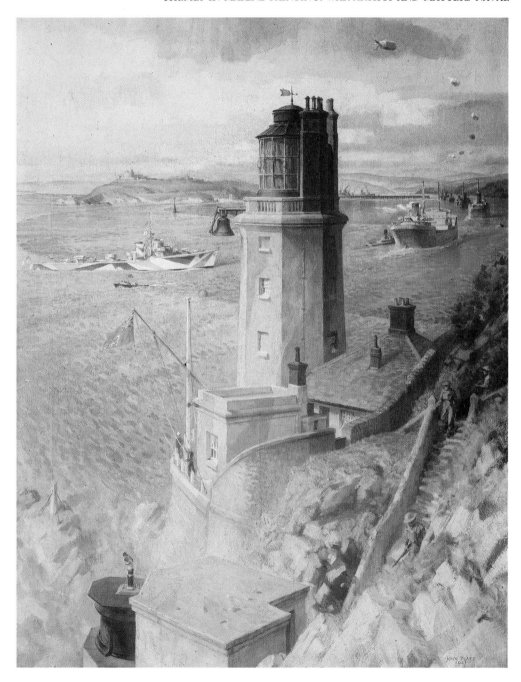

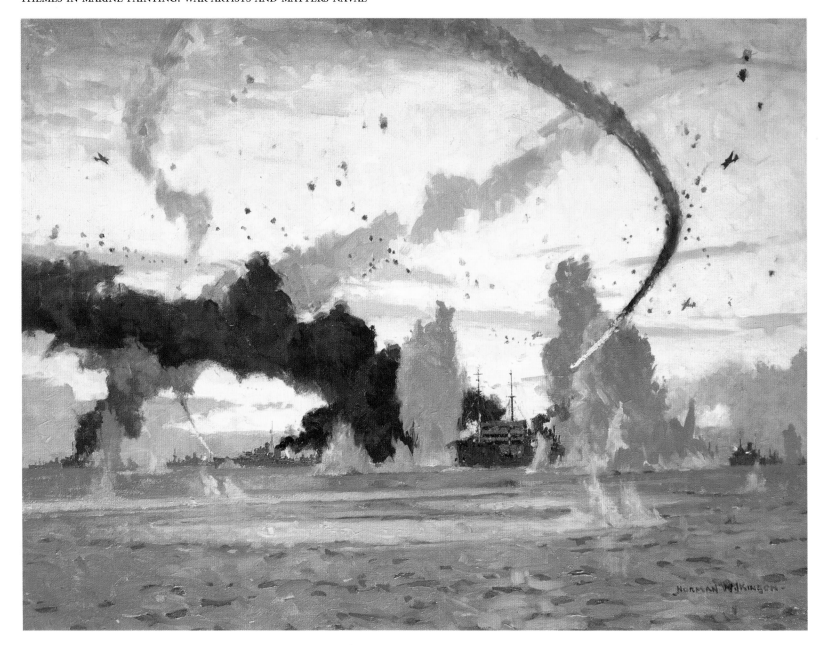

Norman Wilkinson, R.I., R.S.M.A., R.O.I. 'The *Ohio* in the Malta convoy, 10–15 August 1942'. Oil, 30in x 40in. By courtesy of the National Maritime Museum, Greenwich.

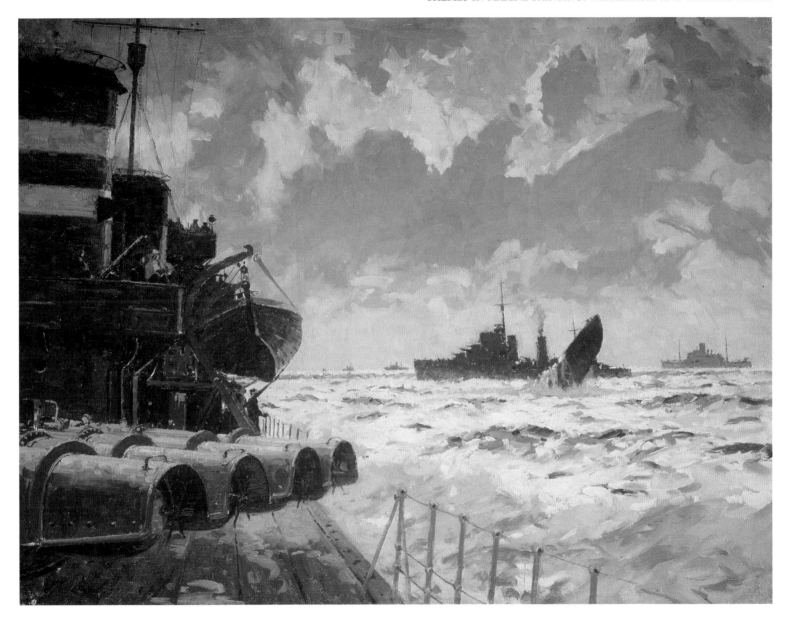

Norman Wilkinson, R.I., R.S.M.A., R.O.I. 'End of a U-Boat'. Oil, 30in x 40in. By courtesy of the National Maritime Museum, Greenwich.

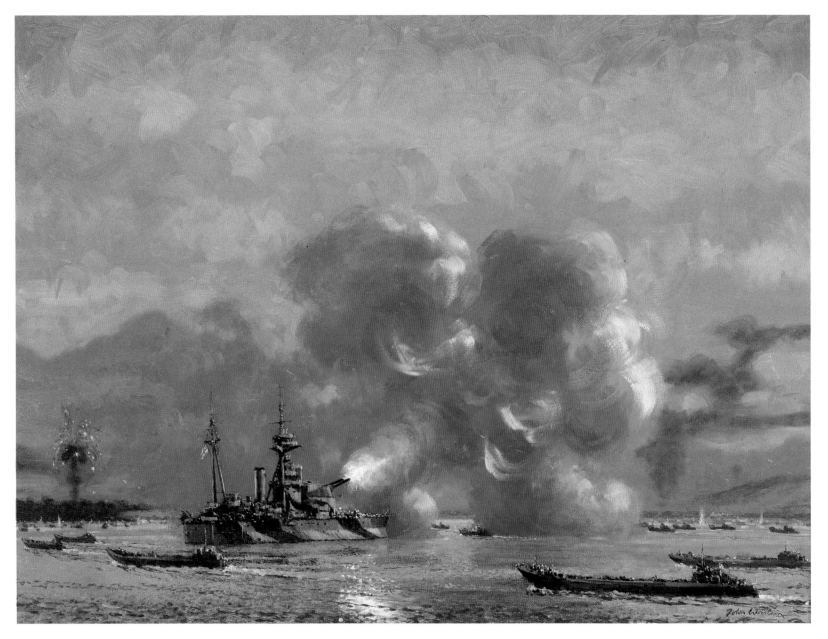

John Worsley, R.S.M.A. 'The 15in-gun monitor HMS *Roberts* bombarding over the top of landing craft at the invasion of Salerno, 9 September 1943'. Oil, 30in x 40in. Artist's collection.

River, Coast and Estuary

by Kenneth Denton, R.S.M.A.

I have always thought that man's love of water has psychological roots that go much deeper than the satisfying of a purely physical need.

This is certainly true of the British, for living as we do in a land surrounded by, and permeated with water, the increasing number of people who reach out to river and coast to fill their moments of leisure bear witness.

Our geographical setting gives rise to weather conditions which combine to emphasise the phenomena of atmosphere and light, providing the emotional impetus to which the true painter must respond. To a marked degree, the focus of the artist's attention today centres upon leisure activities; fifty years ago things were quite different.

The end of the era of sail as a means of conveying the fruits of commerce and industry had begun in the 19th Century. Slowly but steadily, the early part of this century witnessed the decline of the great fishing fleets under sail. River barges, with their diversity of pattern developed to meet local conditions, and coastal traders of all types and rig, rapidly became obsolete.

Few of these working craft were aesthetically attractive. Despite this, some were beautiful examples of the boat-builder's art and their place of origin, and builder, could be instantaneously detected by those familiar with the features of the vessels. They provided wonderful subject matter for the marine painter, and the artist-forbears of today's painters made them a mainstay of their work.

J.M.W. Turner and Clarkson Stanfield, and painters of their calibre, consolidated the British tradition of marine painting in the first half of the 19th Century. They were followed by Thomas Somerscales, Henry Moore and William Lionel Wyllie, who worked well into the 20th Century.

Continuity is important in all traditions, no less so in painting. We all choose our preferences and influences and, to some extent, we each are artistically the product of all those before us. The first half of this century abundantly provided opportunity for artistic influence, and made a vast contribution to marine art. Norman Wilkinson worked right up to the time of his death (aged 93 years) in 1971. Charles Napier Hemy died in 1917 but his pupil, Montague Dawson, was productive until his death in 1973. Add to these the names of Charles William Wyllie (brother of William Lionel), Sir Frank Brangwyn, Charles Dixon, Frank Mason, Charles Pears and Julius Olsson, to mention but a few, and a roll-call of ability and fame begins to emerge.

In 1946, despite the increasing abandonment of traditional sailing craft, the marine scene was still very active. In post-war Britain the fabric of our cities and towns was undergoing extensive repair and rebuilding. Traditional building materials such as timber, bricks, sand and cement continued to travel by water to the wharves of town and city merchants. Coal was still king, much of it still being water borne and frequently propelling the vessel that carried it. There was little competition from other fuels.

The Pool of London, the docks of Liverpool, Hull and other great maritime towns and cities, were an absolute hive of industry. Along with local activity, our ports were host to vessels from all over the Empire, indeed the world, as trading between nations became re-established.

There were great opportunities for the marine artist to develop compositions featuring a wide variety of vessels, and it seemed it would remain like it forever.

The six years of World War II interrupted life on many fronts. In the years before the war a small number of exhibitions had been held in London displaying work of some of our most eminent marine artists, including Charles Pears and Norman Wilkinson.

The post-war resumption of this painting interest and activity eventually led, in 1946, to the inaugural exhibition of The Society of Marine Artists, with Charles Pears as the Society's first President.

Fifty years ago the infrastructure of this country was in a sad state. For six years our resources had been deployed to maintain the freedoms we had defended so strenuously over the centuries. Shipping, industrial machinery, railways, all were pre-war and antiquated: the results of many years neglect and under-investment.

Recent elections had caused political changes and policies were being developed that would change our very way of life. Huge investment was being made in newly nationalised industries to modernise and make them

more efficient and competitive. Freight returned to the railways. At the same time a re-tooling motor industry began producing larger and more reliable vehicles, aiming at door-to-door delivery.

The war had been responsible for the rapid technological development of the aircraft industry. It was now possible to build larger machines of greater capacity and longer duration of flight.

Our shipping industry, depleted by war losses, failed to keep pace. The then political system failed to contain (indeed encouraged) power-building in the trade union movement, and the dockers flexed their muscle. The result was strikes for several weeks, and ships lying at anchor whilst their cargoes of food rotted in the holds. Thus began a decade of decline as dock workers presided over their own eventual demise – and a once great and proud maritime nation witnessed the rupture of a main artery.

Many parts of our coast had taken heavy aerial punishment during the Battle of Britain and subsequently, particularly those areas close to the ports. Defence systems on our beaches were cleared of barbed wire and concrete bollards, and shell holes in the walls of guest houses were repaired as life resumed peaceful normality.

Seaside areas often co-habited with harbours and ports, and artists initially drawn to one source of material, frequently drifted to others. The painter of fishing craft in harbour could see great possibilities in composition upon the beach. Indeed, Laura Knight, Stanhope Forbes and many others, followed Philip Wilson Steer in his depiction of the leisure activity of the coast, rather than the workaday commercial.

The painter has many concerns other than the technicalities of drawing and the management of paint. The generation and development of ideas relating to human activity and conditions have always been central to the expression of the painter's art.

The pure fun and relaxed atmosphere of the seaside with its helter-skelter, big wheel and Punch & Judy show offers a different challenge to the painter, not least in the handling of colour and texture in a higher than usual concentration. Perhaps it is the intensity of life at the seaside beach that inspires the artist – a no-mans-land, neither land nor sea: and yet both of these, inhabited to a density not to be found in the High Street, and all preoccupied with enjoyment.

Deck chairs, costumery and huge beach-balls, all in primary colours. Young desert-gardeners with bucket and spade, creating architectural fantasy which only the sea itself dare demolish. Fathers flying kites they forbid their sons to touch. Puppet shows, donkey-rides, paddlers, surfers, and all aboard for the next trip around the coast.

Look out to sea and you may see anything from a note-in-a-bottle to the worlds largest oil tanker; turn and look the other way for the uncertain delights of Victorian architecture. Within a half-century the parameters of expression comprising marine art have widened considerably.

An estuary is defined as a wide expanse of tidal water where the mouth of a river meets the sea. It has no particular activity of its own. Except you are sailing at leisure, experience of estuary waters will be limited to embarking upon or returning from a sea journey.

It is the integration with the sea on the one hand, and the relative proximity of land on the other, that governs the individual quality of interest to the marine painter.

A half-way house of great elemental forces capable of producing natures display of majesty and magic, coupled with a reaction of terror and humility. A place where the energy of sea breeze meets the air pressure of the land mass, and where the might of the sea must be tamed to make the quiet water lapping the city wharf. Here, the water is of a depth where the influence of its bed no longer seems to contribute to the effect of colour. Here, for the lack of obstruction, the great mass of the sky reaches one's awareness as never quite realised before.

Cloud formation builds sequences designed to indicate the changing conditions of pressure, density and weight. The air itself now contains another element – salt. In turn, the salt conditions the way we see things as the sunlight (which illuminates all) is subject to a partial refraction, producing a myriad of colour to bewilder even the most sensitive eye.

The very atmosphere is different – thicker, and yet more infinite in its subtlety; more infuriating in its capacity to taunt the painter with feelings of inadequacy and despair.

In 1983 I met the Dockmaster of Liverpool. On the Sunday he gave me a guided tour of the docks: of course, he knew every inch of the place and no part was denied me. Because such places are not easy of access I viewed the prospect with some excitement, and a deep sense of privilege.

It was one of the great dock complexes of the world. It was also empty, with redundant warehouses, sheds, unloading bays, and not a vessel in sight. A forest of giant cranes reflecting a mirror image in the still waters of deserted basins. I was assured it was not always like this – a ship was due in on Tuesday. The malady that had struck in the first decades following the war had rendered the victim helpless, and I was witnessing the death-throes.

It is a strange irony that a perfect state of things cannot be maintained, for without change stagnation results.

It is also strange that marine artists did not view the stagnation and consequent run-down of their subject matter with undue alarm: on the contrary, this created something of an improvement. Previously, there had been so much, the water scene cluttered and over-crowded, with the artist needing to exercise discretion to make a composition workable. With the "thinning out", focus was much easier and resulted in a simpler and less competitive composition allowing the painter to dwell with advantage on effects of light and atmosphere. The result of this selectivity and simplification was probably better and more satisfying paintings, artistically.

Fog, and even the dreaded smog, were deployed to soften down the background images, and to secure greater dimension and recession in the picture. Gradually, over a period of years, environmental improvements such as the Clean-air Acts gathered momentum: the great "black-smoke belching" river tugs were laid-up.

The air was cleaner, as was the water. Suddenly, it was all gone – salmon were back in The Thames.

Many of the most famous marine artists were members of The Society, which in the mid-sixties by gracious command of Her Majesty Queen Elizabeth, became The Royal Society of Marine Artists. Some of the painters were reaching the end of their careers and others, the end of their life.

A significant number had sailing experience (some having sailed before the mast) which had a distinct bearing upon the kind and nature of their work, reflecting their experience.

Pears, Muncaster, Brangwyn, Wilkinson, Dawson and Wilcox, all departed this life over a brief period of years. Their work reflected the times in which they had lived and their legacy to the sum of marine art has yet to be assessed; but I am certain it will need no justification.

A retrospective view of fifty years will almost certainly revive memories awakening mixed feelings of nostalgia, sadness, elation, triumph and failure and possibly others.

I have indicated the influences leading up to The Society formation in 1939, and the inaugural exhibition of 1946. I noted factors that demonstrate the inevitability of both social and industrial change, and how these changes affected the artist working in a specialised field such as marine painting. Artists are many things to many people: one of the things they must be is recorders of their time.

The giant Ships-of-the-Line and merchant traders reaching perfection in the tea clippers, were perhaps best painted by those familiar with them.

Those ships, the men who sailed them and the painters who immortalised them have gone; our last link ending in the '70s.

So, what now? Is it all over? Certainly not!

It would be easy to succumb to that mode of thought, and seriously underestimate the vast resource of imagination and enthusiasm that is part of the driving force and make-up of every artist of integrity. The product of that imagination, in all its variety, is to be seen in the annual exhibition of The Royal Society of Marine Artists.

The scope of inspiration is today even wider than in earlier years and the "great days of sail" is still represented, perhaps not in such abundance as previously, but certainly as well done. In fact, it could be argued that artist-historians would be more accurate in their depiction of vessels because of their research and caution for fear of getting things wrong. When something belongs in history it seems that accuracy of detail gains in importance.

I know Roy Cross, with his recourse to a very comprehensive library, to be meticulous about every detail. Derek Gardner, Mark Myers and Geoff Hunt, John Groves – with his remarkable mastery of pastel – Stuart Beck, and many others are keeping the tradition alive. Whilst these contemporary artists may not be painting from personal experience, in some cases their scholarship is augmented by living memory.

I clearly recall the sailing barges on the Thames and Medway, and made many sketches of them during my youth. The young man then thought these wonderful craft, and his mature self still does. In those days, the weighted vessels sat low in the water with their cargo, frequently with their decks awash. Today, as leisure craft they stand higher in the water but still look magnificent.

Wilkinson, Brangwyn, Burgess and Pears were pre-eminent in painting the great liners and merchant ships of their time; today, Colin Verity, Grenville Cottingham and Terence Storey lead the field.

Many of us find plenty to paint around the harbours, with their great variety of craft, architecture, boat-yards and marine paraphernalia. Sonia Robinson and Moira Huntley both display awareness of construction, not only of craft but also, of quay-side architecture.

On the coast and the beach, Sheila Macleod Robertson and David Curtis provide many visual delights; and, for all who saw it, "Lemonade with Grandma & Grandpa" shown in the exhibits of Raymond Leech (1992) was timeless in its recollection of childhood memory.

David Cobb painted yachts, other craft, and the sea in many moods, with great understanding: as did Leslie Kent and Eric Thorp, whilst John Worsley, Keith Shackleton and Alan Simpson are amongst today's many fine exponents.

It would be very easy indeed to adopt a somewhat parochial stance in a reflection upon fifty years of painting in any field. Home territories are all too easily called to mind but, during this period travel has become easier, faster, less expensive and, above all, safer. In effect then, the world *is* getting smaller. Artists have always been inveterate travellers but today we do not suffer the privations endured by our forebears. Jack Merriott and Frank Sherwin enjoyed frequent painting in foreign parts as instructors on painting holidays. Some of our present members also make this valuable contribution to advancing the abilities of others.

The great river ports and harbours of Europe alone yield a feast of material sufficient to keep any painter happy for several lifetimes. For centuries, painters have been drawn to Venice and each year our exhibition proves the floating city has lost none of her allure. Many of us have worked in Turkey, Greece, North Africa, the Maltese islands, the USA and Canada. The cold beauty of the Antarctic glacier coast, with the regional marine wildlife, is one of the more remote locations to be regularly seen in exhibitions. At home and abroad the committed artist will respond creatively to the spirit of place, atmosphere and incident of the subject, be it river, coast or estuary.

Left: John Ambrose, R.S.M.A. 'Porthmeor Beach'. Oil, 20in x 30in. Holidaymakers enjoying the sunny beach and surf.

Above: George Ayling, S.M.A. 'Sorting the night's catch, Scarboro''. Oil, 28in x 35¾in. Reproduced courtesy of Sotheby's. By kind permission of Mr Edward Ayling.

Donald Blake, R.I., R.S.M.A. 'Passing Shower'. Watercolour, 15in x 22in. The artist believes that boats huddled together lose their individual form and colour to produce an all-over texture of colour and form and become part of the total atmosphere. Collection: The Hon. David Curzon.

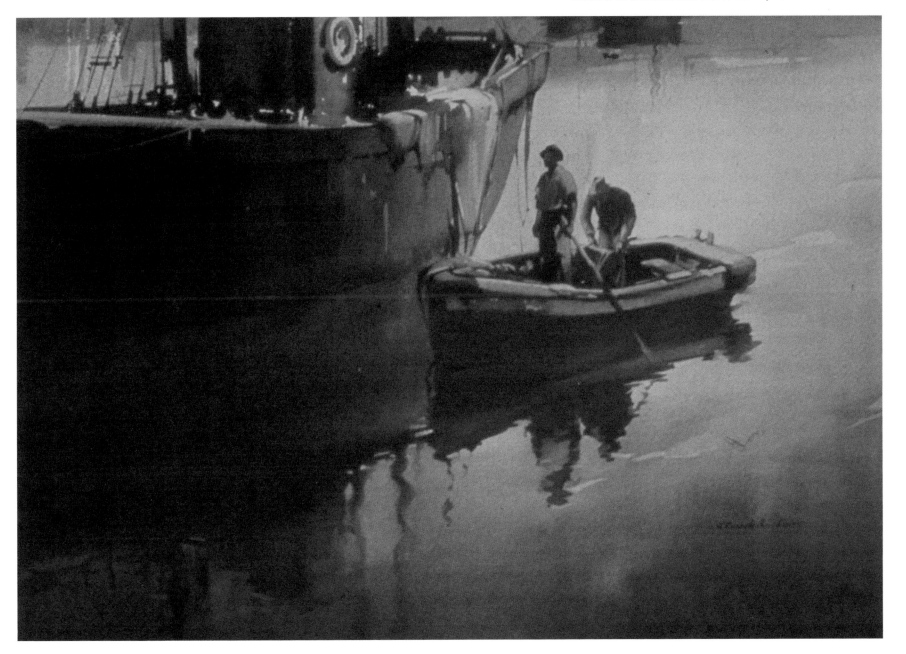

Claude Buckle, R.I., R.S.M.A. 'Going alongside'. Watercolour, 15in x 21in. By kind permission of Mrs Barbara Buckle

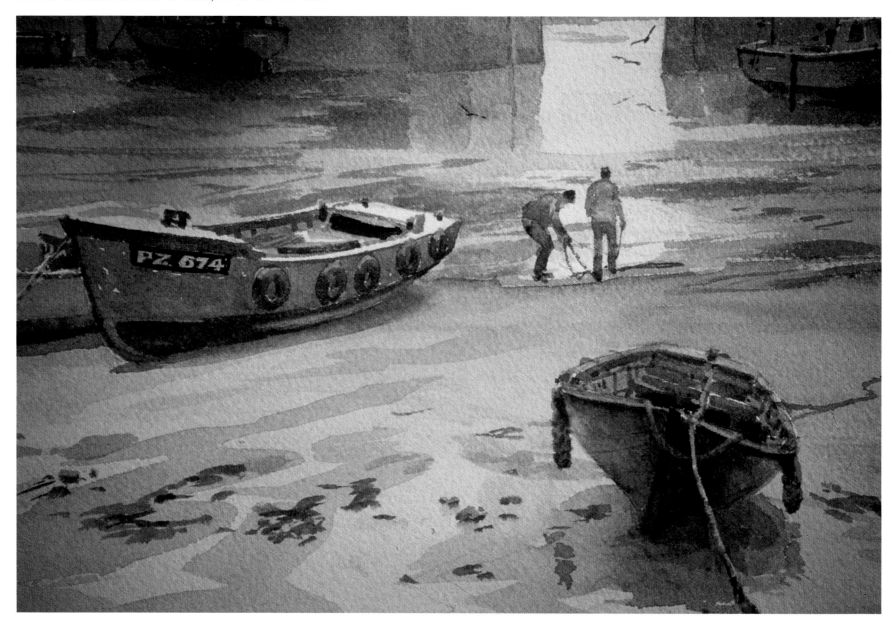

Ashton Cannell, R.S.M.A. 'Mousehole, Cornwall'. Watercolour, 14in x 21in. By kind permission of Mr John E. Cannell.

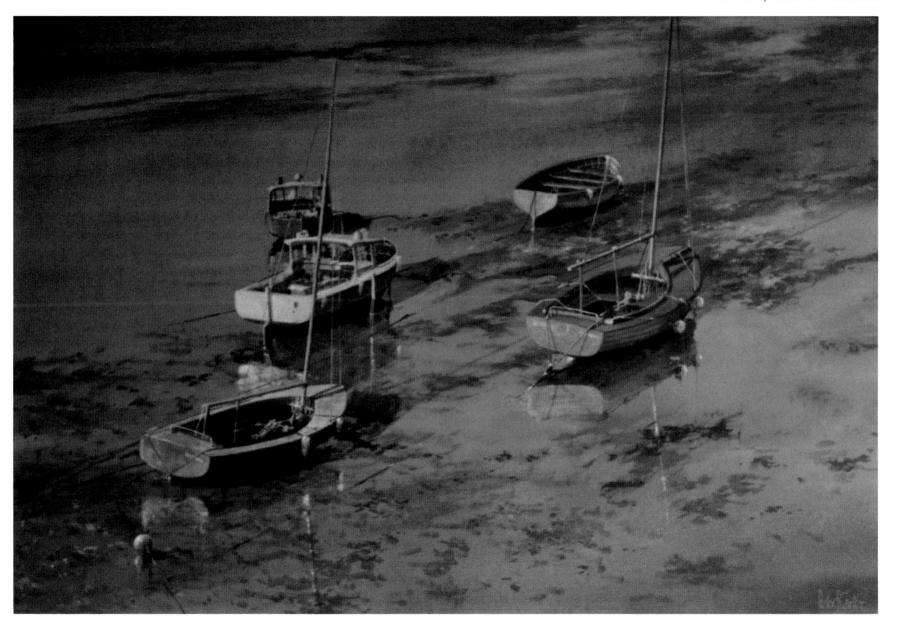

Peter Carter, R.S.M.A. 'Sailing Craft at Paignton'. Oil, 24in x 36in. By kind permission of Mrs Joanna Carter.

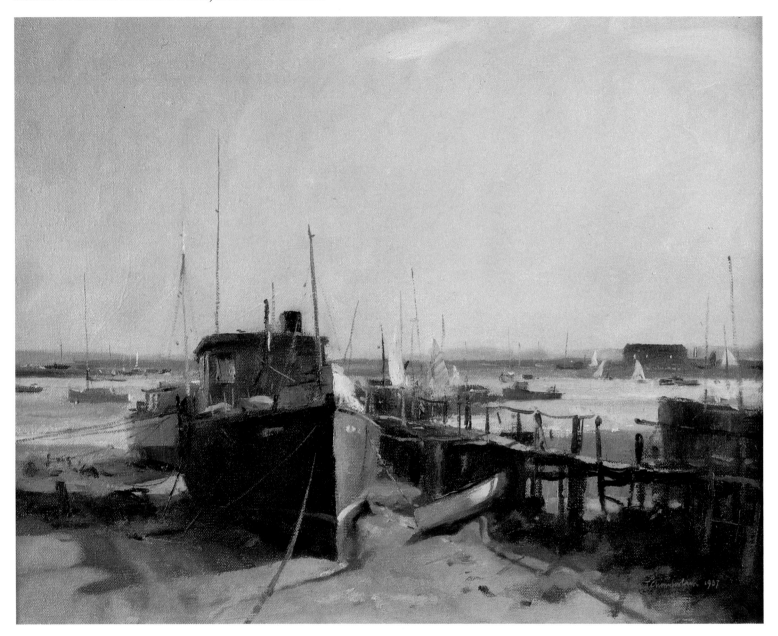

Trevor Chamberlain, R.O.I., R.S.M.A. 'Summer light, West Mersea'. Oil, 16in x 20in. The centre of interest is the boat moored by the old wooden jetty. It is low water, nevertheless sailing activity is to be seen out in mid-stream, under a warm late summer sky. Collection: Mr & Mrs Oliver Swann.

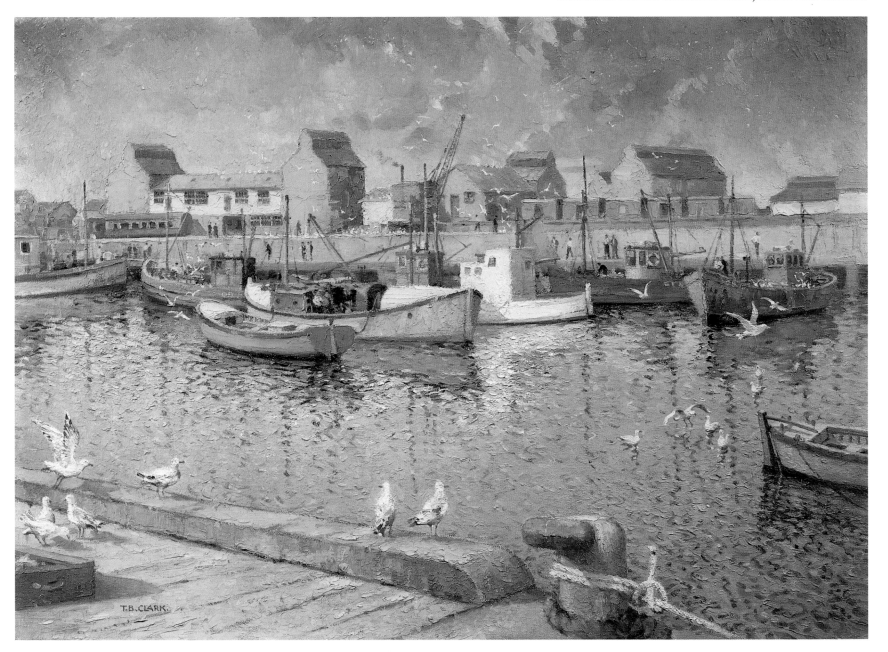

Thomas Clark R.S.M.A. 'Mallaig, West Highlands'. Oil, 20in x 27½in. R.S.M.A. Diploma collection.

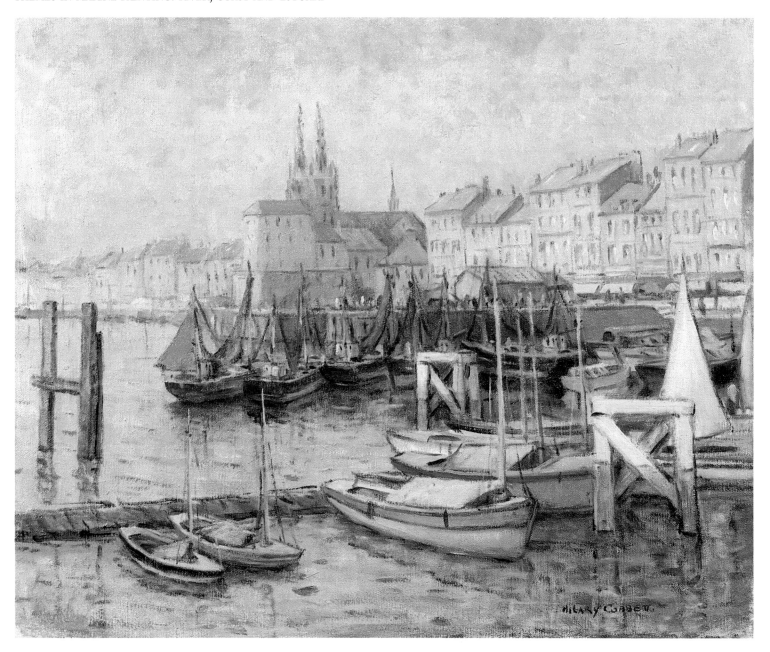

Hilary Cobbett, A.S.W.A., R.S.M.A. 'View of the harbour, Ostende'. Oil, 18in x 22in. R.S.M.A. Diploma collection.

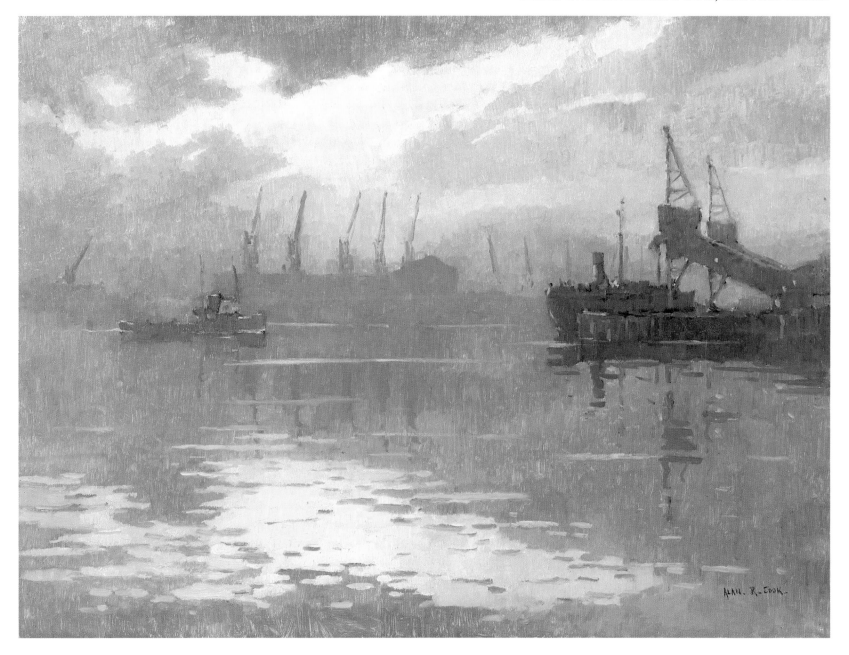

Alan Cook, R.S.M.A. 'Tyne nocturne, White Hill Point'. Oil, 18in x 24in. R.S.M.A. Diploma collection.

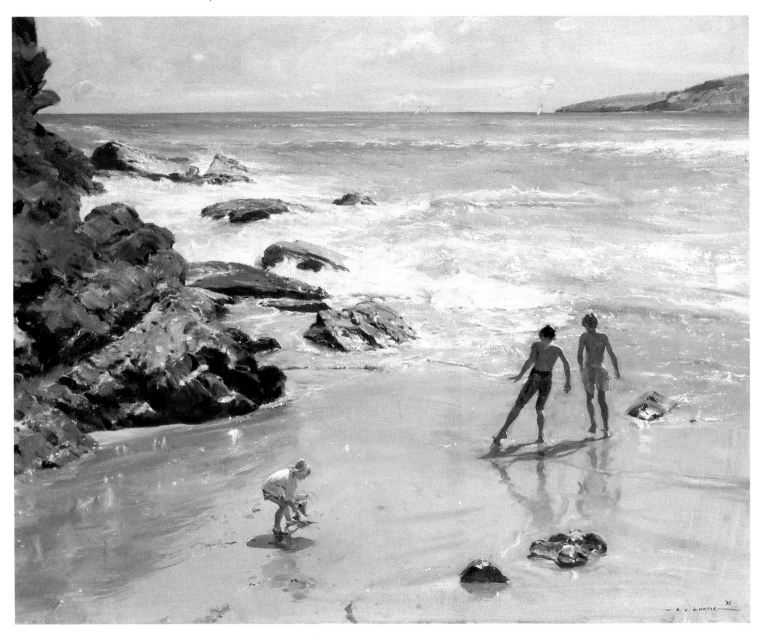

David Curtis, R.O.I., R.S.M.A. 'A morning swim, Porth Ceiriad'. Oil, 24in x 30in. Wet sands and reflections mirroring the early morning activity. Private collection.

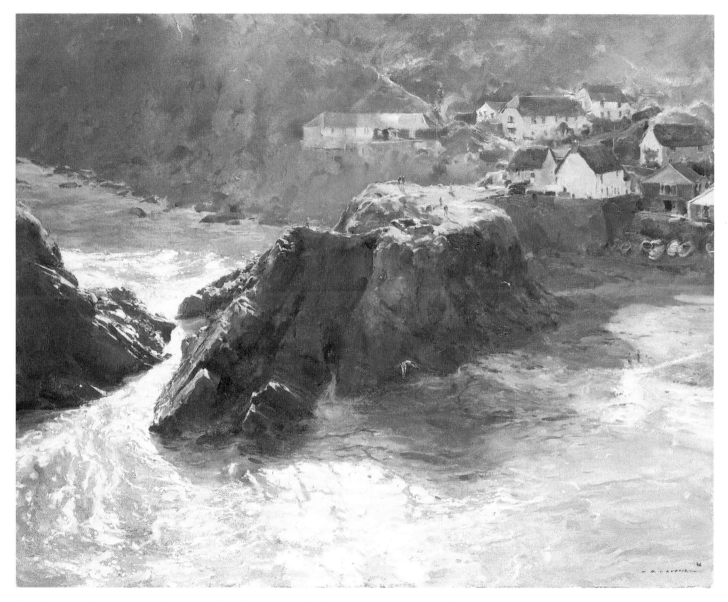

David Curtis, R.O.I., R.S.M.A. 'A bold walk across the Todden'. Oil, 30in x 24in. Shimmering late afternoon sunlight painted *contre jour* across the bay at Cadgwith, Cornwall. Collection: Richard Hagen Ltd.

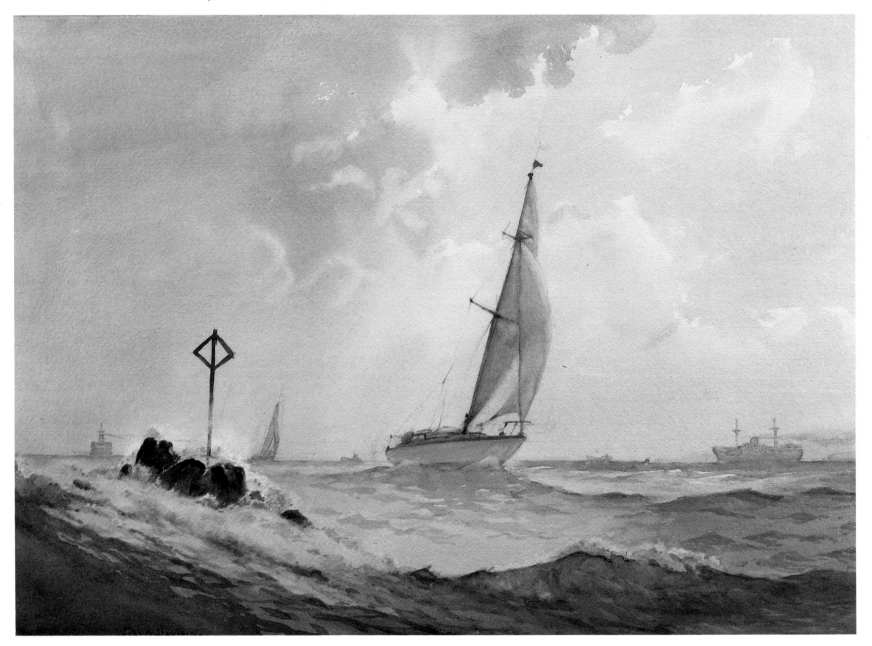

John Davies, R.S.M.A. 'Ebb and flow, Thames estuary'. Watercolour, 13in x 19in. R.S.M.A. Diploma collection, by kind permission Mr Christopher Davies.

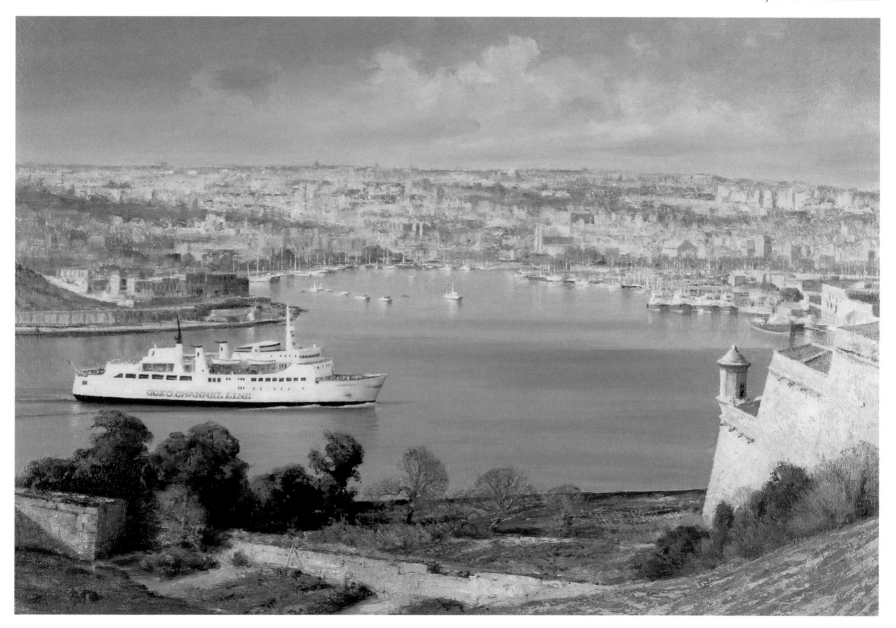

Kenneth Denton, R.S.M.A., I.S.M.P., F.R.S.A. 'The Gozo Ferry'. Oil on panel, 28in x 42in. Marsamxett Harbour, showing Ta'xbiex, Gzira, Manoel Island and Sliema. Collection: Artist's studio.

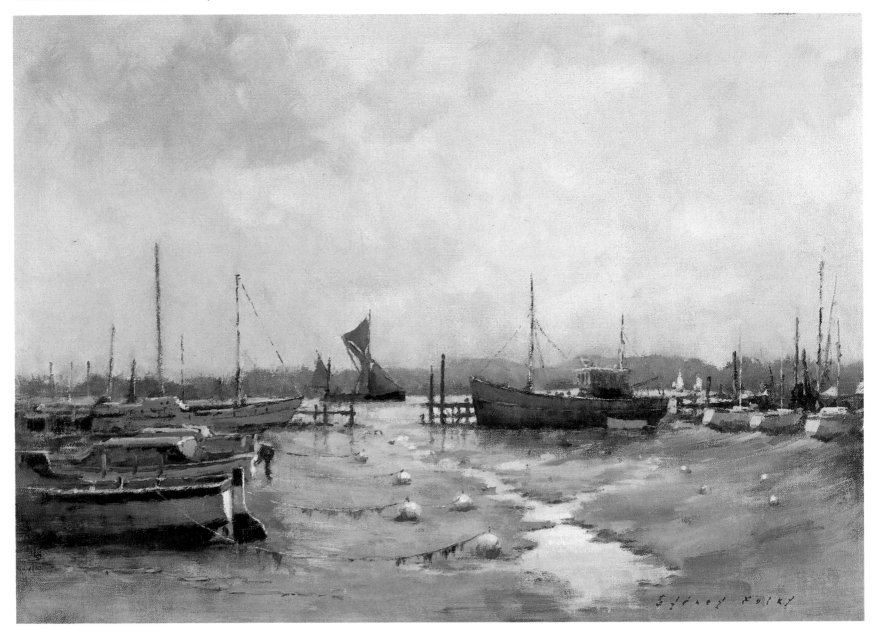

Sydney Foley, R.O.I., R.S.M.A. 'Yellow buoys, River Medway'. Oil, 14in x 20in. A pale sunlight reflects in the mud of the old marina at Hoo as a sailing barge proceeds up-river. Artist's collection.

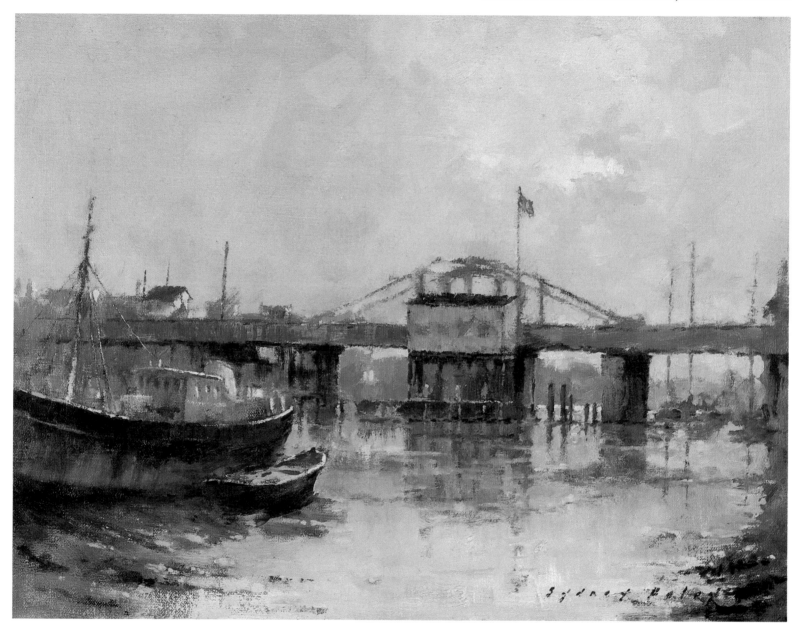

Sydney Foley, R.O.I., R.S.M.A. 'The Swing Bridge, Lowestoft'. Oil, 12in x 16in. The bridge carries the railway serving Lowestoft. The laid-up fishing vessel reflects the declining industry in the seventies and eighties. Artist's collection.

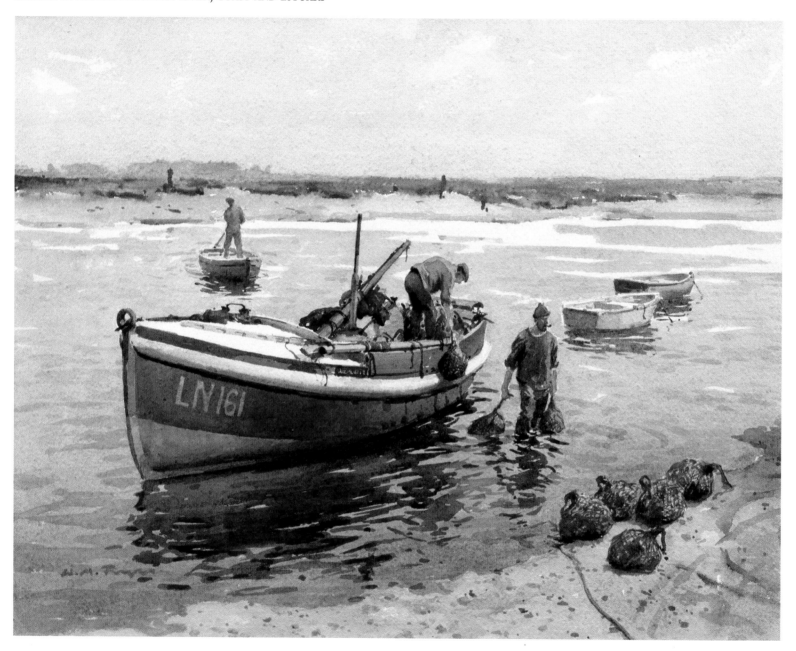

Wilfred Fryer, R.S.M.A. 'Unloading whelks, Wells, Norfolk'. Watercolour, 14in x 19in. R.S.M.A. Diploma collection.

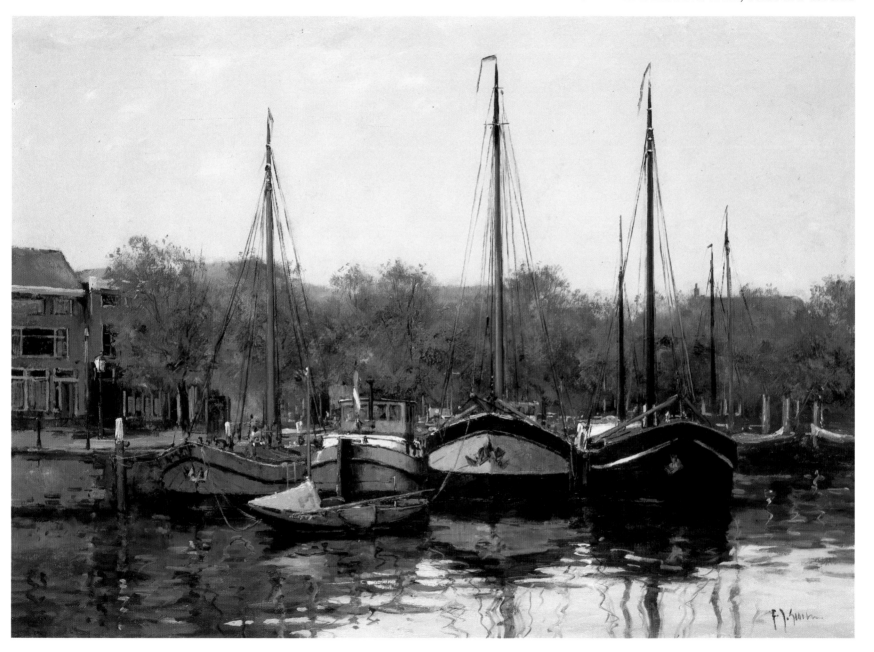

Fritz Goosen, R.S.M.A. 'Dordrecht'. Oil, 50cm x 70cm. By courtesy of Oliver Swann Galleries.

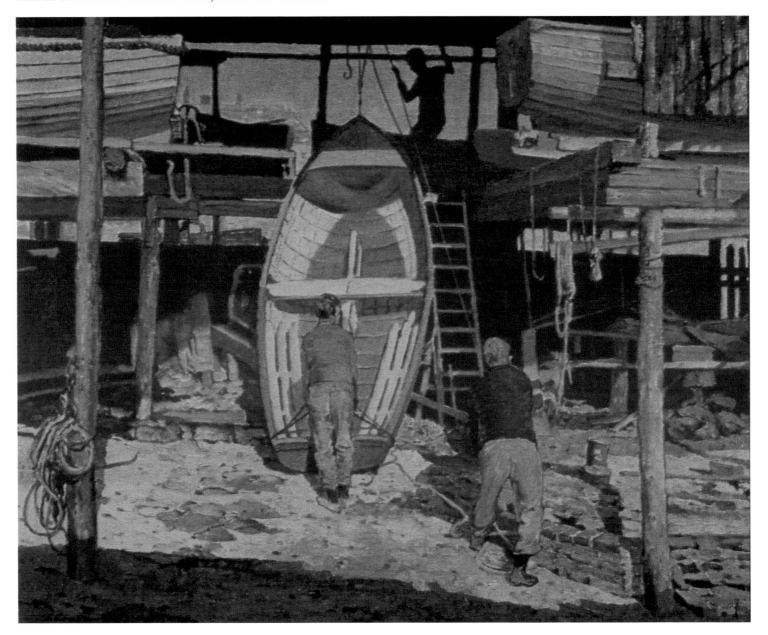

Donald Greig, R.S.M.A. 'Dornom's boatyard, Salcombe'. Oil on board, 24in x 20in. One of the old boathouses in Salcombe, now demolished. Private collection.

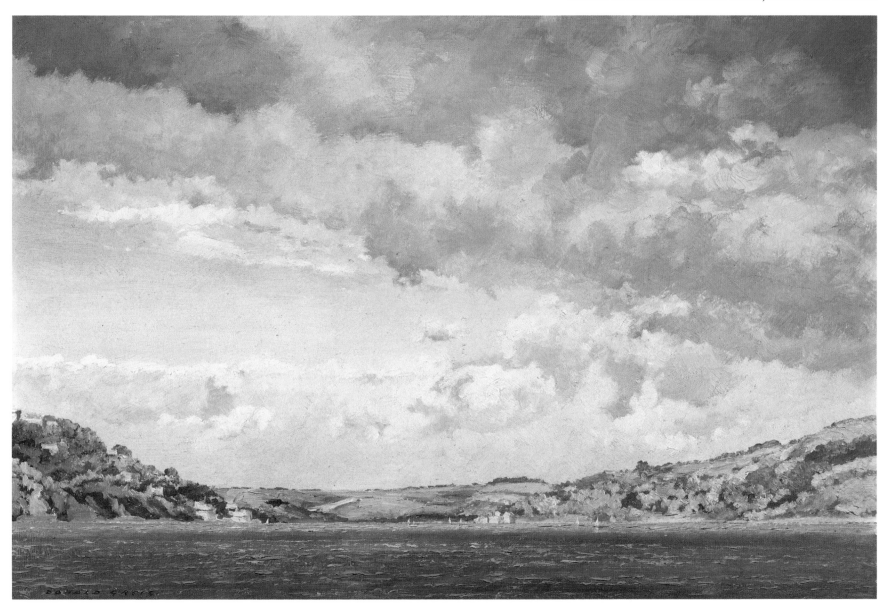

Donald Greig, R.S.M.A. 'Salcombe Haven'. Oil, 20½in x 30½in. R.S.M.A. Diploma collection.

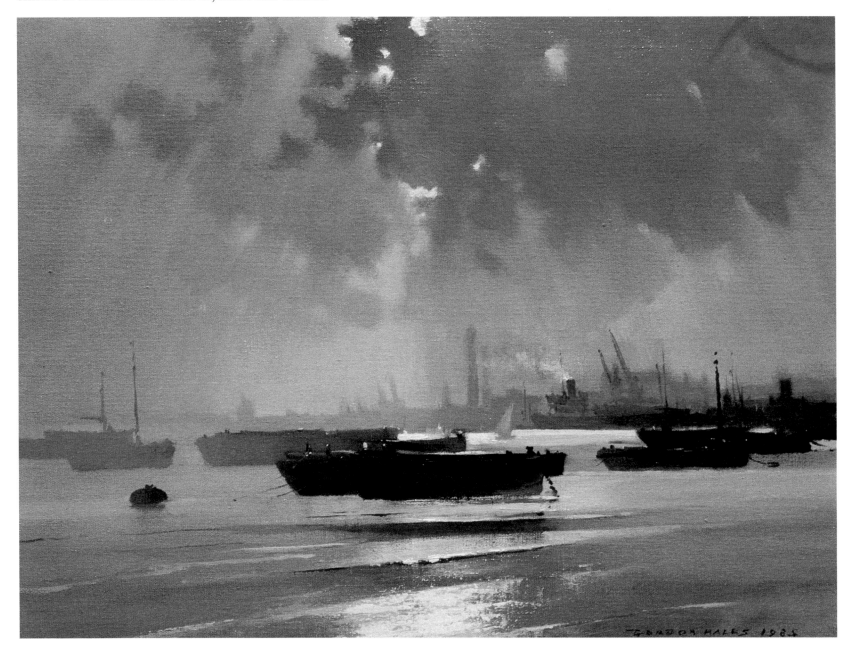

Gordon Hales, R.S.M.A., R.B.A. 'Fiddlers Reach'. Oil, 16in x 20in. Low water at Fiddlers Reach. A departing rain storm sweeps up the estuary on its way to London.

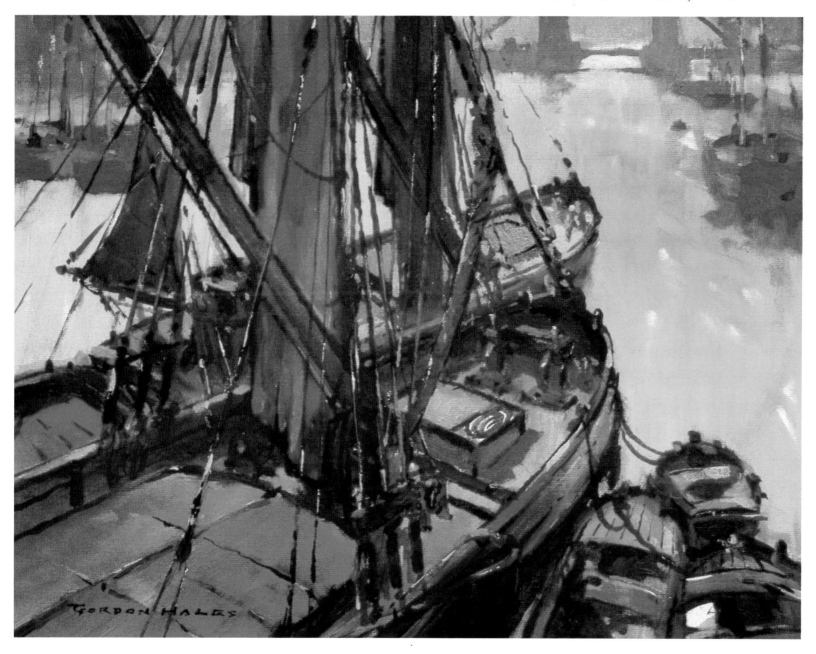

Gordon Hales, R.S.M.A., R.B.A. 'Barges in the sun'. Oil, 16in x 20in. In the midday heat two Thames sailing barges idle at their moorings below London Bridge.

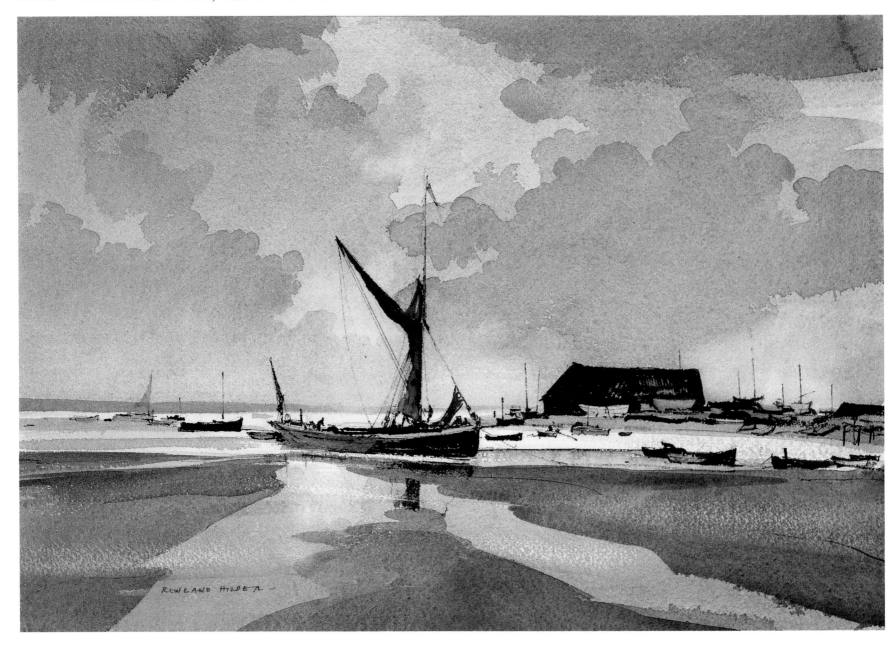

Rowland Hilder, R.I., R.S.M.A. 'The Shipwright's Arms'. Watercolour. By kind permission of Mrs Heather Hilder.

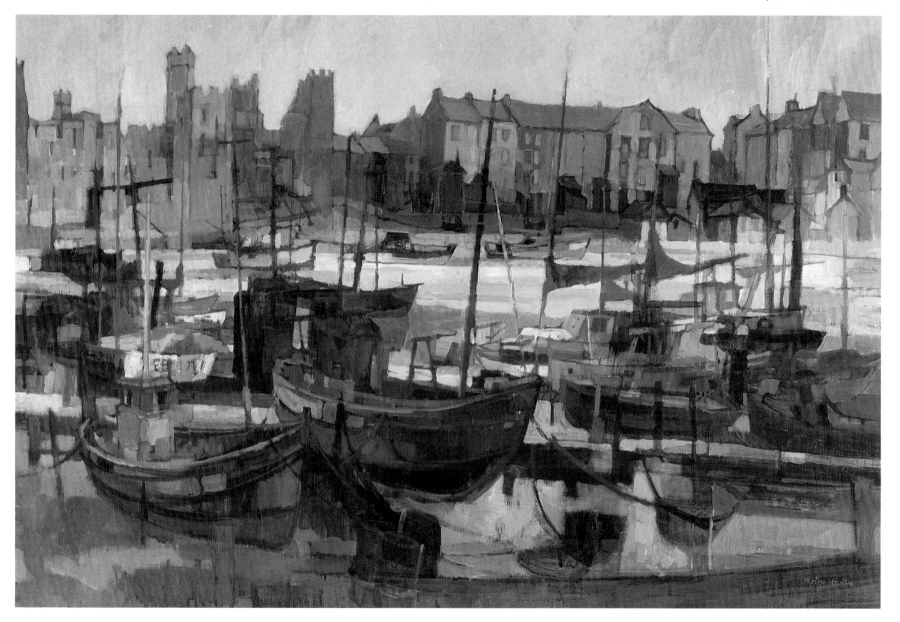

Moira Huntly, R.I., R.S.M.A., P.S., R.W.A. 'Boats at Caernarfon'. Acrylic on canvas, 24in x 36in. Small craft at low water set against a background of Caernarfon Castle. Collection: Artist's studio.

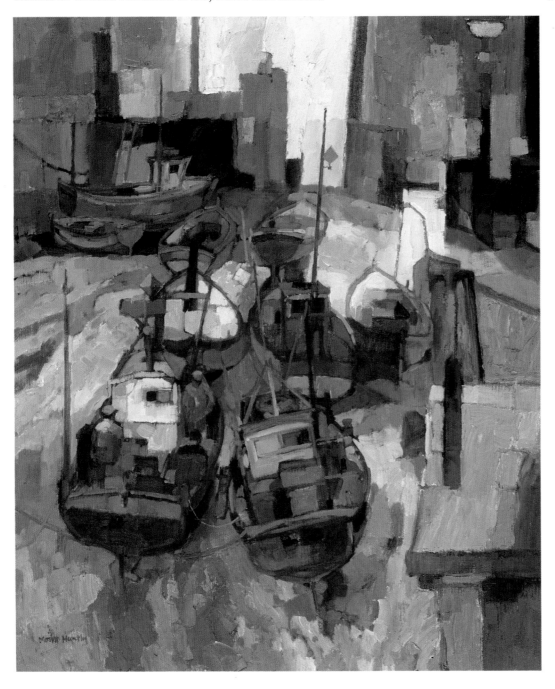

Moira Huntley R.I., R.S.M.A.,P.S., R.W.A. 'Scottish Harbour'. Oil, 30in x 25in. Imaginative composition including fishing boats from the East coast of Scotland. Collection: Artist's studio.

Right: Norman Janes, R.W., R.S.M.A. 'The Thames, London Bridge'. Oil, 20in x 26in. R.S.M.A. Diploma collection.

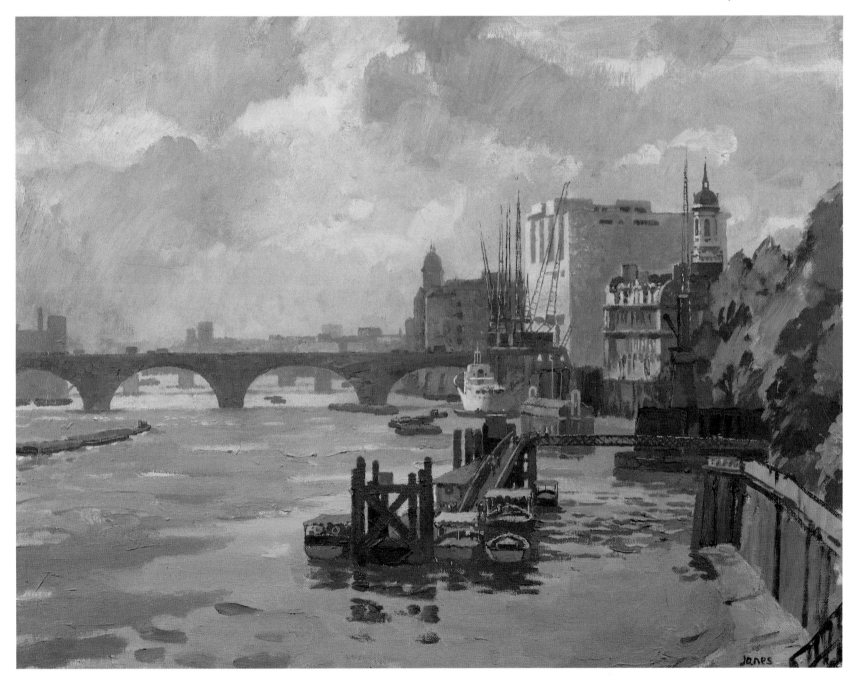

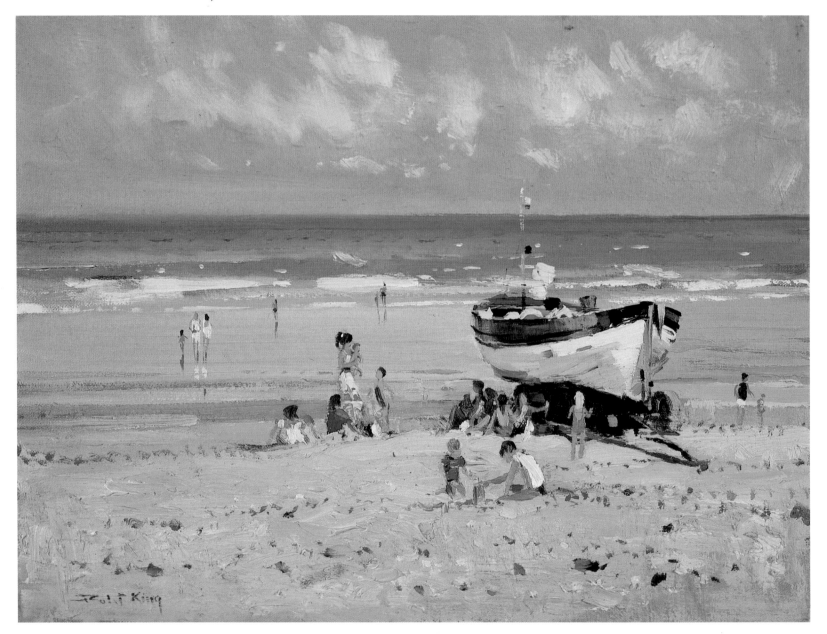

Robert King. R.I., R.S.M.A. 'Sunday afternoon, Cromer'. Oil, 12in x 16in. Families with their children enjoying a warm summer afternoon by the sea. By courtesy Burlington Paintings.

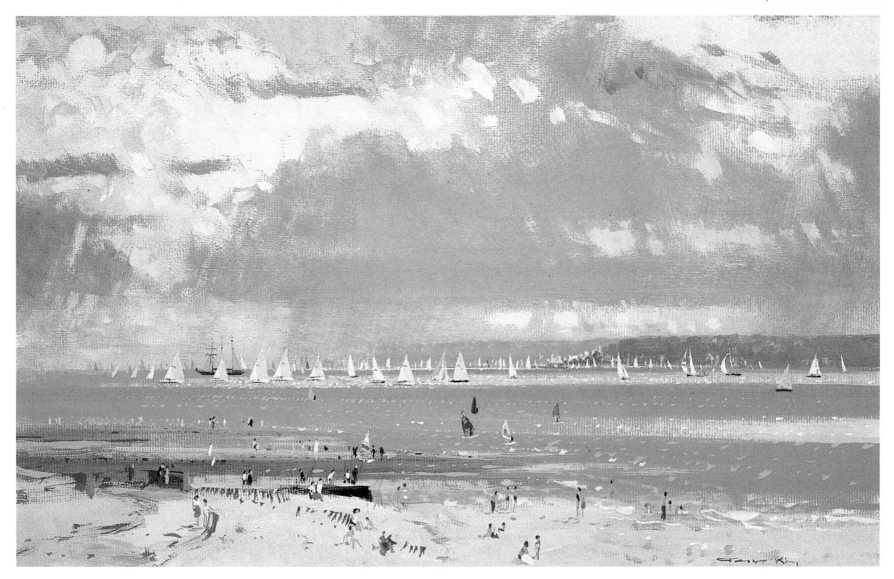

Robert King, R.I., R.S.M.A. 'The Solent, Cowes week'. Gouache, 16in x 24in. A busy scene from the beach at Lepe with yachts racing off Cowes and the training Ship *Winston Churchill* making her way to Southampton Water. Collection: Jonathan Bradbeer Esq.

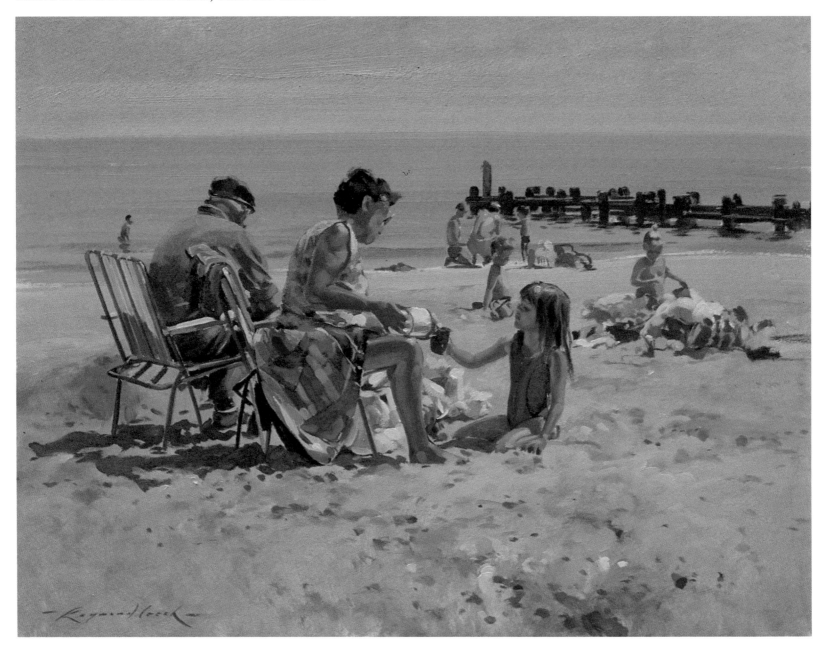

Raymond Leech, R.S.M.A. 'Lemonade with Grandma and Grandpa'. Oil, 18in x 24in. Private collection.

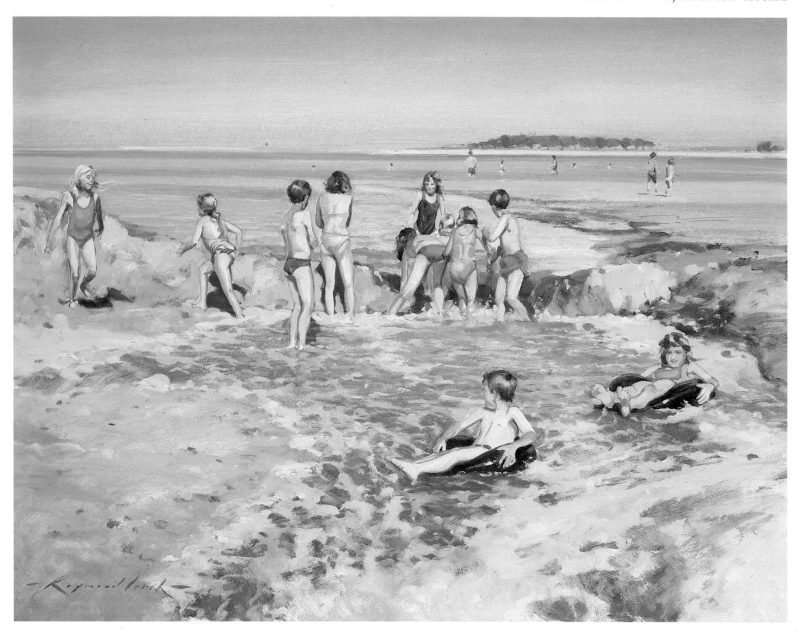

Raymond Leech, R.S.M.A. 'The Dambusters'. Oil, 18in x 24in. A group of children breaking a sand dam built at Wells, with two children riding the flood. Collection: Artist's studio.

Robert Naylor R.S.M.A. 'La Rochelle'

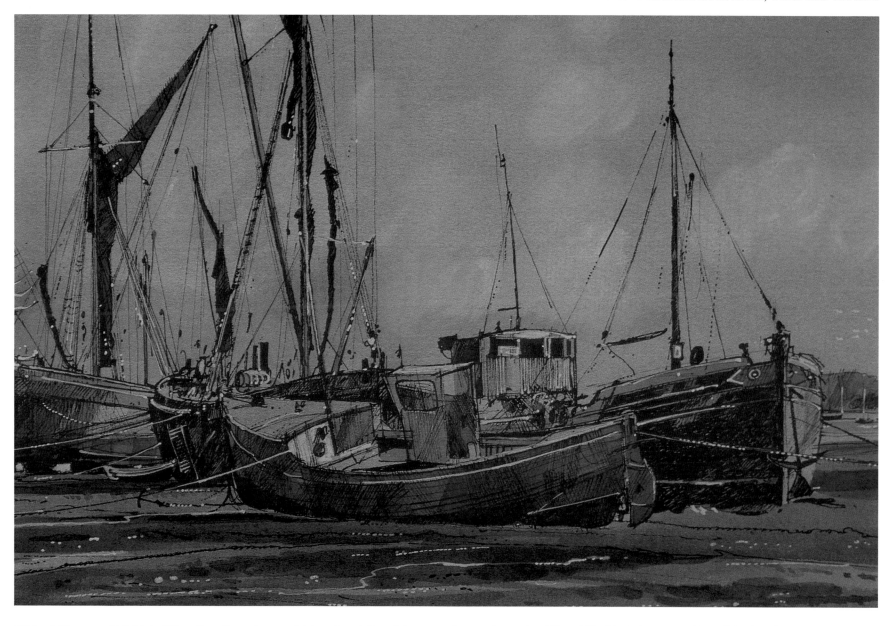

Michael Norman. R.S.M.A. 'River Orwell – various craft lying about'. Pen, ink, watercolour and gouache, 17in x 10in. Typical scene on Pin Mill hard with barges and working boats. Private collection.

Sheila Macleod Robertson, R.S.M.A., S.W.A. 'The Isle of Rhum from Ardnamurchan'. Oil, 18in x 24in. October sunlight on the mountains of Rhum, one of the Inner Hebrides, viewed from Ardnamurchan, the most westerly point of Britain's mainland. Collection of Mr and Mrs Gordon Slater.

Sheila Macleod Robertson, R.S.M.A., S.W.A. 'Gruinard Bay, Wester-Ross'. Oil, 14in x 20in. The diffused light of the Scottish west coast on a typical summer day, enlivened by children sailing a small dinghy. Collection of John Gilmour Esq.

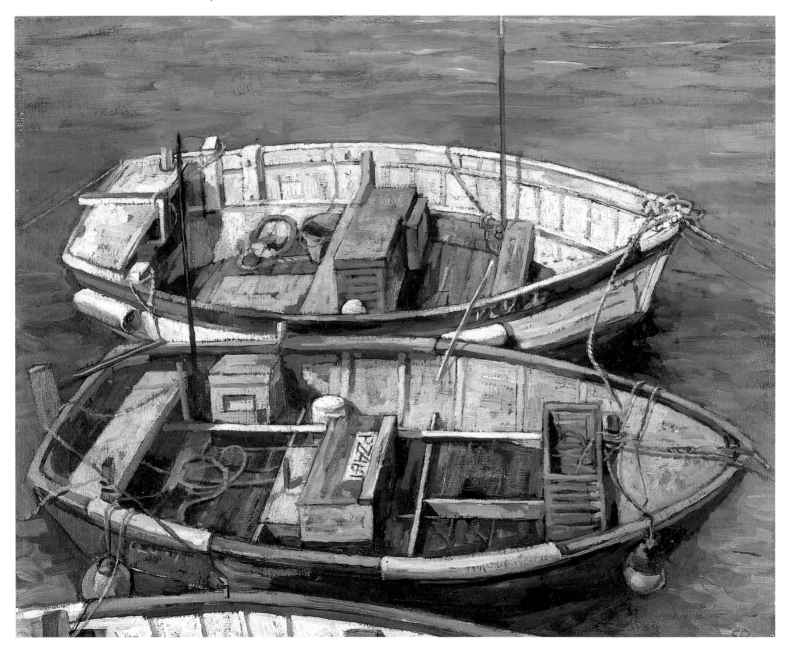

Sonia Robinson, R.S.M.A., S.W.A. 'Rest day, Newlyn'. Oil, 20in x 16in. Newlyn dinghies idling in a corner of the old harbour. Artist's collection.

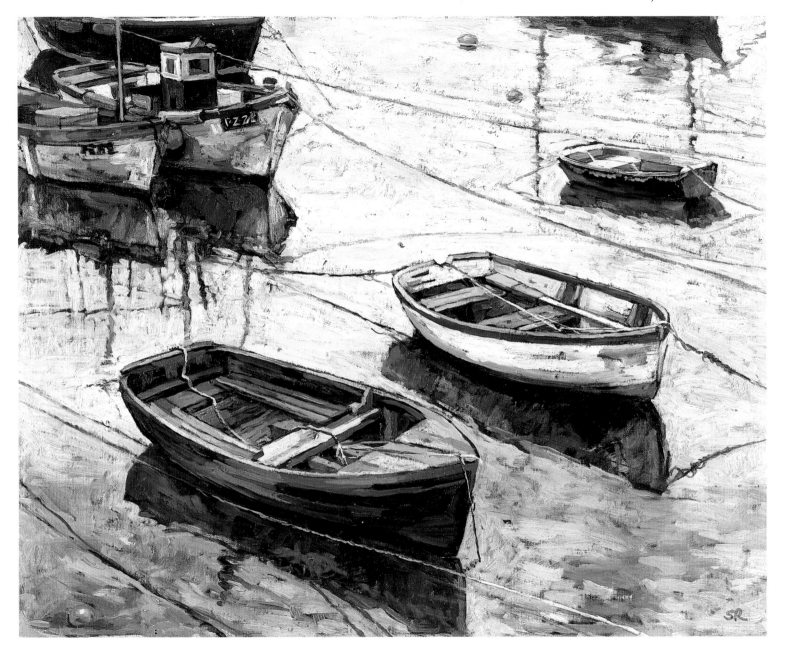

Sonia Robinson, R.S.M.A., S.W.A. 'Dreaming dinghies'. Oil, 20in x 16in. A calm September morning in Newlyn harbour. Artist's collection.

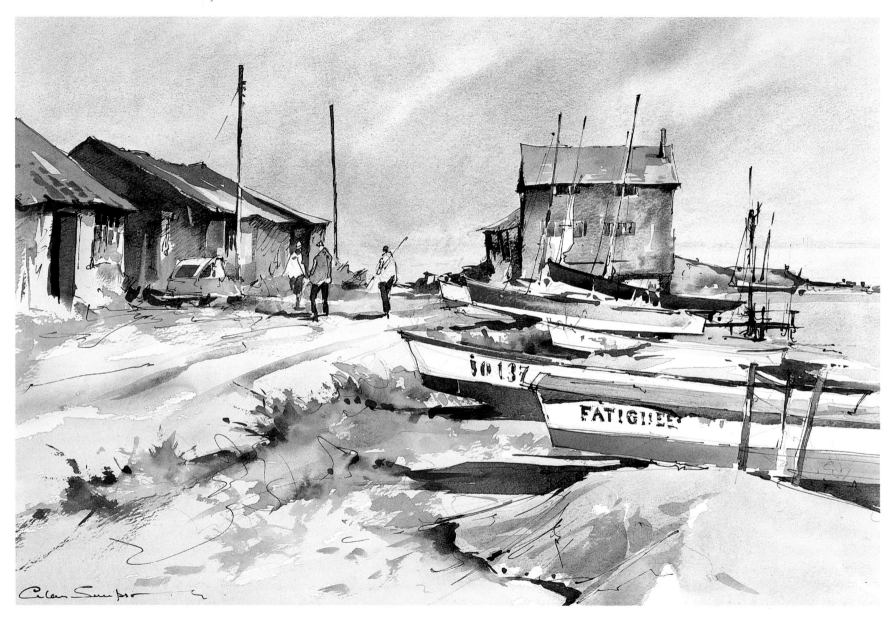

Alan Simpson, R.S.M.A. 'St Trojan, Ile d'Oleron'. Watercolour, 15in x 22in. Fishing boats and rambling sheds adorn the shores of this old oyster fishing creek. Private collection.

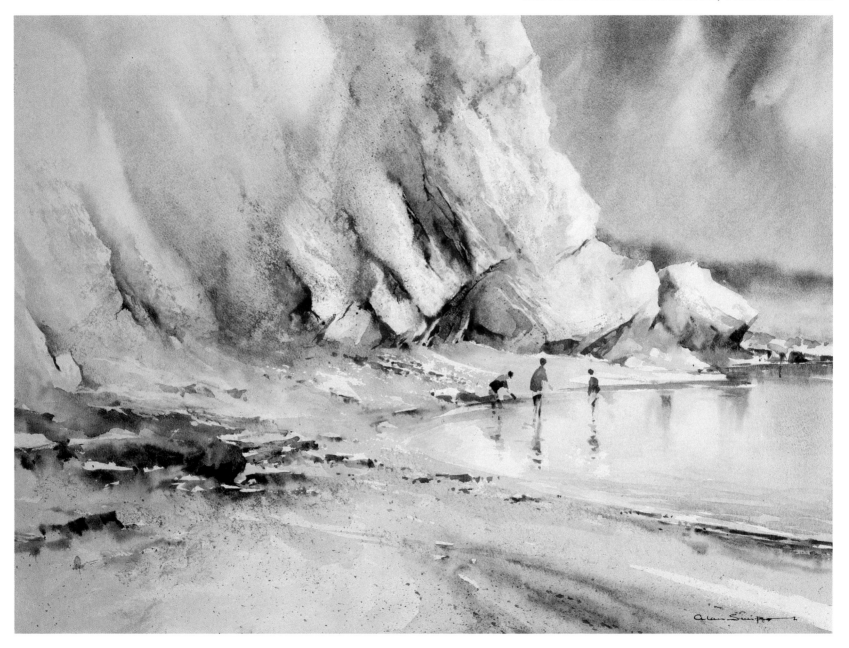

Alan Simpson, R.S.M.A. 'A Devon cove'. Watercolour, 22in x 30in. Children paddle in the shallows on a warm summer evening. Private collection.

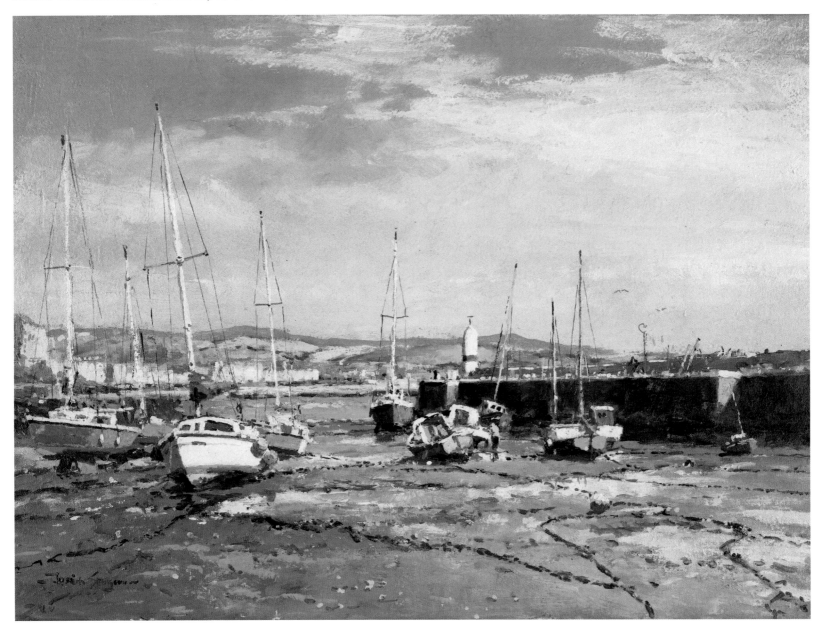

Josiah Sturgeon, R.I., R.S.M.A., F.R.I.B.A. 'Port St Mary, Isle of Man'. Oil, 16in x 22in. In this once busy fishing harbour pleasure craft are seen at low water in the warm light of a bright spring morning. Private collection.

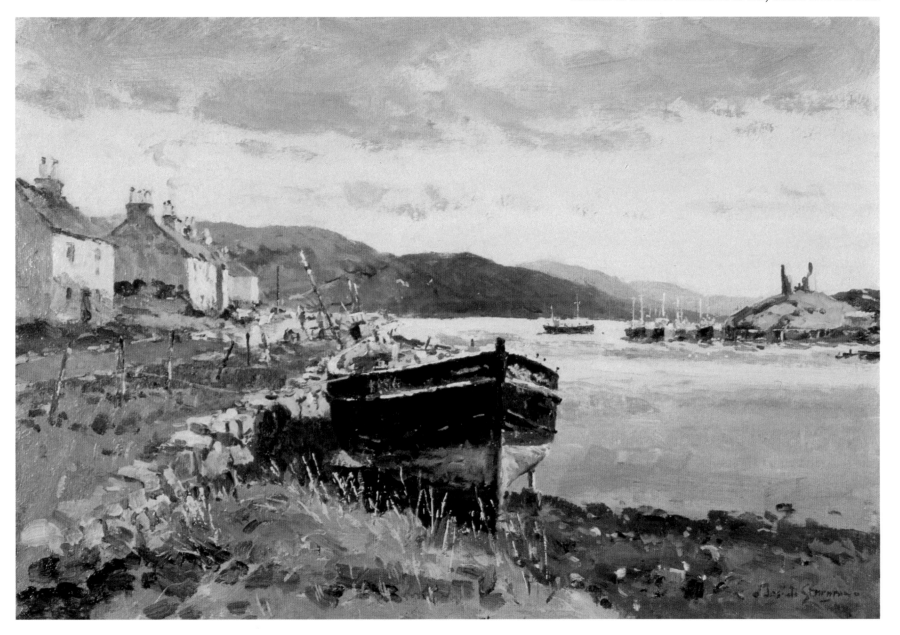

Josiah Sturgeon, R.I., R.S.M.A., F.R.I.B.A. '*Golden Rule* Kyleakin, Isle of Skye'. Oil, 13in x 19in. This wooden fishing boat, built at Arbroath on the Scottish east coast in the 1890s, ends her days off the west coast in the 1990s. Private collection.

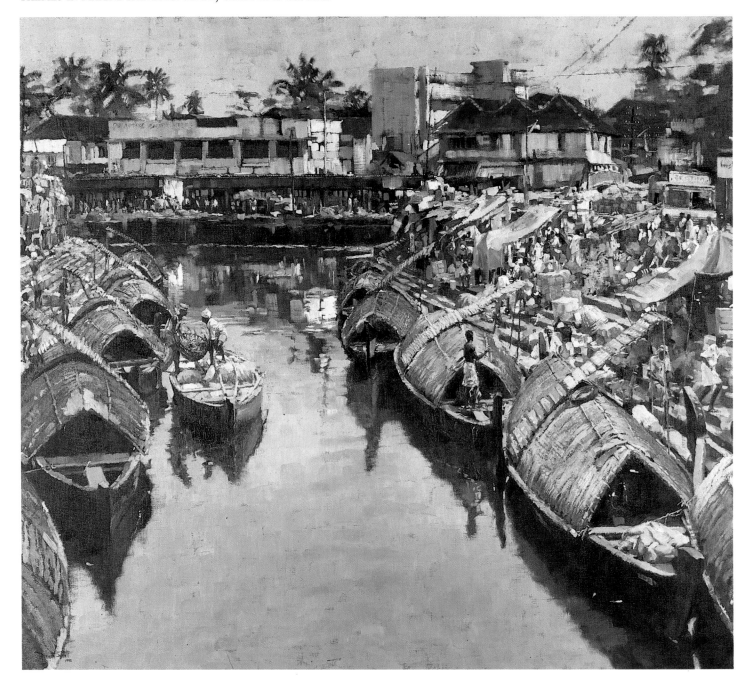

Dennis Syrett, R.S.M.A., R.O.I. 'Monday market'. Oil, 46in x 52in. Recently arrived from the maze of inland waterways, heavily laden rice boats gather along the crowded quayside, Kerala, S. India. Collection: Mr and Mrs G. Morby.

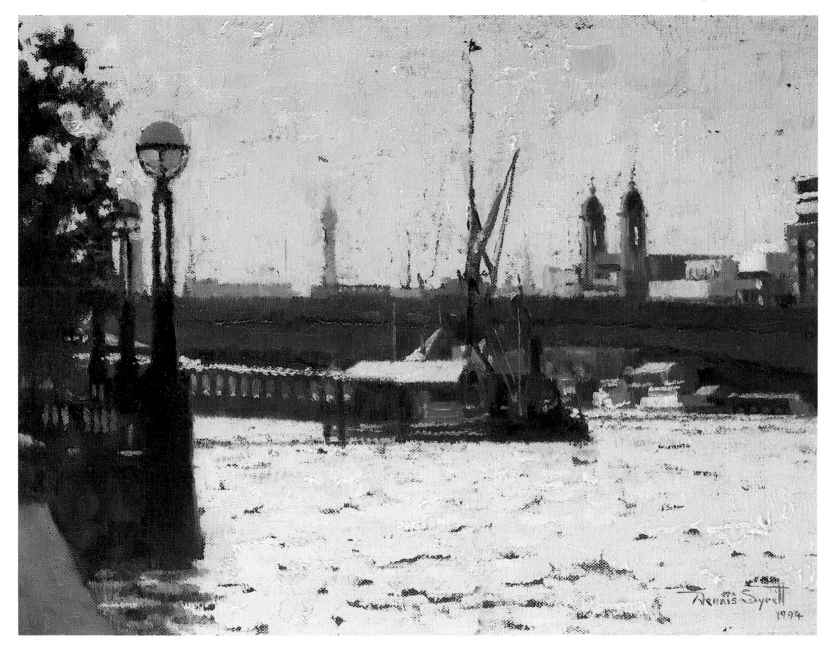

Dennis Syrett, R.S.M.A., R.O.I. 'Thames evening'. Oil, 9in x 12in. A Thames barge lies at rest in early evening sunshine. Collection: Mr & Mrs R. Burgess.

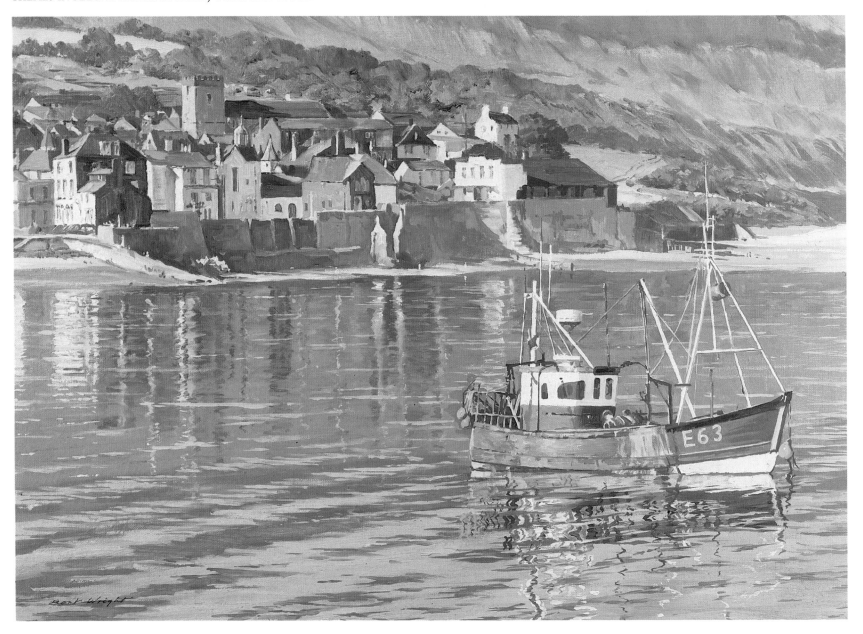

Bert Wright, R.S.M.A., F.R.S.A. 'Reflections, Lyme Regis'. Oil, 25in x 35in. Painted from the Cobb Harbour looking across the bay towards Lyme Regis on a calm summer evening. Collection: Artist's studio.

The Steam Era
by Colin Verity, R.S.M.A.

The introduction of mechanical propulsion in the world's shipping led to a revolution in the design of ships, masts with spars and sails virtually disappearing from the commercial scene. The constraints on the variety, size and speed of ships disappeared, passengers and cargo to and from all parts of the world increased dramatically, which in turn created the need for new and larger docks with improved cargo handling facilities. The world had, in the space of a century, become a much smaller place, just as it became even smaller with the introduction of the aeroplane which sounded the death knell for the great ocean liners.

From the marine artist's point of view, this era has widened the subject horizons almost beyond imagination, and they are constantly expanding, but, as with all art, a thorough understanding of the subject is of paramount importance. Painters of this era require more than a passing interest in the subject, and it is my opinion that continual research is necessary into the development of ships, their purpose, design and construction. Without this understanding the painter cannot get the 'feel' of his subject, and without that, the resultant painting will be open to fair criticism by knowledgeable people in the shipping world, in having failed to be convincingly accurate. This is important and places on the painter's shoulders an added burden not experienced by the 'plein air' painters of beach and small-boat subjects

Painters of this era, today, have complex problems to solve. There are those who paint what they find in the docks on a speculative basis, and their job is made more difficult by trying to produce an interesting and desirable painting from rather uninspiring and aesthetically unattractive ships. Possibly this is one reason why we see so few contemporary ocean-going ships on gallery walls. To paint these ships on commission the same problems must be solved, but there are additional problems dependent upon the requirements of the commission. The ship and its location may not be available to view. The painting must therefore be composed from photographs, general-arrangement drawings, navigation charts and anything that can help the artist to visualise and interpret the requirements of the commission into an acceptable painting.

Since man first floated on a log, shipping has developed slowly and painstakingly through history, the result of countless hours of human endeavour which up to the late 1950s and early 1960s followed a logical design pro-gression to create a safe way for man to ply the waters of the world combating the vagaries of the natural elements. Each succeeding period produced a succession of increasingly beautiful ships, culminating in the graceful liners of the first half of the twentieth century and the elegant motor-ships built after the Second World War up to the mid-1960s. Then almost overnight the beauty of ships became a thing of the past. Gone were the graceful flares, sheer lines and beautifully shaped sterns in favour of angular plate constructions, transom sterns, little if any sheer, and weird-shaped uptakes in lieu of funnels.

Whatever period is considered I believe that the artist must be humble enough to accept and portray that which has been designed by countless generations of marine engineers. There can be very few people who have not been emotionally moved by seeing ships on the high seas, sparkling in tropical climes or fighting the elements in heavy weather or approaching the docks on a misty morning with sunlight touching their upperworks. It is these emotions that prompt the artist to put paint to canvas in the hope that he may convey to others the pleasure he has experienced. The artist must create the painting in visually understandable terms and not by seeking out weird and obscure pseudo-intellectual interpretations, frequently used as a cover for poor draughtsmanship and a lack of understanding of the subject.

The range of subject matter in the marine sphere has never been greater, and each period has its own particular interests and problems. Probably the steam and motor-ship era, because of its greater complexity, has a wider potential interest but poses more problems to solve than the others. We see a greater variety of shipping from the smallest harbour craft to the largest liners and beyond, into the current era of huge and unlovely tankers and bulk carriers and the equally unlovely ferries and cruise ships. Whatever the artist's thoughts may be, he has to convey to the viewer the size and solidity of shipping and the fact that in the realm of ships we have the largest man-made moving objects. In committing them to paper or canvas, good draughtsmanship is essential. Ships are notoriously unforgiving to the poor draughtsman – we have all seen paintings with banana-shaped hulls, funnels and masts off the centrelines, and so on, creating an unstable and disturbing image for the viewer.

To create the illusion of hull length, tonal variations must be used. Weather stains, rust, plate- and weld-lines and shadows are invaluable to

illustrate its shape. The shadow created by the hull shape, by ropes, dockside features, and by other ships and boats moored alongside or in close proximity are important features. The superstructure, its formation and structural elements, together with fittings for that particular type of ship, must be accurately positioned to create the scale and essential character of the ship, no matter whether it be a highly detailed or more atmospheric painting.

One frequently sees paintings of ships that are credibly drawn but which look 'toy-like' and unconvincing, lacking in apparent size. This is because the artist has overlooked the fact that there is not only a scale of dimension, but also of colour. As an example, black hulls are almost any colour but black. Close by, imperfections and the effect of weather modify the colour; at a distance those imperfections disappear, as does the intensity of colour.

The most satisfactory paintings of ships at sea take into account the meteorological situation. In other words, the artist must appreciate the fact that the nature of the sky conveys the weather conditions, which in turn affect the formation of the sea and its colour, and this in turn determines the reaction of the ship to the sea conditions. The artist must be aware of these facts and the potentially destructive forces he is portraying. He must achieve the right balance of the forces involved. How many times have we seen paintings indicating wind direction by the way smoke is billowing from a funnel, only to find flags flying and the sea reacting as if the wind was from a different direction!

Attention to what may seem trivial detail is essential and transforms a painting into an event. Such elements as the language of flags displayed in the correct locations, cargo handling gear onboard and on the dockside, mooring ropes, the juxtaposition of tugs and their hawsers are all relevant. It is also important in the case of harbour approaches that 'the rules of the road' and navigable channels and their buoys are known and respected.

Reference has already been made to problems experienced by the marine artist in composing a painting to illustrate the life and times of a particular ship that no longer exists. The artist wishing to paint such a ship of the steam era is fortunate to have the camera as an ally together with general-arrangement drawings (plans). He should endeavour to obtain copies of these drawings and as many photographs of the ship as possible. It is often the case that during its life a ship undergoes numerous modifications which may not be recorded on the plans; photographs are then an invaluable record.

A lot of nonsense has been written about the use of the camera, and particularly other people's photographs – but how can a present-day artist take his own photograph of a ship that no longer exists? The quality of old photographs often leaves a lot to be desired, but the experienced marine artist is not seeking to copy a photograph, rather to interpret the image and character of the ship. It is essential to create a mental image of the ship from any angle; the artist must feel that he knows that which lies round every corner, and if there is insufficient information his knowledge of shipping of the era should fill in the 'grey areas'.

Present-day cargo handling techniques usually mean that ships are in port for short periods, hardly enough time to paint on location. In any case the ship may not be seen at her best in port, or the painting may be required to portray the ship at sea, or in another part of the world. Quick sketches from different angles, together with memory-prompting photographs and written notes are then essential. By using perspective projection methods, the experienced marine artist can produce an accurate interpretation from any angle using plans of a ship. There are few artists who can simply look at a plan and produce an accurate likeness without resorting to perspective projections. Similarly there are those few who can look at a photograph, old or new, and produce accurate interpretations from different viewpoints. Sketches, photographs and notes taken from museum models are possibly the only information available for some historic steam-ships .

Research is the key activity to successful painting of shipping subjects of any era, but it is also a necessary factor to complete the painting's location, whether it be at sea or in port. For open-sea painting, an artist with knowledge of wave action under all conditions, including a ship's wake, can create his own seas to complete an atmospheric painting and convey the illusion of endless water movement. He is able to give life to the sea when the camera can only create a dead image, akin to counting the spokes of a speeding steam railway engine. Port locations in any part of the world, particularly historic settings, pose their own problems. Take Hong Kong, for example. I have had to discover what the port was like visually at different periods since the turn of the nineteenth century, what local craft would be visible, what other shipping lines would be using the port, orientation for sunlight and shadow, approaches, mooring roads, quays used by a particular shipping company, and so on. The same research is necessary for any port and must be reasonably accurate.

The word 'accurate' can lead to problems for the artist. He has, quite often, to tread a difficult path and be wary of becoming an illustrator rather than an artist. He must be aware that it is his thought process and skill that creates the painting. The more knowledge he amasses concerning the subject, and the better his painting techniques, the easier and more successful his paintings become. Every painting should contain a part of the artist himself and pass on his enthusiasm for the subject to the observer.

However, I do not (as many do) deplore the use of the camera or other people's photographs; they are no more or less than tools – a fund of knowledge for use in creating a painting. People who denounce the use of the camera are pseudo-intellectual ostriches who deny themselves a useful tool. After all, we should remember that the camera is a mechanical contrivance with no

senses or emotion; merely it obediently records whatever lies in front of it, without the intelligent interpretation that can only be given by a true artist.

The founding of the Society of Marine Artists occurred well into the steam and motor-ship era, and most of the early members took their inspiration from the shipping of this period, producing a graphic record of the time. It is always difficult for a writer to refer to past members of the Society when he has not been personally acquainted with them and he has not had the pleasure of discussing and viewing with them their original works. However, a number of names stand out as exponents of the steam era, and it is with apologies to the others who are worthy of mention that reference is made to the few.

Charles Pears and Norman Wilkinson were probably the first members to portray convincingly the ocean liners in all their magnificence, closely followed by Harry Hudson Rodmell with his paintings and posters for many of the world's major shipping lines. he was also renowned for his many graphic paintings and drawings of the Hull trawler fleets and shipping of the Humber. Allanson Hick, a friend and near neighbour of Rodmell, produced many drawings and paintings of naval ships, and atmospheric work in oil and watercolour of shipping in the Hull docks. The 'Glen' liner featured in the painting 'Brotherhood of Seamen' by Arthur Burgess shows an understanding of the way a ship reacts to the sea under storm conditions and is one of his many fine paintings of the steam era. Montague Dawson, though better known for his pictures of the 'Golden Age of Sail' was also adept at painting the steam ship. Chris Mayger will be remembered for his fine paintings of naval vessels, many of which were used as book jacket illustrations. Frank Mason was a prolific painter of this era. Eric Thorpe and Peter Wood were painters for all seasons and produced excellent studies of steamships.

The R.S.M.A. was founded by artists who had a deep love of the sea and ships, and they tended to favour as subjects ocean-going ships and dockland scenes to a greater extent than the present membership. Fortunately a number of members still adhere to what I believe is the raison d'être of the Society and that which sets it aside from other art societies. Present members working in the original tradition are John Worsley, Terence Storey, Grenville Cottingham, Stuart Beck and myself. I feel that much has been painted and said of the 'Golden Age of Sail' and it is high time that the same attention be paid to the era of the steam and motor ship.

Artists are individualistic, and with such a vast range of diverse subject matter in this era it is not surprising that there is an equally diverse range of interest and interpretation. Viewed overall, it is this diversity that is the life-blood of the Society. The illustrations that accompany this major theme illustrate the different approaches and techniques of members past and present. But it should be remembered that the work illustrated under a member's name, though typical, may be but a fragment of that artist's range, which in most cases extends into other major themes and painting disciplines.

Peter F. Anson, R.S.M.A. *'Duchesse d'Aosta* in mid-Atlantic'. Watercolour. R.S.M.A. Diploma collection.

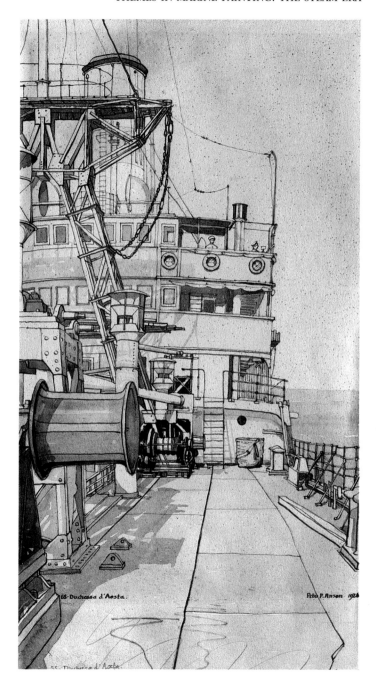

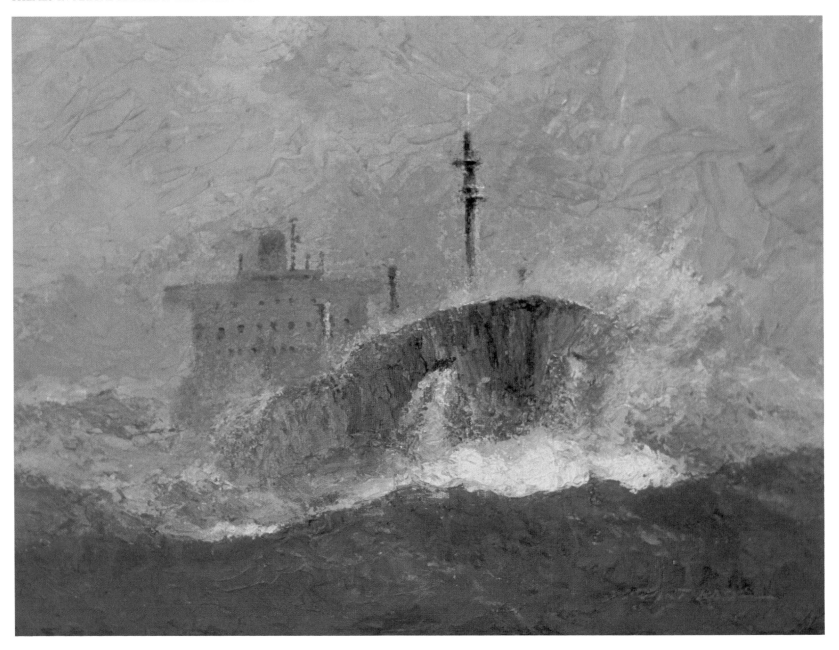

Stuart Beck, R.S.M.A. 'Driving her into it'. Acrylic, 12in x 15in. A bulk carrier showing her power when coping with a very heavy sea.

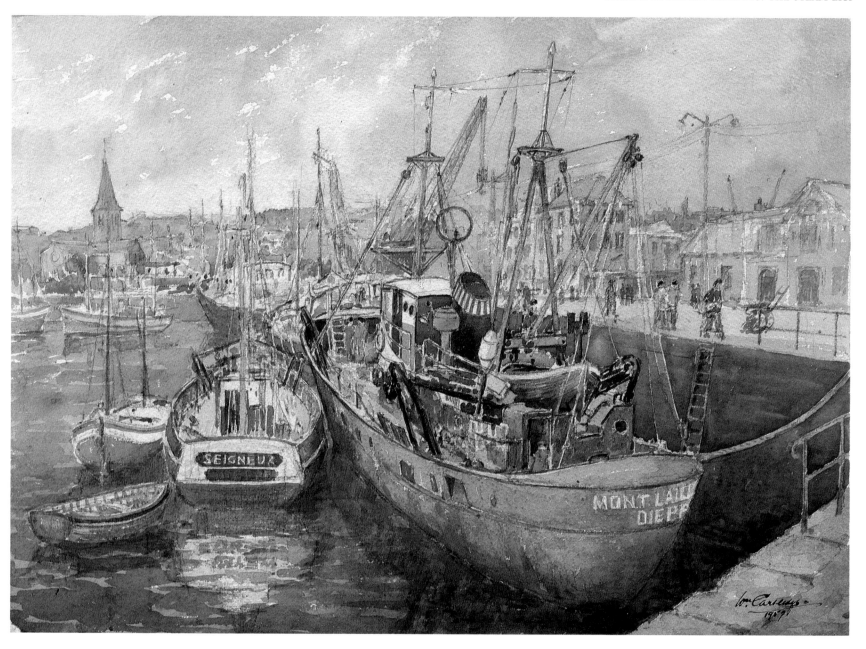

William Cartledge, R.I., R.S.M.A. 'Trawlers in the Canada basin, Dieppe'. Watercolour. R.S.M.A. Diploma collection.

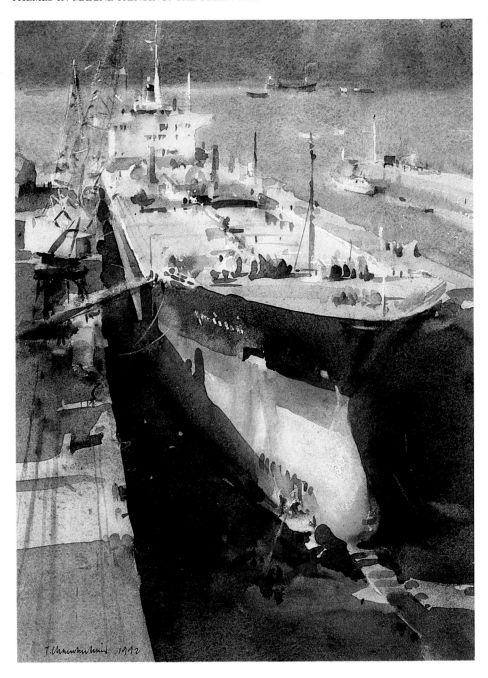

Trevor Chamberlain, R.O.I., R.S.M.A. 'Falmouth dry dock'. Watercolour, 13in x 9½in. The men working on the bows are dwarfed by the great bulk of the vessel, which is bathed in the evening light. Collection: Artist's studio.

Alan Cook, R.S.M.A. 'The Propeller'. Oil, 26in x 20in. R.S.M.A. Diploma collection.

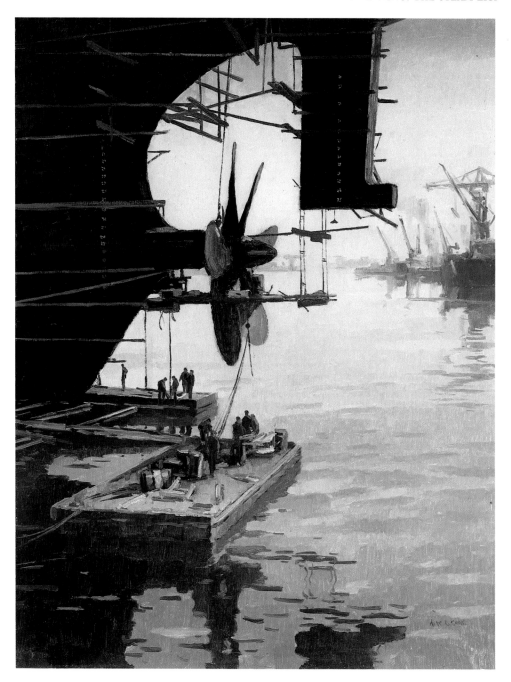

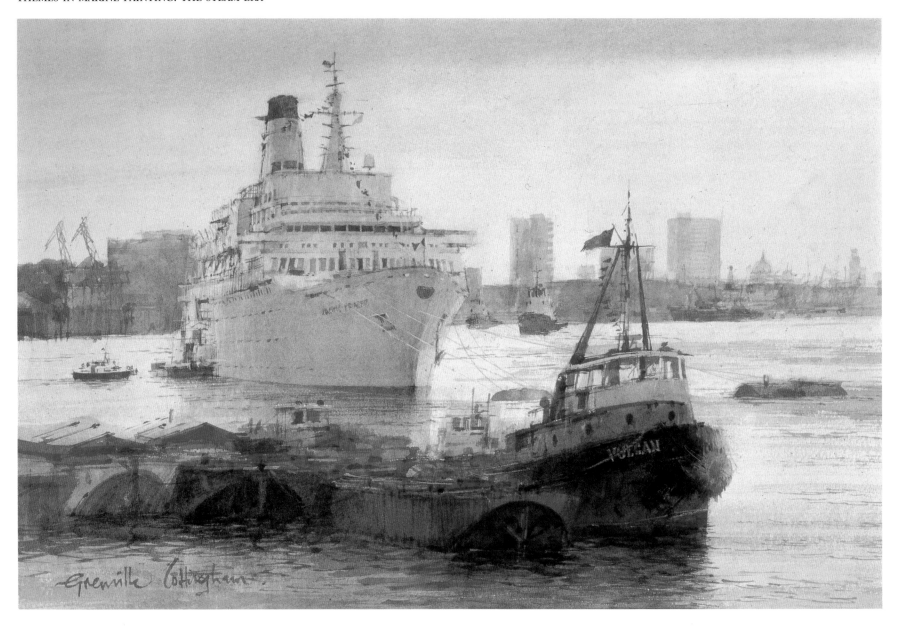

Grenville Cottingham, R.B.A., R.S.M.A. '*Pacific Princess*'. Watercolour, 15in x 22in. Moored at Greenwich in 1987 awaiting the arrival of the Royal party invited aboard to celebrate P & O's 150th anniversary. Collection: P & O.

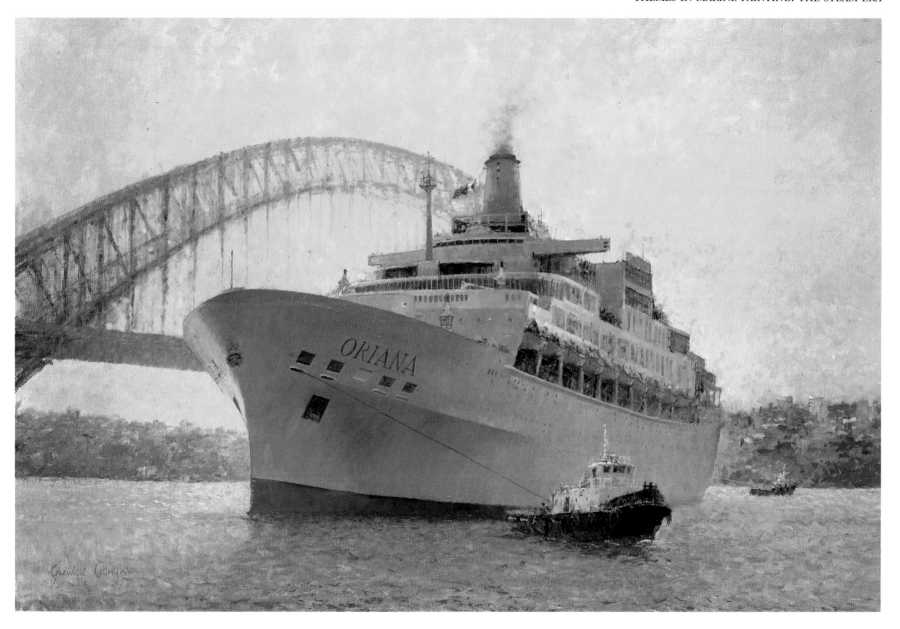

Grenville Cottingham, R.B.A., R.S.M.A. '*Oriana* leaving Sydney'. The first *Oriana* makes an evening departure from Sydney during the 1960s. Collection: P & O.

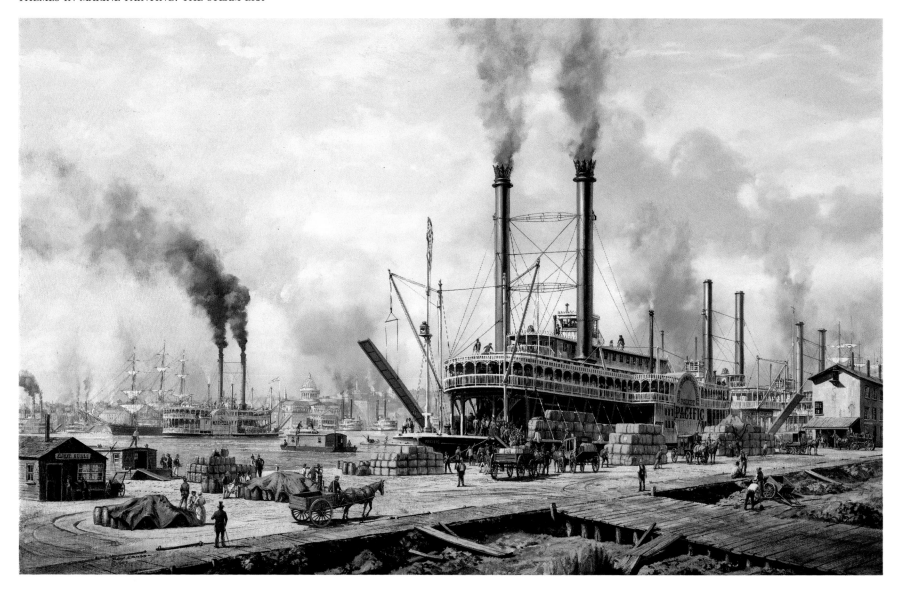

Roy Cross, R.S.M.A. 'The steamer *Pacific* at old New Orleans'. Oil, 30in x 48in. One of the famous Mississippi river boats, *Pacific* was built in 1857 for the Louisville & New Orleans line. Private collection.

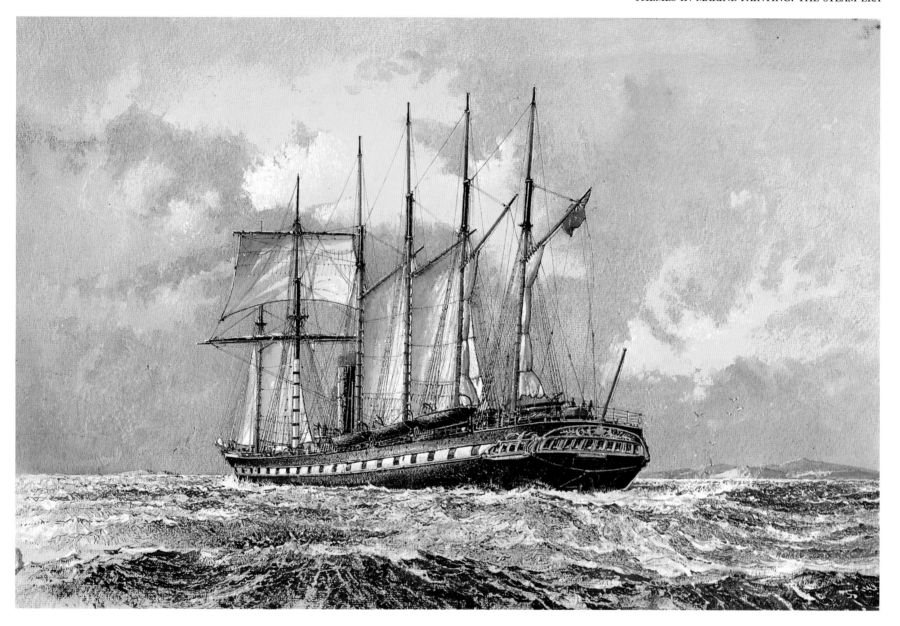

Ronald Dean, R.S.M.A. 'Brunel's revolutionary *Great Britain* through the North Channel on an early voyage to New York'. Watercolour and gouache, 13½in x 19½in. Collection of Ian Charles-Jones.

Pamela Drew, R.S.M.A. 'Shipbuilding, Belfast: Harland & Wolff's fitting-out jetty, 1946'. Oil, 20in x 28in. R.S.M.A. Diploma collection, by kind permission of The Lord Rathdonnell.

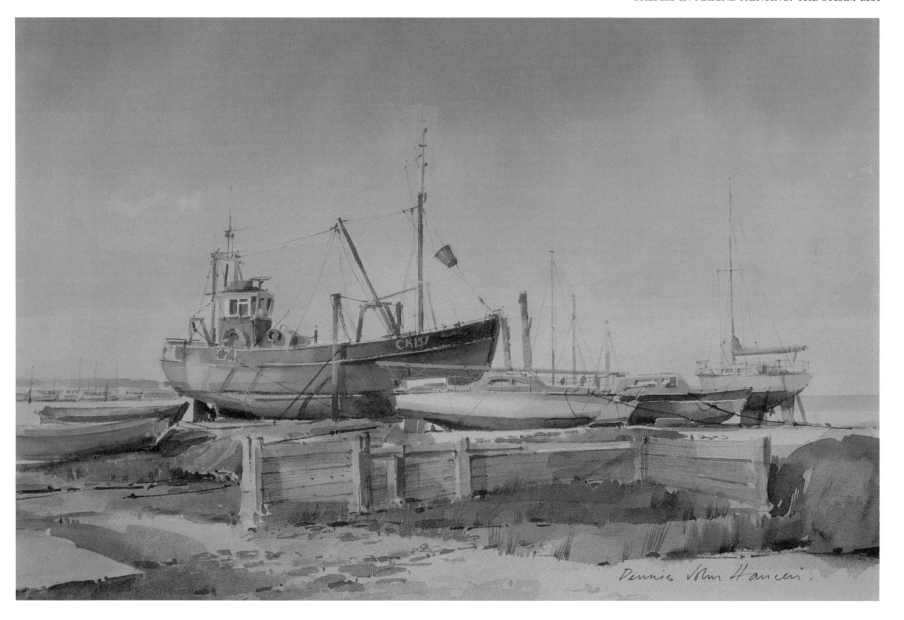

Dennis Hanceri, R.S.M.A. 'High and Dry West Mersea'. Watercolour, 10in x 14in. Private Collection.

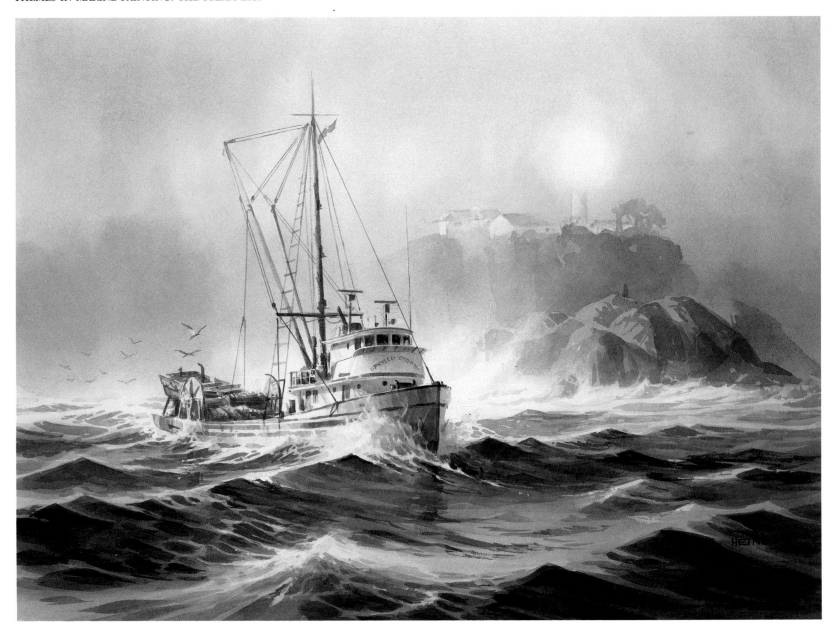

Harry Heine, R.S.M.A., F.C.A., C.S.M.A. 'Passing Friendly Cove, Vancouver Island'. Watercolour, 20in x 28in. Captain Cook landed at Friendly Cove, Nootka Island, in 1778, thus becoming the first European to land in British Columbia. Collection of Inge Kowal, Victoria, British Columbia.

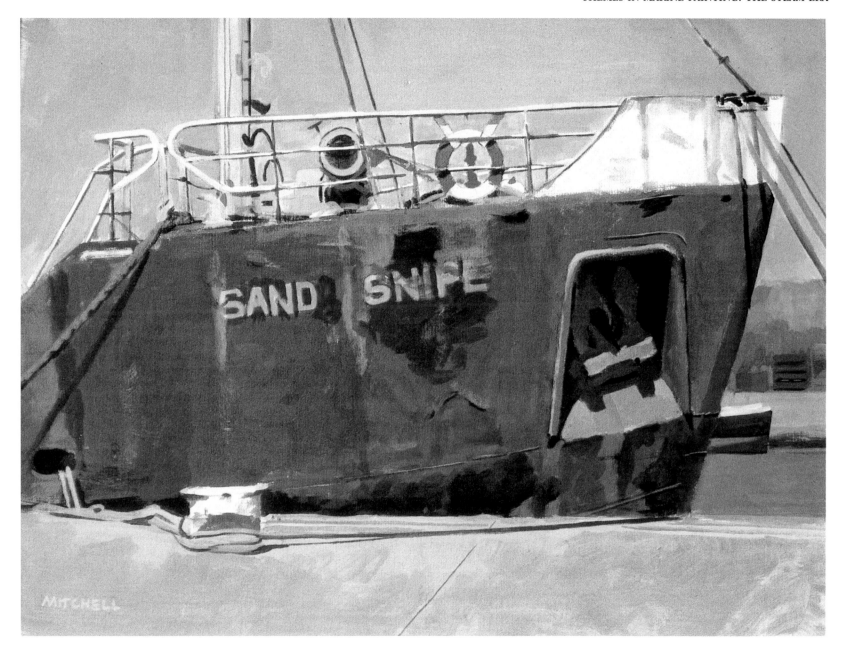

Brian Mitchell, R.S.M.A. 'Sandsnipe'. Acrylic on prepared paper, 9in x 12in. Redundant dredger in Penzance harbour. Collection: Artist's studio.

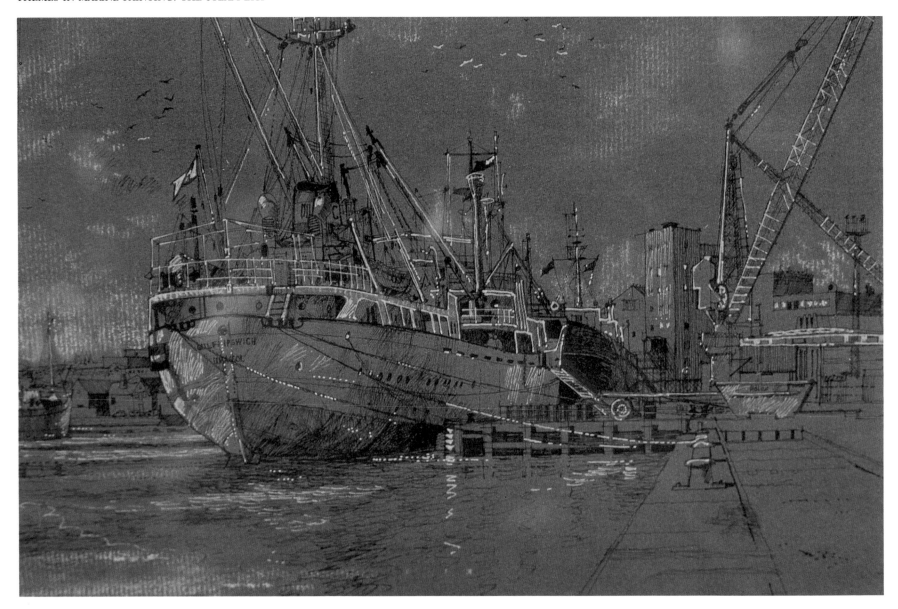

Michael Norman, R.S.M.A. 'Shipping lying at the dockside, Ipswich'. Pen, ink, watercolour and gouache, 12in x 9in. Commercial craft loading and unloading with cranes. Private collection.

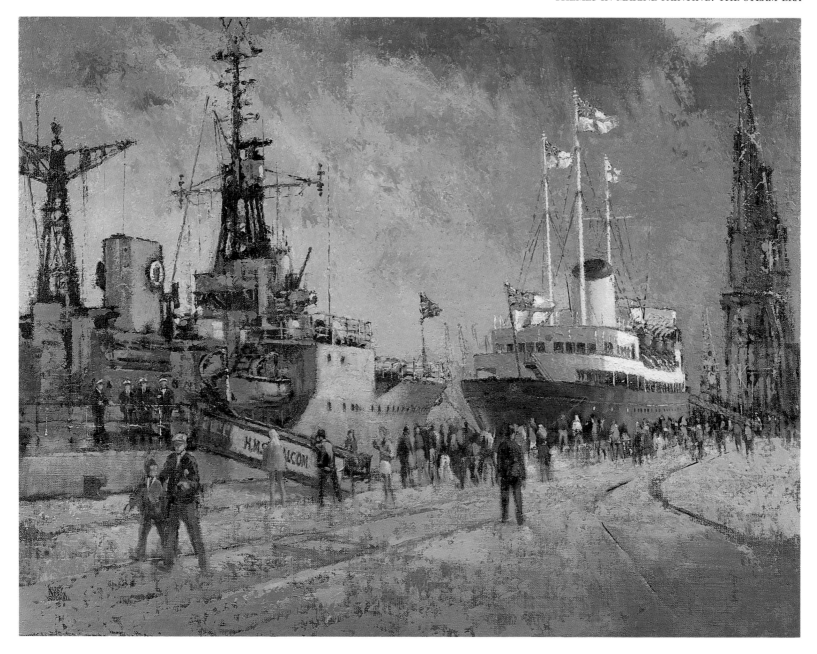

Harry Hudson Rodmell, R.I., R.S.M.A. 'Royal occasion'. Oil, 26in x 34in. R.S.M.A. Diploma collection, by kind permission of Mrs D. T. Rodmell.

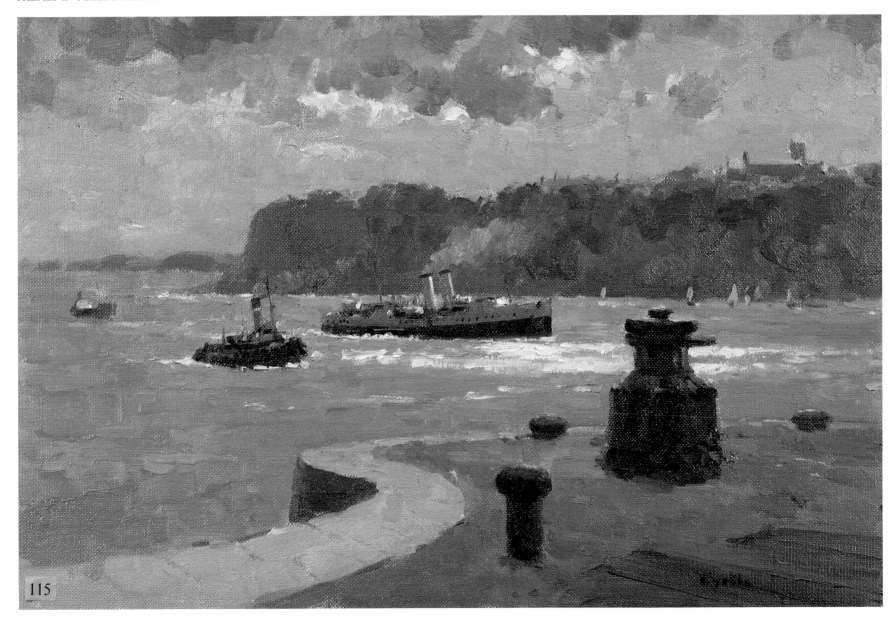

115

Gyrth Russell, R.O.I., R.S.M.A. 'Penarth Head'. Oil, 16in x 24in. R.S.M.A. Diploma collection, by kind permission of Mrs Ronagh Russell.

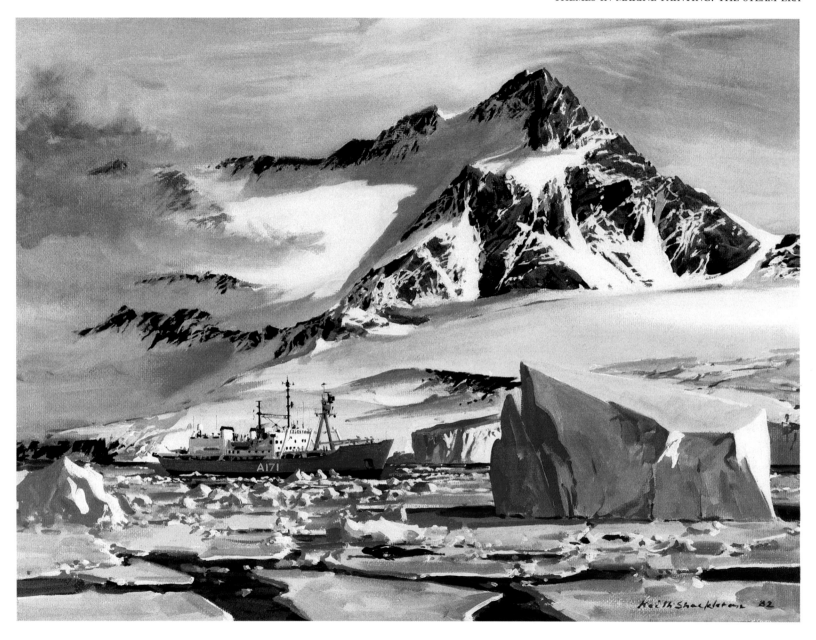

Keith Shackleton, R.S.M.A., S.W.L.A. 'HMS *Endurance* in the ice'. Oil, 18in x 24in. The Royal Navy's Ice Patrol Vessel during the Falklands war, seen at Hope Bay – Mount Flora beyond. Private collection – The Lord Buxton of Alsa.

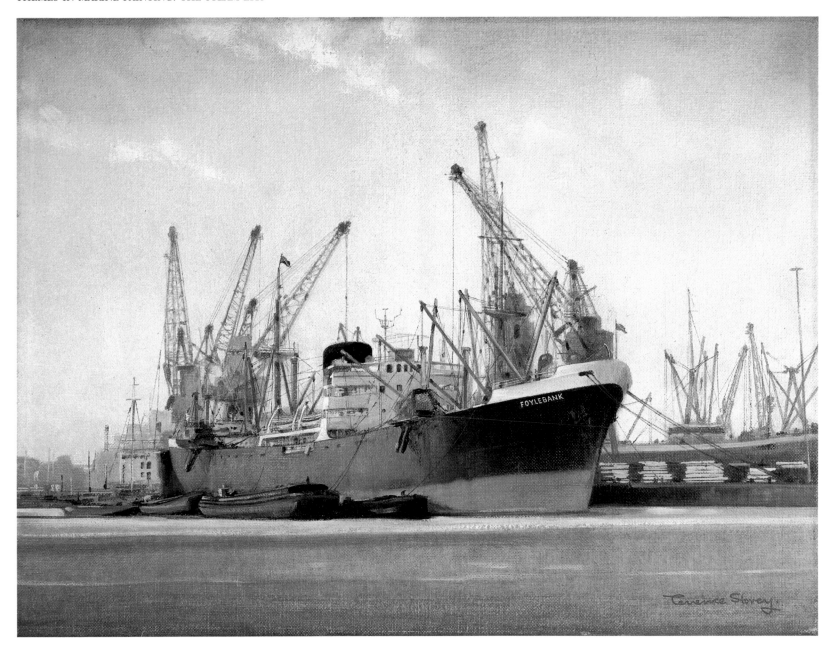

Terence Storey, R.S.M.A., F.R.S.A. '*Foylebank* in Hull Docks'. Oil on canvas, 12in x 16in. Bank Line Ltd (Andrew Weir & Co Managers). Artist's collection.

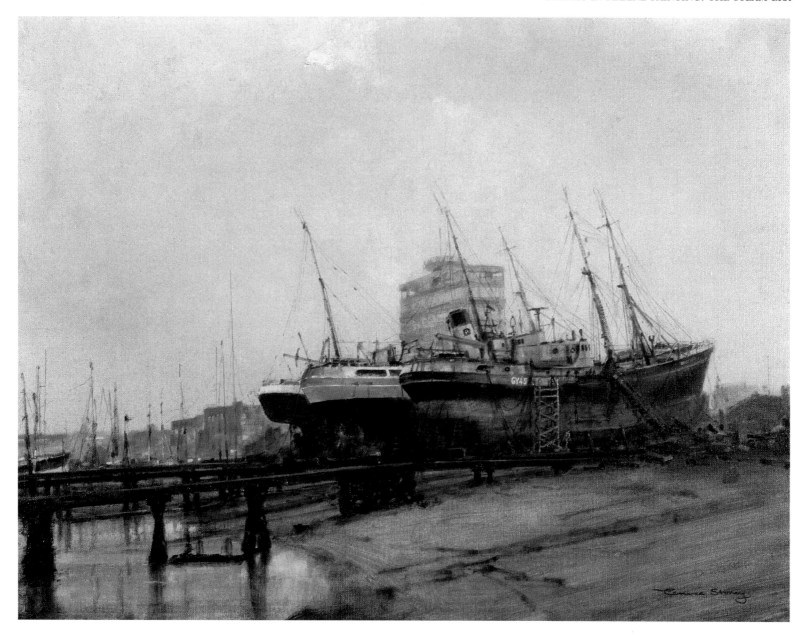

Terence Storey, R.S.M.A., F.R.S.A. 'Grimsby Trawlers'. Oil on canvas, 18in x 24in. Three trawlers on the slipway for repairs, the Ross building in the background. Artist's collection.

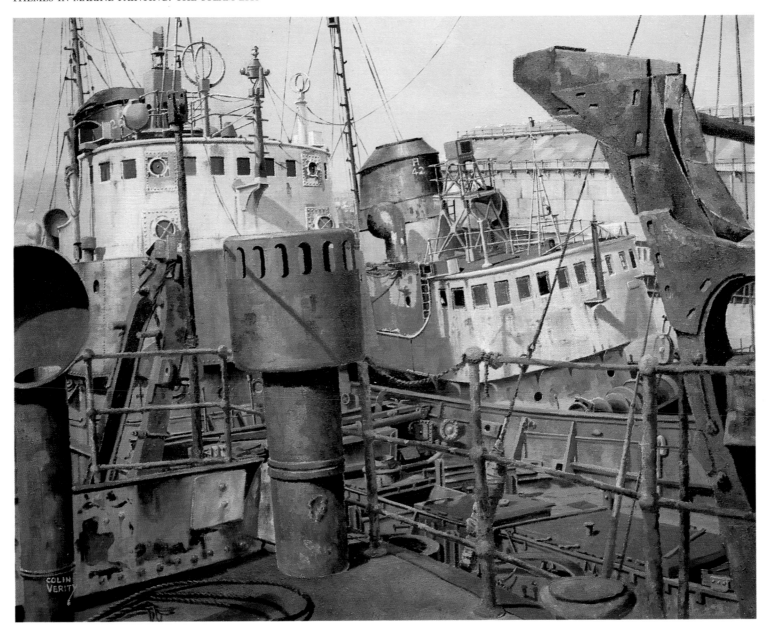

Colin Verity, R.S.M.A. 'Rotten Row'. Oil, 24in x 30in. Three redundant sidewinder trawlers lying abreast in the St Andrew's Dock, Hull, awaiting their last voyage the shipbreakers. Artist's collection.

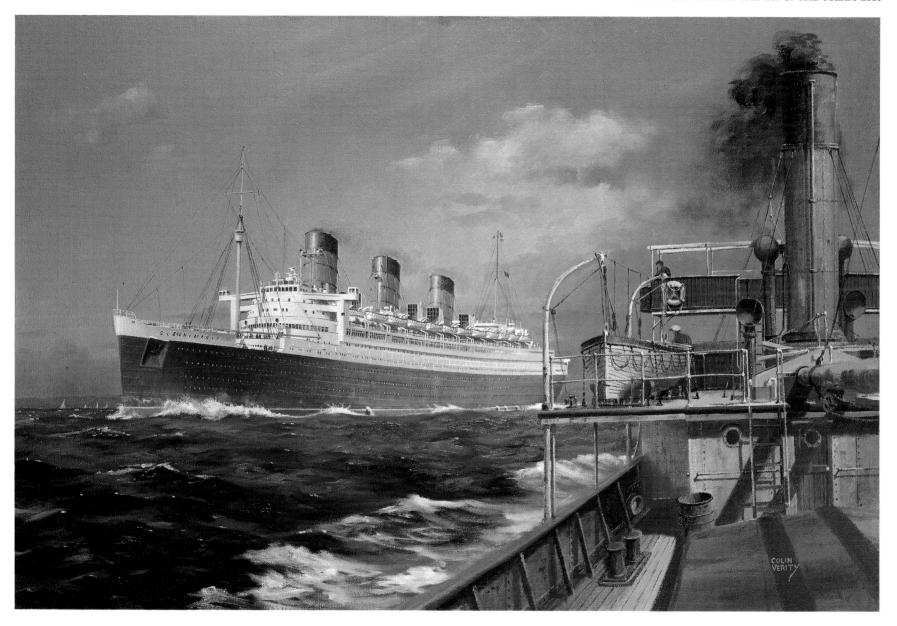

Colin Verity, R.S.M.A. 'R.M.S. *Queen Mary* bound for New York'. Oil, 24in x 36in. R.M.S. *Queen Mary* heading down the English Channel en route for New York, viewed from the deck of an old steam tramp. Private collection of Mr Norman Bisby Esq.

Members of the Society demonstrating their skills at the 1995 Annual Exhibition. Top left: Sheila Macleod Robertson. Top right: Colin Verity. Bottom left: Moira Huntly. Bottom right: David Curtis.

The Royal Society of Marine Artists, 1939 - 2005
by Arthur G. Credland*

with 1995 - 2005 summary by Geoff Hunt P.R.S.M.A.

The immediate stimulus that led to the formation of the Society was a suggestion made in the pages of *The Daily Telegraph* by Borlase Smart that 'contemporary masters of marine art' should join together as a body. This suggestion had already been made by the Earl of Cork and Orrery at an exhibition in Portsmouth, and the idea was also encouraged by the 'Sea Power' exhibition held at the New Burlington Galleries. The latter opened in July 1937, launched 'with pungent phrase and subtle humour by the Rt. Hon. Winston Churchill'.

Charles Pears, who had apparently considered setting up an organisation of marine painters soon after the 1914–18 war, wrote a response to Smart's letter, published 29 December 1939 : 'I have had practical experience in the formation of such a society. Shortly after the war I got together the first exhibition of modern paintings this country has had and the formation of a society of marine artists was then in view. I have worked steadily with the idea since then, latterly joined by my colleague Mr Cecil King.' At this stage, however, Pears considered that there were too few marine artists to form a self-supporting body and 'at present the forming of a society awaits outside help from public funds and sea-lovers. The forming of a lay committee of sea lovers will be a good idea, and I should like the views of any such.'

A letter from Bernard Gribble, writing from Parkstone, Dorset, supported the idea of a society, and he well remembered 'Mr H.C. Ferraby speaking to me about the same idea and saying how strange it was that this country had no Society of Marine Painters' (4 January 1939). In the meantime Charles Pears had received considerable correspondence at his Holland Park address and wrote to *The Daily Telegraph* again: 'Encouraged by the many letters I received from your readers, I am calling a meeting of marine painters for the evening of February 22nd to discuss the formation of such a society. The Commodore of the Royal Cruising Club has kindly lent the library for the purpose. The matter of lay membership will be discussed and those readers who wrote to me about this will be acquainted with the result in due course' (13 February 1939).

The meeting duly convened at 8 p.m. on Wednesday 22 February in the library of the R.C.C. at the Welbeck Hotel, Welbeck Street, London W.1. Eighty-two invitations had been sent, sixty-one had replied and only three of the respondents did not favour the idea of an association. Pears was in the chair and referred again to what he thought was the first exhibition of marine artists this century, stating that in 1926 he had circularised some of those who had been present, but without positive result. Arthur Briscoe, who was present at the Welbeck Street meeting, thought it an inauspicious time to start a new society and 'would mean subscriptions for hard pressed artists with a poor outlook as regards returns'. Borlase Smart declared that 1939 had been his worst year since 1919 but saw the potential of such an organisation and proposed a subscription of five guineas a year . The meeting eventually decided a society should be formed with a subscription of one guinea and that it should be called the 'Society of Marine Artists'. A ten-man committee, referred to as a council, was elected and comprised Arthur Briscoe, Arthur Burgess, Frank Emanuel, Bernard Gribble, Cecil King, Claude Muncaster, Charles Pears, Borlase Smart, Norman Wilkinson and Lieutenant-Colonel Harold Wyllie. Thirty people signed the attendance register; Burgess, King and Wilkinson were nominated in their absence.

The first council meeting was held at the Welbeck Hotel, commencing 5 p.m., Tuesday 4 April, by which time fifty-one people had applied for membership and had sent a foundation subscription of one guinea; Miss Winder Reid generously offered a £25.00 donation in addition to this. The annual subscription was set at four guineas, and additional funds were to be raised from exhibitions. A submission fee of 2s 6d was to be charged, also a hanging fee and a 12 per cent commission on sales by members and 15 per cent on those by non-members. Lay members would pay one guinea a year,

* Born and educated in Hull, Arthur G. Credland took an honours degree in Zoology at Aberystwyth before entering the museum profession. A special interest in Arctic whaling led to a particular study of the work of John Ward (1798–1849) of Hull, one of the finest marine artists of the nineteenth century. This resulted in an exhibition at the Ferens Art Gallery in 1981 (shown at Rotterdam the following year), followed by a retrospective of Harry Hudson Rodmell, R.S.M.A., in 1984, a centenary exhibition of Henry Redmore (1820–87) and in 1991 the first comprehensive display of the work of Allanson Hick, R.S.M.A. In 1993 *Marine Painting in Hull During Three Centuries* was published, a detailed survey of the major and many minor artists active in the city since the eighteenth century. He is presently Keeper of Maritime History at the Town Docks Museum, Hull.

in return for which they would be guests at an annual dinner and receive free admission to exhibitions; a picture purchased by the Society would also be raffled amongst them. At the second council meeting, 16 May 1939, Charles Pears (acting Chairman) was elected first President. Norman Wilkinson was offered the vice-presidency but declared his inability to give sufficient time to the post, so his place was taken by Cecil King. Maurice Hill became Hon. Secretary and Borlase Smart Hon. Treasurer.

A general meeting was held on Monday 24 April at 6 p.m. The Chairman (and President) in the meantime had acquired estimates at several alternative venues for the cost of staging the Society's first exhibition. The best offer had come from the New Burlington Galleries (where the meeting was being held) and included the services of Mr M.B. Bradshaw as professional secretary. Bradshaw, founder with C.R. Chisman of the Art Exhibition Bureau in 1926, had been the organising secretary for the influential 'Sea Power' exhibition in 1937.

It was decided that the show would run from 16 May to 29 June before transferring to the Baltic Exchange, which had a space in the basement suitable for an exhibition. The total cost of the two displays, including printing and typing, would be £217, which could just be covered by the £218.8s provided by fifty-two subscriptions. A further council meeting was held on 29 June and a special general meeting on 12 July, again at the New Burlington Galleries, when it was announced that ten individuals invited to be honorary vice-presidents had accepted this honour, namely Lord Lloyd, the Earl of Cork and Orrery, Lord Essendon, Mr Robertson F. Gibb, Viscount Runciman of Doxford, Sir John Lavery, John Masefield, Sir Vernon Thomson, Frank Brangwyn and Sir Geoffrey Callender. Only the President of the Royal Academy had sent a refusal, but he wished the Society every success. No reply had been received from Winston Churchill, but Charles Pears intended writing to him again. At a meeting of the Social Committee on 23 August it was decided that the Rt. Hon. Anthony Eden be approached to open the exhibition now scheduled to begin on 3 October. John Masefield, the Poet Laureate and an honorary vice-president, was to be second choice and Admiral of the Fleet Sir A. Dudley Pound to be approached if neither of these men were available. A series of lectures was planned following the opening, the first entitled 'Yachting' to be given by Uffa Fox (a lay member and notable yachtsman) on 5 October; the second, 'Round the Horn in a Windjammer', recalling the personal experiences under sail of Claude Muncaster, on 11 October; and a week later 'Sea Perspective' to be given by Lieutenant-Colonel Harold Wyllie. Tickets had also been printed for the Society's first annual dinner on 4 October at the New Burlington Galleries, 'evening dress and decorations to be worn'.

The start of the war with Germany announced by Neville Chamberlain on 3 September and a general mobilisation prevented the fulfilment of the Society's otherwise well-laid plans. At a council meeting on 14 September the exhibition was formally postponed until hostilities had ceased.

A report presented at a council meeting on 29 March 1940 summarised the discussions of a joint committee of the Society of Marine Artists and the Central Institute of Art and Design, which had met on 16 February at the National Gallery. The subject of debate was the possibility of creating a fund 'collected from the large shipping companies with a view to employing artists to record the part played by the Merchant Service in the history of a Maritime Nation'. The last general meeting until after the war was on 17 January 1940, but despite indefinite postponement of the inaugural exhibition the Society was able to make a significant contribution to the United Artists Exhibition at the Royal Academy, where a room was set aside for marine paintings. It was shown from January to March 1940, the proceeds of all sales being divided equally between the Lord Mayor's Red Cross and St. John's Fund and the Artists General Benevolent Institution. Pears represented the S.M.A. on the general committee and other leading S.M.A. members were involved in the organisation, but under different 'hats', Frank Emanuel as President of the Society of Graphic Artists and Norman Wilkinson as President of the Royal Institute of Painters in Watercolours. Charles Cundall was a member of the hanging committee. More than two thousand exhibits were accepted, thirty-four acknowledged in the catalogues as entered by members of the S.M.A. In addition, some who were members of more than one society chose to exhibit in the name of another organisation. A number of individuals who were not members at the time later became so. Selfridges invited the Society to send its exhibition for showing in their New Grosvenor Gallery. This was a much smaller space, so only a selection of smaller works could be transferred, and these were subject to a hanging fee of £1 garnered for the Society's funds. The official opening on Wednesday 3 April 1940 was performed by Admiral Sir Roger Keyes.

1941 was a fallow year for the S.M.A. since the second United Artists Exhibition at the Royal Academy was prevented by bomb damage. At a council meeting in December 1941 Mr C.R. Chisman was appointed Secretary *pro tem* as Bradshaw was entering the R.A.F. A reduced subscription of two guineas was to be asked for 1942, the first subscription having carried through to the end of 1941. No further fees were required from lay members.

The second United Artists Exhibition was staged in 1942, from January to March, in aid of the Duke of Gloucester's Red Cross and St. John's Fund. The surplus of gate money over expenses and half the proceeds of

each sale were given to the charity. In addition to the Royal Academy's own membership, 26 other societies took part contributing 1,500 pictures, while 21 artists exhibited in the name of the S.M.A. Charles Pears again represented the Society on the general committee. Immediately following this event the S.M.A. began a series of showings at provincial galleries organised through the Art Exhibition Bureau. Pears, King, Burgess and Hill formed the selection committee, and the first venue was at the art gallery in Peel Park, Salford, 23 March to 19 April, to coincide with their 'Warship Week'. It showed 92 works submitted by 35 S.M.A. members and four others, Clifford Hanney, James S. Mann, Greer Nicholson and Frank W. Wood. In addition works were contributed by Julius Olsson but in the name of the R.A. and R.O.I. and, though he exhibited in company with the S.M.A. at the United Artists Exhibitions of 1940 and 1942, he did not proclaim his membership of the Society. Each member had been asked to submit up to three works and if insufficient pictures (up to a maximum of about 120) had been obtained then non-members became eligible to contribute. Subsequently the exhibition visited Burton-on-Trent, Halifax, Lincoln, Doncaster and Blackpool, and when it returned to London again was seen at the Whitechapel Art Gallery for some weeks.

In the meantime and with the help of Sir Philip Haldin, President of the Chamber of Shipping, further attempts had been made to ensure a comprehensive coverage of work featuring both the Royal and Merchant Navies. The government response was to limit the appointment of official artists to only two, a small number for such a huge range of subjects.

A third United Artists Exhibition was held at the Royal Academy in 1943, again with the presence of 26 societies, in addition to the R.A., and Charles Pears represented the S.M.A. on the general committee. Nearly eleven hundred pictures were hung, and 21 S.M.A. members are listed in the catalogue. A council meeting on 21 October 1943 decided that only a token subscription of 10s 6d should be levied for 1944, enough to cover incidental expenses such as postage, correspondence and clerical services. No further meeting was held until 29 June 1945, by which time the war in Europe was over, and the next meeting, on 10 December, was after the final cessation of hostilities. Maurice Bradshaw had now returned from the forces but resigned *pro-tem*. No time was lost in extending the contacts of the Society, and a letter was sent to the French Society of Marine Artists suggesting the two bodies cooperate and regretting the absence of the S.M.A. from an exhibition recently held in Paris. The French Society had sent a request for the names of British marine painters, but this had been directed to the Admiralty who had failed to pass on the details to the S.M.A.

A whole gallery of the Naval Art Exhibition at the Suffolk Street premises of the R.B.A. was filled with paintings (77 in number) from S.M.A. members. Sponsored by *The Daily Telegraph*, it was opened by Mr A.V. Alexander, First Lord of the Admiralty, and ran from 29 January to 23 February 1946. Also shown were contemporary naval pictures lent by the War Artists Advisory Committee and a small collection of works commissioned by the Navy League within the preceding five years. All proceeds were given to the Navy League Sea Cadet Corps Appeal. The S.M.A. pieces were subsequently sent on for showing in Blackpool.

At the first post-war General Meeting, held on 28 January 1946, the chief topic of discussion was the long-postponed inaugural exhibition of the Society. Arrangements were made to stage this at the newly constructed Guildhall Art Gallery in the City of London, courtesy of Mr. Raymond Smith, the director, and members were asked to submit designs for the cover design of the catalogue. This would be only the second exhibition hung there. Sadly, no copy of the catalogue for this exhibition seems to have survived, but a report in *Sea Breezes* magazine (vol.3, 1947), for a time the official organ of the S.M.A., lists all the members and non-members who contributed. This landmark in the history of the Society was opened by the former First Lord of the Admiralty, A.V. Alexander, by then the new Minister of Defence, on 14 November and ran for a month. Over a hundred oil paintings and about seventy watercolours were on view.

The annual membership fee was re-established at four guineas at the 1946 Annual General Meeting and remained at that level until 1962. At the A.G.M. held at the galleries of the Royal Society of Painters in Watercolour on 26 March 1947, amendments were made to the rules for election of members. The original rule had been that the successful candidate was simply the one who received the greatest number of votes cast. This was altered to (not less than) two thirds of the votes, and the general meeting could elect up to one half of the declared vacancies, in the order of the ballot, if the figure of the ballot proved insufficient to effect the said election. On this occasion W. H. Jarvis, who had been third in the postal ballot, was admitted after a vote by the meeting; Pamela Drew and Leslie Wilcox had been the successful candidates in the postal ballot. The President also told the meeting that a suggestion had been made that a diploma collection* should be formed and this was duly approved by the members present. A request

* Shortly after being elected to the Society, each member is supposed to give one example of his or her work (known as 'the diploma work') to a permanent collection (the Diploma Collection) which should thus represent the work of the Society for present reference and as an historical record.

was again made for a design for the catalogue cover, and that finally selected was a watercolour of a warship in the Hull docks by Allanson Hick.

On 7 June 1948 the A.G.M. was held at the Kensington Art Gallery, Kensington High Street, where the Society staged the first of a number of exhibitions. The assembly expressed sadness at the deaths of Borlase Smart, Frank Emanuel and Charles Tracy since the last meeting. More than eleven thousand people attended the annual exhibition that year and attendance reached nearly fourteen thousand in 1949.

An invitation had been received to hold an exhibition at Bournemouth in spring 1950, and Winston Churchill was to be invited to open the annual show at the Guildhall. Non-members, like the members, were now to be allowed to submit four paintings rather than just two.

1950 saw a major display by the Society at Greenwich from 18 April to 10 May, when 208 pictures were hung. Although the museum was a prestigious venue, attendance was disappointing compared with the Guild-hall. Only four pictures were sold and only 275 catalogues out of a print run of one thousand. Immediately afterwards (27 May to 18 July) the exhibition moved to the Russell-Cotes Art Gallery and Museum in Bournemouth, where it was opened by Charles Pears, the President, replacing Admiral Gordon Campbell who was the original choice. (Bournemouth was to be the site of other major S.M.A. exhibitions in 1967, 1968, 1970 and 1971.) June of 1950 also saw a major contribution to a display at the Kensington Art Gallery in which more than eight hundred paintings were hung in company with ship models, some contemporary and others antique. There was further debate on the diploma collection, and it was decided that the final selection should be made by council from works submitted within four years of the election of new members and four years from the confirmation of the rules for present members. In order to reduce costs the lunch for lay members was to be replaced by a cocktail party as from 1951. The President, Charles Pears, gave a lecture entitled 'British Marine Painters Today' at the 4th International Congress of the Sea at Ostend, held at the Palais des Thermes on 22 July 1951. The Port of London Authority invited the Society, with the Wapping Group of Artists (some of whom were also members of the S.M.A.), to a river trip aboard their steam yacht *St. Katharine* on 7 September. Intermittent negotiations, which had begun in 1947, regarding the Society's possible contribution to the Festival of Britain in 1951 came to nothing.

The 1953 (coronation year) annual exhibition attracted 8,068 visitors. All the 1,500 catalogues printed were sold as were 50 works. A council meeting decided that the A.G.M. should be held at the time of the exhibition, as many members lived outside London and attendance had been quite low.

This was held aboard the *Wellington* courtesy of the Honourable Company of Master Mariners, as were many subsequent gatherings of the council. The election procedures were further debated, and it was decided that works submitted for the annual exhibition should be scrutinised in order to select names to put before the A.G.M.

In 1954 the first National Boat Show was held at the Empire Hall, Olympia, sponsored by *The Daily Express*, and the S.M.A. were invited to participate. A commission of 15 per cent was levied on each painting sold, two thirds of which was given to the sponsors. The Society returned to the Boat Show the following year, and thereafter pictures were submitted every year for some thirty years.

The accounts for the year ending 1955 showed a deficit for the first time, resulting partly from the expenses at Olympia, leaving the society more than £65 out of pocket despite sales of over £600. In addition there was an unexpected tax demand when the Inland Revenue decided to assess the society on all deposits in the Post Office and profits deriving from the submissions of non-members! At Olympia in 1956 pictures to a value exceeding £700 were sold but nothing was sold at the Chatham Navy Week exhibition. The A.G.M. was held at the premises of the Royal Society of Painters in Watercolours in Conduit Street since the *Wellington* was being used by the Honourable Company of Master Mariners for their own general meeting. A proposal was made to form a school of marine painting possibly aboard the *Cutty Sark* and a sub-committee was set up to investigate the possibilities. After discussions with the London County Council it was clear that the regulations governing such a body aboard the *Cutty Sark* would be too restrictive and the advantages to the Society too small. The project was therefore abandoned.

The A.G.M. returned to the *Wellington* in 1957 and, following the death of Charles Pears, Claude Muncaster was elected President. The following year the election system came under scrutiny yet again, and it was decided that it should be the task of members of the council to consider all works submitted on selection day for the annual exhibition. Voting papers were to be issued only at the exhibition to ensure members only voted after actually seeing the works. A sub-committee was appointed formally to re-draft the rules. Mrs. Pears was sent a silver salver, which had originally been prepared as a memento for presentation to the President signifying the gratitude of all the members of the Society for his efforts on their behalf since its foundation. A salver was also presented to Maurice Bradshaw, the long-serving secretary. It was decided to seek the royal prefix for the society, which was now well established and whose activities, including the exhibition and promotion of marine art, had won it an excellent reputa-

tion. Formal application was made to the Under Secretary of State at the Home Office, signed by the President and submitted with a brief history of the Society and a copy of the balance sheet; and in 1966 Her Majesty the Queen was graciously pleased to grant the title of 'Royal Society of Marine Artists'.

There was an invitation to exhibit at the Boat Show again (in 1959–60), now at Earl's Court, and each member was asked to submit up to three works. To ensure that all the expenses of the event were covered commission on work sold was increased to 20 per cent.

The emblem designed by Harry Hudson Rodmell for the cover of the annual exhibition catalogue in 1948 became firmly established as the Society's official badge. In 1949 he was asked to submit a smaller version suitable for use on stationery, and the badge also featured on the private-view card introduced in 1960. Immediately after the A.G.M. that year, held at 6½ Suffolk Street, there was a Special General Meeting to confirm the rules of election. There were still problems over procedure, however, and in 1961 there were 54 candidates, 26 of them with works in the current exhibition, though owing to lack of space not all the works that had been passed by the selectors could be hung.

The 1960 annual exhibition had been cut short by two weeks owing to the reception of the King of Nepal at the Guildhall, but despite this a surplus of £19 was achieved after all expenses had been taken into consideration. An extensive building programme was planned for the Guildhall which threatened to prevent the use of the art gallery for a while, and it was decided to establish a reserve fund to cover the costs of hiring a gallery. The subscription was therefore raised to six guineas as from 1 January 1962.

Following an invitation by the Director Frank Carr of the National Maritime Museum, the Port of London Authority agreed to lend their steam yacht *St. Katharine* for an excursion to Greenwich on 22 June. Members and non-members were invited aboard and, after partaking of a whitebait lunch at the museum, enjoyed tea afloat on the return journey to Tower Pier. An invitation was received to exhibit at Gothenburg and at the end of the year the accounts showed an excess of income over expenditure of £109 including receipts from the Earl's Court event, which had cleared a profit of £39.

The question of a diploma collection was raised again after the scheme had been 'put on ice' because no suitable accommodation was available. A breakthrough was finally achieved with the intervention of H.R.H. the Duke of Edinburgh, who personally asked the Director of the National Maritime Museum, Frank Carr, to provide the necessary space. It was suggested that each year the Society should present a painting to the nation and a sub-committee was set up to consider this idea. In 1963 with a donation of £30 from

the Society the Greenwich Museum purchased the first such piece when it acquired 'Boats at Cai Newydd' by Peter M. Wood.

The council (23 October 1963) decided to appoint three trustees to oversee the Society: David Cobb, Charles Cundall and W.M. Fryer. It was further decided that diploma work should be submitted within six months of election or an extended period as the council might decide. Existing members were to be asked to provide works for scrutiny as soon as possible and preferably within twelve months. At the A.G.M. of 3 November 1966, it was debated whether to use the initials R.M.A. or R.S.M.A., the latter being adopted by a majority vote.

The number of paintings hung at the 21st annual exhibition was a record 249, compared with 203 in 1947; and in 1992 at the Mall Galleries 270 works were displayed. The friendly relationship with Greenwich was maintained when in 1967 Basil Greenhill, the new Director of the National Museum, was invited to be an Honorary Vice-President. A major change in the running of the R.S.M.A. followed the offer in December 1968 by the Federation of British Artists to take over the collection of subscriptions, organisation of exhibitions and general administration. It was remarkable that the Society, whose activities had developed so much in the last twenty years, had managed to create such an active programme of exhibitions at home and abroad by relying on the goodwill and industry of its membership.

The 1969 Boat Show was very successful, with the sale of 72 of the 188 works hung, valued in total at £4,053. To ease the congestion being experienced at the Guildhall exhibition it was decided to hold *two* cocktail parties, since there were now some 450 lay members on the roll. In 1970 the council decided that the President should have a badge and Carl de Winter produced a design, based on Rodmell's emblem, which was approved with minor modifications the following year. The cost of the Guildhall catalogue was raised from 1s 6d to 2s 0d, and a travelling exhibition toured Darlington, Harrogate, Hartlepool, Rotherham, Bournemouth, Bridlington and Southgate. A sub-committee considering a dinner to mark the silver jubilee of the Society postponed this event owing to the ill-health of the President. In 1971 the travelling exhibition was booked by Swindon, Birkenhead, Stafford, Wigan, Bournemouth and Grimsby. That same year Maurice Bradshaw tendered his resignation as Secretary to the Society in order to devote more time to his post as Secretary General to the F.B.A. In recognition of his many years' devotion to the interests of the R.S.M.A. he was elected Honorary Vice-President.

The expense of new headquarters for the F.B.A. necessitated the raising of the subscription to £7.50, and commission on exhibition sales was raised to 15 per cent for members and 20 per cent for non-members. Rising costs necessitated a further increase in fees in 1975. Submission and hanging

fees and catalogue prices were all raised; commission on members' sales advanced to 20 per cent and for non-members to 25 per cent, while the subscription was held at £7.50 instead of a suggested £10. It may be noted that the catalogue's upright format was altered to a horizontal one in 1976, still retaining the society's emblem on a plain background, a design that was retained up to, and including, 1991.

At the Boat Show in January 1974, 188 works were hung. Despite the problems caused by the miners' strike and the resulting power restrictions, attendances were remarkably good, especially considering that closing times were brought forward from 9 p.m. to 7 p.m., Earl's Court was closed all day on Sundays, and a bomb incident also took place. During the time the building was cleared prior to the explosion someone took the opportunity to steal a picture; however, 'he obviously visited the bar as well and was caught by the police a few hours later for drunken driving with the picture in the back of the car and so it was recovered promptly'.

The R.S.M.A. was invited by the Plymouth Art Gallery to participate in a special exhibition to mark the 150th anniversary of the foundation of the Royal National Lifeboat Institution, to be shown from 19 July to 11 August 1974. As a tribute to the recently deceased Lieutenant-Colonel Wyllie a large oil painted shortly before his death was featured, together with two other works, in the annual exhibition at the Guildhall. The election rules were further amended to specify that the selection committee should consist of not less than three or more than five, to recommend candidates for approval by the A.G.M. The travelling exhibition for 1975, a selection of pictures from the Guildhall show of the previous year, went to Swansea, Mansfield, Bridlington and Birkenhead, and a selection from the 1976 Boat Show exhibition was planned to go to Rotherham and Weston-super-Mare.

Since 1946 it seems that no fees had been charged by the City of London for the annual show at the Guildhall, but following the appointment of a new director in 1977 the Society was asked to cover the cost of lighting, heating, cleaning and staffing. This was acceded to, and the event continued to be a great success despite occasional problems caused by visiting dignitaries which might curtail an exhibition or delay its opening. The anticipated interruption from building works did not materialise, and the Guildhall continued to be used for the annual show without a break until 1980.

An American Society of Marine Artists was established with the assistance of Californian-born Mark Myers, an R.S.M.A. member since 1975. He sought permission, duly granted, for the A.S.M.A. to model its draft constitution on the English body, taking its rules as guidelines.

In December 1978 the council agreed that Harry Rodmell should be made an honorary member in recognition of his long years of service beginning in 1939. This proposal was approved at the A.G.M. The Boat Show that year was marred by the theft of no less than nine paintings, taken on three separate occasions, and it was decided that for the following year a minimum size of 14 inches (for the longer side including the frame) should be established for all submissions. There was, in fact, no security problem in 1979, but bad weather and transport strikes reduced attendance and sales.

After the 1980 show, the 35th in the City of London, the Guildhall Art Gallery ceased to be an exhibition venue, and henceforward the Society's annual show would be held at the Mall Galleries of the F.B.A. The sale in 1981 of the contents of Charles Pears' studio, bequeathed to the Society, raised £30,000, providing a solid foundation for future development. An invitation was received to display at Mystic Seaport in the United States in September 1982. The Brighton Art Gallery was also interested in showing the diploma collection or at least a major selection from it.

In 1985, Raymond Leech was the first recipient of the Charles Pears Memorial Award, a cash prize of £250 for the work judged the best by a non-member at the annual exhibition. He was elected to membership the following year. The award was made to Dennis Syrett in 1986, and he was eventually elected to the Society as an associate member in 1994.

Phoenix Public Relations were appointed to promote the Society's exhibitions, but results were disappointing and there was criticism of the poster for the annual display in the Mall Galleries. The Federation of British Artists was reconstituted after a considerable amount of anguish, and the R.S.M.A. rejoined this important umbrella organisation, which took most of the administrative load from the Society's members.

The Federation of British Artists took space at the Düsseldorf International Boat Show during January–February 1987, a showcase exhibition in which the artists represented publicised their availability for commissions. A painting and a transparency were accepted from each member, and slides were shown of works not actually hung. The Society repeated its involvement in the event from 1988 until 1990.

Grenville Cottingham was the third winner of the Charles Pears Memorial Award, followed by Jeff Harpham in 1988. Since 1986 the National Maritime Museum had not been exercising the privilege of accepting a £50 (previously £30 then £35) grant towards the purchase of a picture. The award was now actually being made by the F.B.A., but it was agreed by the latter that the sum should be raised to £100 with a matching amount from the Society's own funds.

The first exhibition by the R.S.M.A. in the United States was at Mystic Seaport (Connecticut) in 1982 (12 September to 24 October), when 24 artists contributed 42 paintings and several items of sculpture. Its opening

was attended by Hugh Crooke, Cultural Attaché at the British Embassy in Washington; Duncan Robinson, Director, Yale Center for British Art; Peter Stanford, President, National Maritime Historical Society; while the R.S.M.A. was represented by Ronald Dean, David Cobb being in the Falklands.

A selection from this display crossed the border for the Society's first Canadian exhibition, staged at the Harrison Galleries, Vancouver, which opened on 3 November in the presence of the Lieutenant-Governor of British Columbia, the Hon. Harry Bell-Irving, D.S.O., O.B.E. After a ten-day showing, the exhibition transferred to the Museum of Science and Industry, Seattle (15 November to 12 January 1983).

A second exhibition at Mystic in 1988 (26 July to 18 September) was another great success, 30 members participating. Entries were mailed direct and were framed when received in America. Thirty-eight works were sold with a total value approaching £50,000.

There was now great dissatisfaction with the location of the exhibition at the Earl's Court Boat Show, and the Society withdrew from the event after 1988. Income in recent years had barely exceeded expenditure, and in 1988 only fourteen pictures were sold.

The old-style catalogue cover, plain except for the Society emblem, was used for the last time in 1991, and since 1992 a full-colour reproduction of a marine painting has graced both the back and the front.

In 1991 the decision was taken to re-house the diploma collection at the Ferens Gallery in Hull under the care of the Museum and Art Gallery service, particularly appropriate since two local artists, Allanson Hick and Harry Rodmell, had made significant contributions to the Society, both were founders and Hick had attended council meetings from 1947 to 1962 and Rodmell from 1948 to 1962.

The National Maritime Museum, to whom the Society was greatly indebted, had stored, cared for and, whenever possible, displayed the diploma works for nearly thirty years. Under the direction of the President, Terence Storey, and the Secretary, David Curtis, the transfer to Hull was accomplished in the autumn, shortly before the Ferens Art Gallery was due to re-open, after its extension and refurbishment. A substantial selection of diploma pieces was hung on the mezzanine floor and, on 31 October 1991, the President was a guest for the official opening of the gallery by H.M. The Queen Mother.

The 50th annual exhibition took place in 1995, and the 50th anniversary of the Society's inaugural exhibition was celebrated in 1996, the first edition of this book being a permanent reminder of the occasion. Since 1995 the Society has been ever more active, staging exhibitions in Portsmouth Cathedral (2000 and 2005); the Forbes Gallery, New York, and Mystic Seaport (2001); the St Barbe Museum and Gallery, Lymington, and "Seatrade" at London Excel (2003); and the National Maritime Museum, Greenwich (2004); quite apart from the annual exhibitions each October at the Mall Galleries. In 2004 the Diploma Collection was moved from Hull to Falmouth, finding a new home at the National Maritime Museum Cornwall, where in 2005 it was augmented by some twenty additional works.

The R.S.M.A. has established itself as a major force for the promotion of marine painting, a great native tradition that began with the Van de Veldes' residence in England in the seventeenth century. With its sound financial base and enthusiastic membership, numbering in recent years some forty people, and an active lay membership, the Society can look forward with confidence to another successful 60 years and an expanding influence in the twenty-first century.

Three Presidents of the Royal Society of Marine Artists at the 1993 annual Exhibition. From the left: Keith Shackleton, Terence Storey, John Worsley.

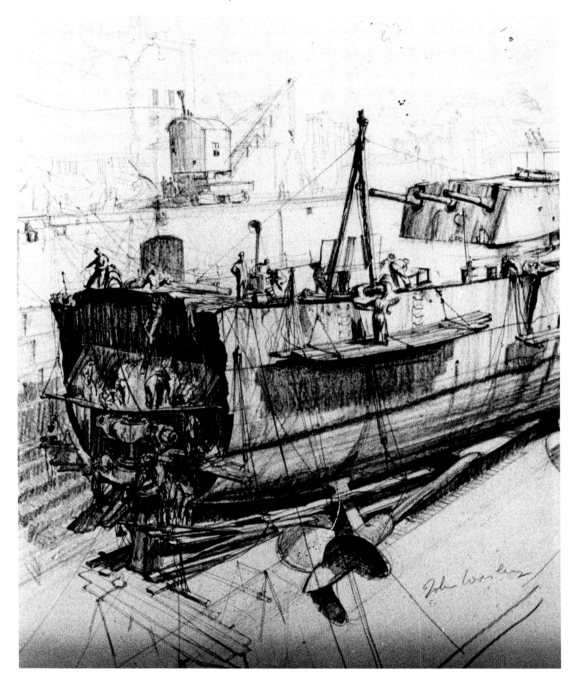

John Worsley, R.S.M.A. 'The stern of the cruiser H.M.S. *Newfoundland*, having been blown off by a mine, being repaired in a Malta dry dock, August 1943.' Charcoal pencil, 20in x 15in.

Directory of Members of the S.M.A. and the R.S.M.A 1939 - 1995*
by Arthur G. Credland
Abbreviations and current membership compiled by Kenneth Denton

*with amendments to 2005. For Members 1995 - 2005 see p. 191

Art Society Abbreviations and Qualifications

A.	Associate, when preceding a group of letters
A.S.M.A.	American Society of Marine Artists
B.W.S.	British Watercolour Society
C.S.M.A.	Canadian Society of Marine Artists
F.	Fellow, when preceding a group of letters
fl	Flourished, the period when the artist was most active
F.R.S.A.	Fellow of the Royal Society of Arts
G.I.	Royal Glasgow Institute of Fine Art
H	Honorary, as in Honorary Vice-President
I.S.	International Society of Sculptors, Painters and Gravers
I.S.M.P.	International Society of Marine Painters
N.D.D.	National Diploma of Design
N.E.A.C.	New English Art Club
N.S.	National Society of Painters, Sculptors and Gravers
P.	President, when preceding a group of letters
P.P.	Past President, when preceding a group of letters
P.S.	Pastel Society
R.A.	Royal Academy
R.B.A.	Royal Society of British Artists
R.B.S.	Royal Society of British Sculptors
R.B.S.A.	Royal Birmingham Society of Artists
R.C.A.	Royal Cambrian Academy
R.E.	Royal Society of Painters, Etchers and Engravers
R.H.A.	Royal Hibernian Academy
R.I.	Royal Institute of Painters in Watercolours
R.I.B.A.	Royal Institute of British Architects
R.O.I.	Royal Institute of Oil Painters
R.P.	Royal Society of Portrait Painters
R.S.	Royal Society
R.S.A.	Royal Scottish Academy
R.S.M.A.	Royal Society of Marine Artists
R.S.W.	Royal Scottish Society of Painters in Watercolours
R.W.A.	Royal West of England Academy
R.W.S.	Royal Society of Painters in Watercolours
S.Av.A.	Society of Aviation Artists
S.G.A.	Society of Graphic Art
S.M.A.	Society of Marine Artists (1939 to 1966 when the 'Royal' prefix was granted)
S.W.A.	Society of Women Artists
S.W.L.A.	Society of Wildlife Artists
U.A.	United Artists
V.P.	Vice-President, when preceding a group of letters

Other Abbreviations

I.W.M.	Imperial War Museum
N.M.M.	National Maritime Museum
W.A.G.	Walker Art Gallery

Note on the Early Membership List

Forty-two individuals are listed as members for the 1946 inaugural exhibition; nine others exhibited as non-members but were subsequently elected to the Society.* There are records of the election of only three members prior to 1947, namely Edgar Pullin and Stanley Rogers in 1943 and C.W. Simpson 1945.

Pamela Drew and L.A. Wilcox were elected after the 1946 exhibition by postal ballot and W.H. Jarvis at the 1947 Annual General Meeting. Elsie Atkins and Eleanor Best resigned in 1943 and five others died between 1941 and 1945.

Cundall showed in 1946 as a Royal Academician, and there is no record of his attendance at any of the early meetings; however, he was a council member in the 1960s. Olsson showed at Salford as RA and was not represented in 1946. Rowland Langmaid exhibited in 1940 as a member but was not present in 1946.

There is no record of Donald Greig or C.F. Norton attending any of the early meetings or displaying in 1946.

* A tenth, Ian McDougall, a candidate in 1945, was not elected.

Key

(1939)	Attended first meeting, 22 February
+	Attended first general meeting, 24 April
(1940)	Showed at first United Artists exhibition as S.M.A.
(1942)	Showed at second United Artists exhibition as S.M.A.
(1943)	Showed at third United Artists exhibition as S.M.A.
*	Showed at Salford as S.M.A.
1946	Showed at inaugural exhibition as S.M.A. (All other unbracketed dates are year of election)
(1946)	Inaugural exhibition but not as S.M.A.
✳	Indicates member of first council of the Society.

For illustrations of artist's works see *Page numbers* following each entry.

The names of all members of the Society are given in alphabetical sequence. In order that current members (1995) may be recognised, their names are followed by letters representing the societies and institutions with which they are associated.

ALLAN Robert Weir (1852–1942)
Oil, landscapes. Born Glasgow and educated there and at Paris. Travelled widely, exhibited R.A., R.S.A., Paris Salon. Elected A.R.W.S. (1887) and R.W.S. (1896). Works in many provincial galleries and abroad. Attended April 1939 meeting of S.M.A.

AMBROSE John (1931 -) **R.S.M.A. 1989** (resigned 1997)
Born and educated Brierley Hill, Staffordshire, now living in Cornwall. Art School training under the influence of D.A. Chatterton of Plymouth. Main influences have been Eugene-Louis Boudin and Edward Seago. Subjects mainly feature ports, harbours, coastal scenery and Venice. Exhibited: European continent, St.Ives Society of Artists, R.B.A. and R.O.I. *Page 80*

ANNISON Edward S. (fl 1910–48) **(1939) + (1942) * 1946**
Oil. Exhibited: inaugural exhibition of S.M.A., 1946; also R.A. and Walker Art Gallery, Liverpool.

ANSON Peter Frederick (1889–1975) **(1940) (1942) * (1943) 1946**
Watercolour, landscapes, architectural, pencil portraits. Born Portsmouth 22 August 1889, son of Admiral C.E. Anson; student at Architectural Association School. Became a monk and resided with various communities. Author of *Mariners of Brittany* (1931), *How to Draw Ships* (1941) etc.; illustrated these and work of other authors. Collection of his drawings at N.M.M. Exhibited: R.A., R.S.A., R.H.A., N.E.A.C., R.W.A., G.I., Goupil Gallery. Died 10 July 1975. *Page 125.*

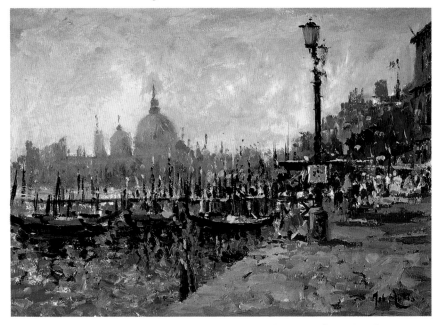

John Ambrose, R.S.M.A. 'The Salute – Venice'. Oil, 9in x 13½in. Gondoliers at rest. Private collection.

Donald Blake, R.I., R.S.M.A. 'Harbour Group'. Watercolour, 13in x 18in. No particular harbour but a distillation of many from the artist's experience and memory; and concerned with the textural qualities of colour and form expressed in a semi-abstract style. Collection: Artist's studio.

ATKINS Mary Elizabeth (Elsie) (fl. 1920s–30s) **+ (1940) ***
Oil, landscapes, flowers, interiors. Born London; studied at the Slade School. Work purchased by Italian Minister for Foreign Affairs at Venice International. Exhibited: R.A., N.E.A.C. and Leeds. Paintings in Leeds City Art Gallery. Resigned from R.S.M.A. (1943).

AYLING George (1887–1960) **(1942) * (1943) 1946**
Oil, watercolour, landscape, figure. Born Kensington, London, 27 August 1887, he followed his father as a maker of boats' oars and sculls before entering Putney School of Art. Art master for Middlesex Education Board. United Artists exhibition in 1940 but not S.M.A. Showed under S.M.A. banner in 1942 United Artists. Showed at inaugural S.M.A. Exhibition, 1946; R.A., R.O.I., R.B.A., N.E.A.C., provinces and Paris Salon. *Page 81.*

BALDWIN Frederick William (1899–1984) **1956**
Watercolour, pen and pencil. Born 17 March 1899, son of a builder. Self-taught. Lived at Westhall, near Halesworth, later moved to Stoven, Beccles. Works bought by Birmingham Art Gallery, Stoke A.G. and Ipswich A.G. Resigned 1966. Exhibited: R.A., Ipswich Watercolour Society.

BEALE Mrs Margaret L.C. (b. 1886–?) **(1939) (1940) (1942) * (1943) 1946**
Oil, watercolour. Born Yaldham, Kent, 30 June 1886; studied under William Orpen and P. Tudor Hart. Keen small-boat sailor. Present at first meeting in February 1939; showed at inaugural exhibition. Exhibited London and Chichester, where she lived.

BECK Stuart (1903 - 2000)
R.S.M.A. 1980
Oil, watercolour. Born Barnes, London, son of Master Mariner. Rochester School of Art, general graphic designer in printer's studio; technical illustrator; R.N.V.R. (1941–6); full-time sea painter from 1968. Exhibited: 1946 R.S.M.A. inaugural show, R.I., R.B.A., S.G.A., Paris, Vancouver, U.S.A., Düsseldorf, N.Z. Author of *Ships, Boats & Craft* and *A Dash of Salt. Pages 23 and 126.*

BEST Eleanor (b?–1958) **+ (1940) (1942)**
Oil, portraits, flowers and still life. Born Amport, Hants; studied at Slade School. Latterly resided at Richmond, Surrey. Resigned S.M.A. 1943 and died aged over 80. Exhibited: R.A., R.S.A., N.E.A.C., R.S., provinces, Paris Salon, Stockholm, Pittsburgh, New York.

BLAKE Fredrick Donald (1908 - 1997) **R.I., R.S.M.A. 1972**
Oil, watercolour, etching, pen and ink. Born Greenock 7 June 1908. Studied at Camberwell School, Goldsmiths' College, Brixton School of Building, becoming an architectural draughtsman. Produced maps and battle impressions for *Daily Express*. Elected R.I. 1951; also Chelsea Arts Club, Wapping Group and Past-President of London Sketch Club. Exhibited: R.A., R.I., N.E.A.C., R.O.I., R.B.A., Los Angeles, Chicago, San Francisco, Düsseldorf and Brussels. *Pages 82 and 156.*

BOND Arthur J.F. (1888–1958) **(1939) + (1940) * 1946**
Oil, watercolour, etching. Born Devonport 29 April 1888. Studied at Heatherleys, Goldsmiths' College and Central School of Arts and Crafts. Served in Royal Navy 1916–19, Harwich force minelayers. Member of Wapping Group and Langham Sketch Club. Present at 1939 meetings. Exhibited R.A., R.I. and Paris Salon. Died 24 March 1958.

BONE Sir Muirhead (1876–1953)
Oil, watercolour, etching. Born Partick, 23 March 1876. Studied at Glasgow School of Art. Official War artist 1916–18 and 1939–46. Exhibited N.E.A.C., Royal Glasgow Institute of Fine Art and Royal Academy. Was appointed to the S.M.A. hanging committee in 1939 but membership ended 1943. Died Oxford 21 October 1953.

BONE Stephen (1904–1958)
Oil, illustrator. Born 13 November 1904 at Chiswick, son of Sir Muirhead. Slade School under Henry Tonks, 1922–24. Official artist to Royal Navy 1943–6. Membership ended 1943. Died in London 15 September 1958.

BOYCOTT-BROWN Hugh (1909–90) **1969**
Oil, watercolour, landscapes. Born 27 April 1909. Watford School of Art, Heatherleys, privately under Bernard Adams R.O.I. and Sir John Arnesby Brown R.A. Art Master of Royal Masonic Junior School, Bushey, Herts. Enthusiastic small-boat sailor, joined R.A.F.V.R. 1943 and posted to Coastal Command. Member of Wapping Group. Died 12 November 1990. Exhibited: R.A., R.S.A., R.I., R.B.A., R.O.I., N.E.A.C., G.I., S.G.A., Geneva and U.S.A. *Page 24.*

BRADSHAW George Fagan (1878–1960) **(1940) (1942) * (1943) 1946**
Oil, tempera, watercolour. Born Belfast, 6 December 1887. Educated H.M.S. *Britannia*, Dartmouth; entered Royal Navy 1903, 1914–18 war in submarine service, retired as Lieutenant-Commander with D.S.O. 1921. Studied at St. Ives where he lived for many years. Exhibited: R.A., R.S.A., R.W.A., Paris Salon. Died 27 October 1960 following many years' ill health after his boat detonated a magnetic mine in Falmouth Harbour during 1939–45 war. *Page 158.*

✳ **BRISCOE Arthur John Trevor** (1873–1943) +
Oil, watercolour, etching, illustrator, including sports sketches. Born Birkenhead 25 February 1873. Slade School under Fred Brown and Henry Tonks; Académie Julian, Paris. Founder member of Blackwater Sailing Club, regularly cruised to Continent, punt-gunner, author and illustrator of *A Handbook of Sailing* under pen name 'Clovehitch'. Lieutenant R.N.V.R. 1914–18 war; A.R.P. Warden 1939–45. Exhibited: R.A., R.S., N.E.A.C., Member of first S.M.A. committee; elected A.R.E. (1930), R.E. (1933) and R.I. (1935). Died Chelmsford 27 April 1943. *Page 25.*

BUCKLE Claude (1905–73) **1964**
Oil, watercolour. Born London 10 October 1905. Trained as an architect but turned to art in 1928. Elected to R.I. 1962. *Page 83.*

✳ **BURGESS Arthur James Wetherall** (1879–1957) **(1939) + * 1946**
Oil, watercolour. Born Bombala, N.S.W., Australia, 6 January 1879. Studied art in Sydney. Settled in England 1901 and continued studies at St. Ives. Illustrator for *The Graphic, The London Illustrated News, Sphere.* Art Director of *Brassey's Naval & Shipping Annual*. Official marine artist for Australia in 1918; founder member and Vice-President of S.M.A. Exhibited: R.A. and Paris Salon. Member of R.O.I., R.I., Langham Sketch Club and

George Bradshaw, S.M.A. 'Untitled' (barque under full sail). Oil, 15in x 19in. Collection of Mr David Tovey.

Rodney J. Burn, N.E.A.C., A.R.A., R.A., R.S.M.A. 'Dalquay'. Oil, 13in x 20in. R.S.M.A. Diploma Collection.

Wapping Art Group. Died London 16 April 1957. *Page 11.*

BURN Rodney Joseph (1899–1984) **Hon. Member 1958**
Oil, landscapes and figures. Born Palmers Green, London, 11 July 1899. Studied at Slade School under Tonks. Senior Tutor at R.C.A., Director of Drawing and Painting at Museum of Fine Arts, Boston. Worked in Tate Gallery and British Museum Print Room. Member of N.E.A.C. (1924) and Hon. Secretary; A.R.A. (1954), R.A. (1962), Royal West of England Academy and President of St. Ives Society of Artists. Exhibited: Goupil Gallery, Imperial Art Gallery, Paris. *Above.*

CACKETT Edward Leonard (1896–1963) **(1946) 1948**
Oil, watercolour, pastel, etchings, landscape. Born Tottenham, 5 June 1896. Bolt Court School of Art and Lithography, and Hackney Institute of Art. Draughtsman at Air Ministry in 1939–45 war. Elected R.W.S. (1940), S.G.A. (1961). Member of St. Ives Society of Artists, Society of Sussex Painters and West Sussex Art Club. Exhibited: R.A., R.I., R.B.A., R.O.I., R.W.A., P.S. and in provinces.

CAIN Charles William (1893–1962) **(1939) + (1940)**
Oil, watercolour, etching, landscape. Born Chelsea, 22 August 1893. Cam-

berwell and Royal College. Served in the Artists' Rifles in 1914–18 war. Watercolours in Imperial War Museum. Last showing with R.S.M.A. in 1954. Exhibited: R.A., R.S.A., Paris Salon.

CANNELL Edward Ashton (1927–1994) **1980**
Watercolour, landscape. Born Isle of Man, 12 September 1927. Isle of Man School of Art; Liverpool College of Art; Head of Art Department Rutherford School, London, and Art Assessor for Metropolitan Regional Exam Board. Exhibited: R.A., R.I., R.B.A., Paris Salon (Silver Medal 1973, Gold Medal 1975) and U.S.A. Member of Langham Sketch Club, Wapping Group, United Society of Artists and R.W.S. *Page 84.*

CARLYON John (1917–1982) **1977**
Sculptor. Born Cornwall, 1917 near the Lizard where he stayed throughout his life, except for service with Coldstream Guards in 1939–45 war. Keen fisherman and nature lover. Exhibited: Tryon and Moorland Galleries in London and in West Country. Carvings mainly from local serpentine stone. Resigned from R.S.M.A. *Page 159.*

CARR Leslie (1891–?) **(1939) + (1942) * 1946**
River, sea and architectural subjects. Born London, 23 January 1891. Lieutenant in Tank Corps 1914–18 war. Present at first meeting in 1939.

CARTER Peter (1920–79) **1968**
Watercolour, portraits, still-life. Born

London, left school aged 14 to study engineering. Joined Royal Observer Corps in 1939 in which he served for the duration. Founded his own engineering firm and in 1962 moved to Devon where he developed as a marine painter. *Page 85.*

CARTLEDGE William (1891–1976) **1962**
Oil, watercolour, portraits, landscapes, flowers. Born Manchester, 30 January 1891. Manchester School of Art and Slade School under Brown, Tonks and Steer. Assistant at City School of Art, Liverpool, Staffs. County School of Art and Crafts, and headmaster of Pudsey School of Arts and Crafts. Elected R.I. 1955, work in Manchester City A.G., Whitworth Institute, Stoke-on-Trent and Staffordshire A.G. Exhibited: R.A., R.I., R.B.A., Goupil Gallery, provinces and abroad. *Page 127.*

CAUSER William Sidney (1880–1958) **1948**
Oil, watercolour, landscape, town scenes. Born Wolverhampton, 1 December 1880. Studied at local school of art, also London and Italy. Exhibited: R.A., R.S.A., N.E.A.C., Paris Salon, one-man shows at Leger Gallery and Fine Art Society. Member of R.I., R.B.S.A. and N.S. Died Sidmouth, 18 December 1958.

CHAMBERLAIN Trevor (1933–) **R.O.I., R.S.M.A. 1970**
Oil, watercolour, town and landscape, with emphasis on atmosphere and light, paints 'Alla Prima' from life. Born Hertford 13 December 1933. Self-taught painter who initially worked as an architectural assistant, but painted professionally from 1964. Works featured on T.V. and in the collection of Guildhall Art

Gallery and Hertford Museum. Author of *Oils.* Member of R.O.I. and Wapping Group. Exhibited: London (including R.A.) and abroad. Winner of numerous prizes. *Pages 86 and 128.*

CLARK Thomas Brown (1885–1986) **1953**
Oils, landscapes. Born Glasgow, 12 August 1885. Glasgow School of Art and Glasgow Royal Technical College. Theatre Design in his early career. Exhibited: R.A. and abroad. *Page 87.*

COBB (Charles) David (1921–) **(1946) 1948**
Oil, gouache. Born Bromley, Kent, 13 May 1921; educated Nautical College, Pangbourne and studied art under Borlase Smart (*q.v.*) Six years in R.N.V.R., mainly in M.T.Bs. Keen yachtsman, started painting professionally in 1946. Member of R.O.I., Past-President of R.S.M.A. Author and illustrator, including *Three Mile Limit* (1950) and *Starting to Sail* (1964). Resigned from R.S.M.A. Exhibited: R.O.I., R.B.A. and widely abroad. *Pages 26 and 59.*

COBBETT Hilary Dulcie (1885–?) **(1939) + (1940) (1942) * (1943) 1946**
Oil, watercolour, etching. Born Richmond, Surrey. Studied at Richmond School of Art; teacher of Art. Present at 1939 meetings of S.M.A. Resigned 1966. Exhibited: R.A., R.B.A., R.P.S., R.O.I., R.I., S.W.A., elected A.S.W.A. *Page 88.*

COOK Alan R (fl. 1959–74) **1973**
Oil, watercolour. Lived at Whitley Bay. Mainly Northumberland and Tyneside shipping scenes. Died 1974. *Pages 89 and 129.*

John Carlyon, R.S.M.A. 'Octopus'. Stone, 7½in high. Collection of Kenneth Denton.

COTTINGHAM Grenville George (1943–) **R.B.A., R.S.M.A. 1987**
Appointed 1966 by Marine Society as their first sea-going artist tutor, travelled 150,000 miles aboard nineteen merchant ships. Senior College Lecturer ten

years. Oil, watercolour, commissioned by P&O, Ocean (T&T), O.C.L., R.N.R. (Lond.), Royal Fusiliers and leading financial institutions. Member of Wapping Group. Exhibits: R.A., R.B.A., R.I. Recent solo exhibition Bruton Street Gallery. *Pages 130 and 131.*

CROSS Roy (1924–) **R.S.M.A. 1976**
Born London; began as technical illustrator (aircraft) during war then as freelance journalist/artist to aviation and other industries. Early member of Society of Aviation Artists. Gave up commercial practice to concentrate on historical Marine art 1970. Solo shows: Sweden, U.S.A., where there is a large following for his realistic depictions of historic ships, yachts, ports, naval action, etc. *Pages 27 and 132.*

CUNDALL Charles Edward (1890–1971) **(1946)**
Oil, watercolour, town and landscapes, sporting. Born at Stretford, Lancashire, 6 September 1890. Manchester Art School and scholarship to R.C.A. Wounded in 1914–18 war, returned to R.C.A.; Slade School and Paris. Designed pottery and stained glass for Pilkingtons. Work in the Tate, Liverpool, Manchester, Bristol etc. Official war artist to the Air Ministry in 1940. Exhibited: R.A., one-man show Colnaghi's (1917); elected N.E.A.C. (1924), A.R.W.S. (1935), R.B. (1933), A.R.A. (1937), R.W.S. (1941), R.A. (1944). 1946 Inaugural exhibition as R.A. Died 4 November 1971. *Page 60.*

CURTIS David Jan Gardiner (1948–) **R.O.I., R.S.M.A. 1983**
Oil, watercolour. Born June 1948. Headed engineering design team until 1988. From then, full-time painter.

Commissions include Sultanate of Oman, Crown Commissioners, Portman Estate. Works in permanent collections: Ferens Art Gallery, Hull; Doncaster Museum; Tate Gallery. Exhibited: R.A., R.I., R.W.S., N.E.A.C., Elected R.O.I. (1988). *Pages 90 and 91.*

DALISON J.S. (fl. 1938–1948) **(1940) (1942) 1946**
Oil, watercolour. Lieut. Cdr. R.N. awarded D.S.O. Painted naval subjects. Lived in Weymouth. Exhibited: under S.M.A. banner at United Artists show 1940 and 1942: four pictures in 1946 inaugural exhibition.

DAVIES John Alfred (1901–1987) **1967**
Oil, watercolour, landscape, figures, aircraft. Born Ware, 22 April 1901. Educated R.M.A. Woolwich and played central role in wartime supply organisation: awarded O.B.E. and American Legion of Merit. Founder of British Tabulating Machine Co. (later I.C.T. and I.C.L.). Keen yachtsman and ocean cruiser. Studied art at Heatherley's and painted with Jack Merriott (*q.v.*) etc. Member of Wapping Group. Exhibited: R.A., R.W.S., Armed Forces Art Society, Guild of Aviation Artists, R.I. and Paris Salon. Died 10 August 1987. *Page 92.*

DAVIS George Horace (1881–1963) +
Oil, watercolour, illustrator. Born Kensington, 8 May 1881. Head of Aerial Diagrams Section R.F.C. (1917–18). Official war artist (1918) and then staff artist with *The Illustrated London News* from 1923, cut-away drawings a speciality. Exhibited: R.A., Imperial War Museum, Reading Art Gallery. Present at S.M.A. 1939 meeting.

DAWSON Montague (1895-1973) **(1940) * (1943) 1946**
Oil, watercolour. Apprenticed to commercial studio; pupil of C. Napier Hemy. Served in Royal Navy 1914-18 war . Noted for his clipper ships in full sail; ten naval paintings in Imperial War Museum. Exhibited: R.A., Liverpool; work widely circulated in print form. Died 21 May 1973 at Midhurst, Sussex. *Pages 28 and 61.*

DEAN Ronald Herbert (1929–) **F.C.I.I., R.S.M.A. 1970**
Born Farnborough, Hants, 16 August 1929. Marine Insurance broker at Lloyd's. Self-taught marine and landscape artist in watercolour/gouache. Solo shows: Biarritz (1975), London (1978) and Salem (Oregon) 1981. R.S.M.A. Treasurer 1983–88. Exhibited: R.I., R.B.A. *Pages 29 and 133.*

DENHAM Henry James (1893–1962) **1947**
Oil, watercolour, figure subjects. Born Bristol, 14 February 1893. Studied at Bristol School of Art under John Fisher and R.E.J. Rush. Painting and Life Master there 1913–23. Member of S.G.A (1950), founder member of Wapping Group (1946) and belonged to Langham Sketch Club. Exhibited: R.A., R.I., R.W.A. and provinces.

DENTON Kenneth (1932–) **R.S.M.A., 1976 I.S.M.P., F.R.S.A.**
Oils, landscape, marine, town. Training: Apprentice decorative artist. Studied: Medway College of Design. Fellow: Royal Society of Arts; British Institute of Interior Design, Chartered Society of Designers. Member: International Society of Marine Painters. College Lecturer. Reproductions: prints, calendars,

cards, books, magazines and journals. Radio and television appearances. Awards: Hunting Group. Exhibitions: 38 international solo; 6 duo; numerous group. *Pages 30 and 93.*

DESOUTTER Roger Charles (1923 -) **R.S.M.A. 1995**
Oil, landscapes. Degree in Engineering at Loughborough and from 1942 to 1945 part of Sir Frank Whittle's design team working on jet engines. Sketched and painted in spare time and retired in 1990 as Chairman of family engineering firm. Exhibited: R.S.MA. from 1974 and Society of Aviation Artists from 1955. *Pages 31 and 62.*

DREW Pamela (Lady Rathdonnell) (1910–89) **(1946) 1947**
Oil, pastel, aeronautical. Born Burnley, 11 September 1910. Studied under Dorothy Baker at Christchurch; Iain McNab, Grosvenor School of Modern Art, Roger Chantel in Paris. W.R.N.S. rating 1942, junior staff C-in-C Rosyth 1943, Naval Liaison 10 Group Fighter Command 1944 and F.O.I.C. Northern Ireland 1945. Works in Belfast Municipal Gallery, I.W.M., Port of London Authority, R.A.F. Museum, Hendon. Elected by ballot following 1946 exhibition, minuted 1947. Member of Society of Aviation Artists. Exhibited: R.B.A., R.O.I. *Page 134.*

ELLIOTT, Aileen Mary (Mrs Beale) (1896–1966) **(1939) + (1940) * (1943) 1946**
Watercolour, etching. Born Southampton 19 December 1896. Studied at Regent St. Polytechnic, Central School of Arts and Crafts and studio of William T. Wood. Served with Red Cross in two World Wars. Exhibited: R.A., provinces and Paris Salon. *Page 32.*

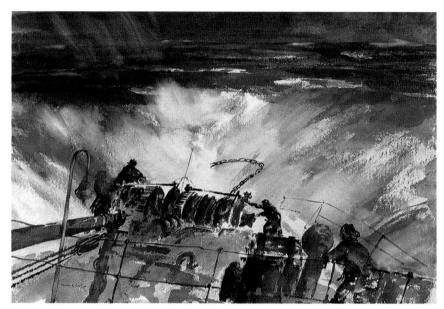

Francis Russell Flint. R.W.S., R.S.W., R.O.I., R.S.M.A. 'Drama on the fo'c'sle head'. Watercolour, 15in x 22in. R.S.M.A. Diploma collection, by kind permission Mrs Susan Russell Flint.

ELLIS Victor William (1921–84) **1969**
Lived at Leigh-on-Sea, worked mainly on East Anglian coast and Thames estuary, wide knowledge of East Coast smacks and sailing barges. Served in Royal Navy 1939–45, including Atlantic convoys, awarded D.S.M. Member of Wapping Group of Artists. *Page 33.*

✳ **EMANUEL Frank Lewis** (1865–1948) **(1939)** + * **(1946)**
Oil, watercolour, etching, lithography, landscape, interiors, architectural. Born in Bayswater, London, 15 September 1865. Slade School under Legros, Académie Julian in Paris under Bougerau and T. Robert Fleury. Instructor of Etching at L.C.C. Central School of Arts and Crafts, special artist for *Manchester*

Guardian. On first S.M.A. committee 1939, Member and President S.G.A. Work in Tate Gallery, British Museum, Victoria & Albert Museum, Durban, Ghent, Prague. Exhibited: R.A. and Paris Salon. Died 7 May 1948. .

EURICH Richard Ernst (1903–92) **Hon. Member 1975**
Oils, landscapes. Born at Bradford 14 March 1903, student at Bradford School of Arts & Crafts under H. Butler. Slade School under Henry Tonks. Taught at Camberwell School. Official war artist to Admiralty 1941–5. Works in Tate, I.W.M., Bradford A.G., Hull, Leeds and Aberdeen. Received O.B.E. in 1984. Exhibited: R.A., (elected 1953), N.E.A.C. (member 1943), one-man show at Goupil Gallery 1929. Died 6 June 1992. *Page 63.*

EVERETT John (1876–1949) **(1939)**
Attended first meeting in February 1939 but probably never a member.

FISHER Roger Roland Sutton (1919–1992) **C.B.E. D.S.C. 1983**
Oils. Born Dover, 3 August 1919. Captain in Royal Navy Supply and Secretariat branch. Barrister 1950. Deputy Circuit Judge. Member of Armed Forces Art Society, Wapping Group. Paintings in HMY *Britannia*, Norwegian Royal Yacht, Trinity House, RNLI, Naval Museum. *Page 64.*

FISHER Rowland (1887–69) * **1946**
Oil, landscape. Born Gorleston, 19 January 1887, son of a Master Mariner, lived much of his life at Great Yarmouth. President of Yarmouth District Society of Artists. Member of St. Ives Society of Artists, and R.O.I. Exhibited: R.A., R.O.I. Died 14 May 1969. *Page 34.*

FLINT Francis Murray Russell (1915–76) **1947**
Oil, watercolour, landscape. Born 3 June 1915, son of Sir William Russell Flint. Training ship *Conway*, apprenticed to Shaw Saville and Albion Line. Studied at Grosvenor School of Modern Art. R.A. Schools and in Paris. Lieutenant-Commander R.N.V.R. in Far East 1939–46, Official War Artist. Art master Lancing College. Work in Imperial War Museum. Member R.W.S., R.S.W. and R.O.I. Exhibited: R.A., R.S.A., R.W.A., R.W.E.A., provinces and abroad. *Above.*

FOLEY Sydney (1916 - 2001) **R.O.I., R.S.M.A. 1983**
Oil, watercolour. Hornsey School of Art but largely self-taught; in later years under Jack Merriott. Painting since his

middle forties; landscape, townscape, home and abroad; mainly coastal and river, especially Thames, Medway and East Anglia. Member R.O.I., Wapping Group (President 1992–), United Artists, London Sketch and Langham Sketching Clubs. Twenty years teaching in Adult Education. Royal Artillery 1939–46. *Pages 94 and 95.*

FOSTER Deryck (1924–) **1963**
Oil. Born Bournemouth, 1 March 1924. Southern School of Art, Bournemouth, and Central School of Art, Holborn. Extensive seafaring experience; work in National Maritime Museum and Russell Cotes Museum, Bournemouth. Lives and exhibits in Bermuda. Resigned R.S.M.A. *Page 35.*

FRYER Wilfred Moody (1891–1967) **1947**
Oil, watercolour, landscape. Born Marylebone, 4 April 1891. Bradford School of Art. Art work for Ministry of Supply, Ministry of Information and National Savings during 1939–45 war. Sometime Chairman of Langham Sketch Club and President of Wapping Group. Exhibited: R.A., R.I., R.B.A. and provinces. *Page 96.*

GARDNER Derek George Montague V.R.D. (1914–) **R.S.M.A. 1966**
Self-taught artist in oil, watercolour. Educated Oundle. Commander R.N.V.R. Seven one-man shows Polak Gallery, London. Hon. Vice-President R.S.M.A. for life 1988. Works in National Maritime Museums Greenwich, Bermuda, R.N. College Dartmouth. *Pages 36 and 37.*

GLANVILLE Roy (fl. 1950–66) **1954**
Marine artist and illustrator. Exhibited: R.B.A. and R.S.M.A. *Page 162.*

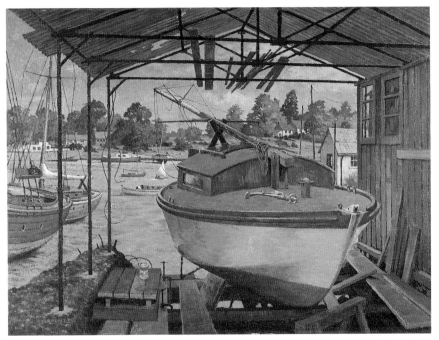

Roy Glanville, R.S.M.A. 'Awaiting high water'. Oil, 30in x 40in. R.S.M.A. Diploma collection.

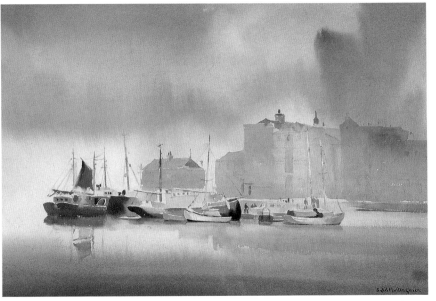

Sybil Mullen Glover, R.S.M.A., R.I., R.W.A. 'Sutton Pool, Plymouth'. Watercolour.

GLOVER Sybil Mullen (1908–95) **R.I., R.W.A., R.S.M.A. 1964**
Watercolour. Studied at St. Martin's School of Art and R.V. Pitchforth. Work in permanent collections: Plymouth Museum and Art Gallery, Brighton Art Gallery, National Maritime Museum, Walsall Art Gallery, Sweyne School, Royal West of England Academy, the Mansion House, Cardiff. Gold and Silver Medals, Paris Salon. Member R.I., R.W.A. Exhibited: R.A., R.O.I., R.S.A., N.E.A.C. Died 28 July 1995. *Above.*

GOOSEN Fritz (1943–) **R.S.M.A. 1990**
Born Hilversum, Netherlands, 13 December 1943. Encouraged in his youth by Steven Hip, a local artist. Professional artist since 1975 after working ten years as a manager in the Amsterdam docks where he sketched and studied the old fishing boats and the sailing community. One-man shows in Netherlands, Switzerland, United Kingdom, U.S.A., Germany. *Pages 38 and 97.*

GRAVE Charles (1886–1942/43) **(1939) + ***
Watercolour, black and white, sporting. Born Barrow-in-Furness, July 1886. On staff *Sporting Life, The Daily Chronicle* and *The Daily Graphic.*

GREIG Donald (1916–) **R.S.M.A. 1967**
Watercolour, oil and etchings. Son of Scottish artist James Greig. Training:

Southend College of Art. Gold Medal: Paris Salon 1966. Public and private collections in U.K. and abroad. Member Old St. Ives Society. Home and studio at Kingsbridge, South Devon. Exhibited: R.A., R.O.I., R.B.A., R.W.A., R.I., N.E.A.C. *Pages 98 and 99.*

✳ **GRIBBLE Bernard Finegan** (1873–1962) **(1939) + (1940) (1942) * 1946**
Oil, watercolour. Born South Kensington, 10 May 1873. Worked with his architect father, then South Kensington Art School. Marine Painter to Worshipful Company of Shipwrights; artist to *The Queen* and *Black & White* magazines. Member of first S.M.A. Committee. Works: Preston A.G., Bristol Museum

and A.G., Russell-Cotes, Bournemouth, Naval Academy, Annapolis, U.S.A. etc. Exhibited: R.A., R.I., R.H.A., provinces and Paris Salon. *Page 39.*

GROVES John Michael (1937–) **R.S.M.A. 1977**
Oil, pastel, pen and ink. Born Lewisham, 9 March 1937. Camberwell School of Arts and Crafts 1951–7; commercial artist and illustrator for sixteen years; began painting marine subjects 1970, full-time since 1977. Five large historical oil paintings for Shell in the 1980s. Works mainly to commission. *Pages 40 and 41.*

GUY Mrs Edna W. (1897–1969) **1953**
Watercolour. Born Sutton, Surrey, 10

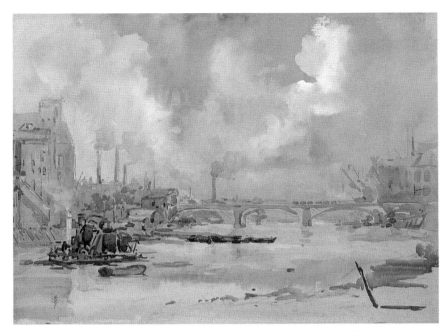

Edna Guy, R.S.M.A. 'Low tide, Battersea'. Watercolour, 11in x 15in. R.S.M.A. Diploma collection.

July 1897. Studied art in South Africa under J.H. Amshewitz, Académie Julian, Paris; Spenlove School of Art and Slade School. Exhibited: R.A., R.I., R.S.A., Paris Salon and Salon de la Marine (Paris). *Above.*

HAGEDORN Karl (1889–1969) **1960**
Oil, watercolour, landscape, portraits, figures, flower painting, textile designer. Born Berlin, 11 September 1889, studied Paris and Slade School. Member R.B.A. (1935), and R.I. Grand Prix of International Exhibition of Decorative Art, Paris 1925. Works in British Museum, Whitworth Institute (Manchester), Salford and Southport Art Galleries. Exhibited: R.A., R.B.A., N.E.A.C., Paris and Manchester.

HALES Gordon Hereward (1916 - 1997) **R.B.A., R.S.M.A. 1981**
Painter in oil and watercolour. Born Matlock, Derbyshire. Educated Northampton School of Art, Leicester College of Art. Member R.B.A., Wapping Group of Artists, London Muster of Artists (Founder), the Artists Society and Langham Sketching Club, Armed Forces Art Society. Favourite subjects: ships, the sea, the streets of London, men at work. Exhibitor: R.I., R.O.I., P.S. *Pages 100 and 101.*

HANCERI Dennis John (1928–) **R.S.M.A. 1970**
Watercolour, gouache. Graphic Designer. Born London, 6 June 1928; studied graphic design St. Martin's School of Art. Member of Wapping Group of Artists. Exhibited: solo shows Denver, Colorado, Centaur Gallery, Dallas, Texas and Mystic Seaport, Connecticut. *Pages 42 and 135.*

HARDIE Martin (1875–1952) **(1946) 1948**
Watercolour, etching. Born London, 15 December 1875. Studied etching under Sir Frank Short. Elected A.R.E., R.E., R.I., R.S.W., was Keeper of Department of Painting and Engraving, Illustration and Design at Victoria & Albert Museum. C.B.E. in 1935. Wrote *Watercolour Paintings in Britain* (3 Vols. 1966–8), the standard work on the subject. Exhibited: R.A., R.I. Died 20 January 1952.

HARNACK Frederick Bertrand (1897–1983) **(1946) 1950**
Oil, watercolour, woodcut. Born London, 22 July 1897. Leyton School of Art, studied under Arthur Briscoe (*q.v.*). Sometimes signed his work 'Fid Harnack' – his nickname from infancy. Sailed three-masted bark to Baltic in 1930. Joined R.N.V.R. and was a Gunnery Officer in Coastal Forces. Sailed a gaff-rigged sloop which he owned with his brother. Exhibited: R.A. and provinces. *Page 43.*

HARPHAM Jeff (1943–) **1990**
Born Nottinghamshire. Apprenticed to photo-lithographic artist and now divides his time between painting and family business. Subjects: mainly landscape and marine subjects in pastel, watercolour, oil and mixed media. Member: Nottingham Society of Artists. Pears Award winner R.S.M.A. 1989–90. Exhibits: Mall Galleries, London, and several local galleries. Resigned R.S.M.A. 1994.

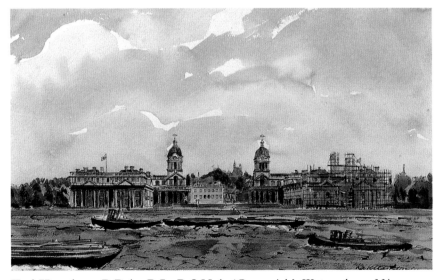

Karl Hagedorn, R.B.A., R.I., R.S.M.A. 'Greenwich'. Watercolour, 11in x 18in. R.S.M.A. Diploma collection, by courtesy of The Hagedorn Trust and Chris Beetles Ltd.

HEINE Harry (1928 - 2004)
R.S.M.A., 1980
Watercolour. First Canadian member of the R.S.M.A. Honorary Alberta Artist (1983). Honorary Citizen of Victoria (1985). Works in public collections including Government of British Columbia and Washington State Arts Commission, etc. Exhibited annually with R.S.M.A. Mystic Seaport Museum and regular gallery exhibitions. *Pages 44 and 136.*

HICK Allanson (1898–1975) **(1939) + (1940) * (1943) 1946**
Oil, watercolour. Born Hull, 19 June 1898. Architect, F.R.I.B.A. Member of Art Workers Guild (1958); S.G.A. Work in Ferens Art Gallery and Town Docks Museum, Hull, the latter mainly drawings of vessels within the Humber defences during 1939–45 war. Exhibited: R.A., R.B.A., R.S.A., Paris Salon. *Page 65.*

HILDER Rowland (1905–93) **(1940) * 1946**
Oil, watercolour, landscape, book illustrator. Born Greatneck, Long Island, 28 June 1905. Studied at Goldsmith's College School of Art where he became Illustration Master. Lieutenant in Army Camouflage. Work in National Gallery, Australia and Manchester Art Gallery, also many private collections, including H.M. The Queen and Prince Philip. Member of Wapping Group. Exhibited: R.A., N.E.A.C., elected R.I. (1938), President 1964. *Page 102.*

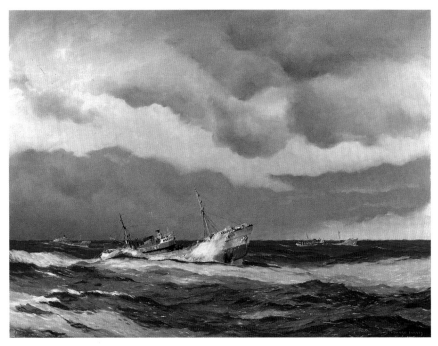

Howard Jarvis, S.M.A. 'Deep sea trawlers approaching the Arctic fishing grounds/ stout hearts and stout ships'. Oil, 30in x 40in. R.S.M.A. Diploma collection.

HILL Phillip Maurice (1892–1952) **(1939) + (1940) (1942) * (1943) 1946**
Oil. Born in Yorkshire, 18 June 1892. Central School of Art and Design, Architectural Association, London and St. Ives. Abandoned architectural training, admitted a solicitor 1922. Became General Manager of UK Chamber of Shipping. Exhibited: R.A., R.B.A., R.O.I., N.E.A.C., Paris Salon, Goupil Gallery, United Artists, St. Ives Society of Artists. Died 5 August 1952 at St. Ives.

HOWARD Norman Douglas (1899–1955) **+ (1940) 1946**
Architect, illustrator. Born Nottingham, 12 April 1899. Camberwell School of Art, Westminster School of Art. Work produced in *The Illustrated London News*, *Life* and *Studio*. Exhibited: R.A., R.O.I., I.S., W.A.G., Goupil Gallery. President of Richmond Art Group. Died 9 March 1955. *Page 66.*

HUNT Geoffrey William (1948 -)
R.S.M.A., 1989
Oil, watercolour, gouache. Studied Graphic Design, Kingston and Epsom Schools of Art. Two years in advertising. Freelance book designer for Conway Maritime Press; Art Editor of *Warship* journal 1977 - 9. Cruised yacht *Kipper* to Mediterranean and back 1979 - 80. R.S.M.A. President (2003 -). Twelve paintings in R.N. Museum, Portsmouth. Many book cover illustrations. Exhibits: London, U.S.A. *Pages 45 and 67*

HUNTLY Moira (1932 -) **R.S.M.A., 1985 R.I., P.P.S., R.W.A.**
Born Motherwell, Scotland. Studied Harrow School of Art, Hornsey College of Art. Memberships: President, The Pastel Society, Royal Institute of Painters in Watercolours, Royal West of England Academy. First Prize Laing National Painting competition 1986 and many other prestigious Awards. Exhibits widely in U.K., Europe and North America. Author of many books on drawing and painting. Governor, Federation of British Artists. *Pages 103 and 104*

IRVING Lawrence Henry Foster (1897–?) **(1940)**
Oil, landscapes. Born St. Pancras, London, 11 April 1897. Royal Academy and Byam Shaw Schools. Member of Art Workers Guild. Art Director and Designer for stage and film productions. Author, illustrator. R.N.A.S. and R.A.F. 1914–49; staff of R.A.F. 1940, 2nd Tactical Air Force 1943–4; awarded Croix de Guerre, O.B.E. Director of Time Publishing Company. Resigned 1948–9. Exhibited: R.A., Fine Art Society.

JANES Norman Thomas (1892–1980) **1946**
Watercolour, etching, wood engraving, landscapes, town scenes, portraits. Born Egham, Surrey, 19 May 1892. Slade School, Central School, R.C.A. Member R.E., R.W. Works in British Museum, Victoria & Albert Museum, Whitworth (Manchester), Brighton, Bradford, New York Public Library. Exhibited: N.E.A.C., R.A., I.S., Grosvenor Gallery, Goupil Gallery, France, Italy, Sweden and U.S.A. *Page 105.*

JARVIS William Howard (1903–1964) **(1946) 1947**
Born Liverpool, 6 February 1903. Studied at Liverpool and Naples. Trained on H.M.S. *Conway* 1918–20. Served as Lieutenant R.N.V.R. 1939–46. Designed canopy for Her Majesty's state

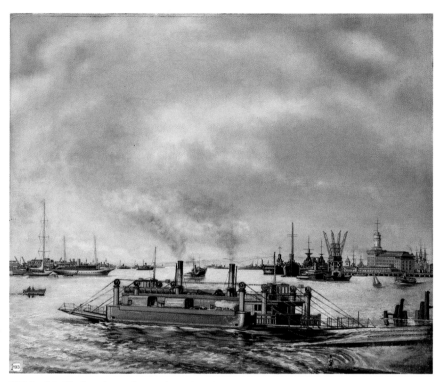

Wilfred Jefferies, R.W.A., R.S.M.A. 'Floating Bridge'. Oil, 20in x 24in. R.S.M.A. Diploma collection.

barge (1953). Works in Walker Art Gallery, Liverpool, Great Yarmouth Municipal Gallery. Large mural for Canadian Shipbuilding Co., Montreal. Elected at 1947 General Meeting. Exhibited: R.A., R.O.I. *Page 164.*

JEFFERIES Wilfred Avalon (1907–70) 1964
Oil, tempera, watercolour, etching. Born St. Georges, Bristol, 1907. Bristol Municipal School of Art, Académie Julian (Paris), Geneva Academy, British Academy, Rome. Theatre decor. Head of Drawing and Painting, Portsmouth; Winchester and Basingstoke Schools of

Art. Member R.W.A. and S.G.A. Exhibited: R.A., R.I., R.B.A. and provinces, Paris, Rome, Boston (U.S.A.). *Above.*

JOBSON Patrick (Pat) Arthur (1919–) (1939) (1942) * 1946
Oil, watercolour, tempera, pastel. Born Ilford, 5 September 1919. Fourth generation of artists; trained under his father F.M. Jobson and North Tottenham Polytechnic under A.E. Hayes and Frank Brangwyn. Royal Navy 1940–6. Founder member and past-President of Wapping Group of Artists (1977-82). Past-President of Artists' Society and Langham Sketching Club. Elected

S.G.A. (1949). Has illustrated some sixteen sea books. Exhibited: R.I., R.B.A., P.S. Resigned R.S.M.A. *Page 46.*

JOHNSTON Robert (1906–84) 1951
Oil, watercolour, landscape. Lived at Birmingham and later near Banbury, Oxfordshire. Member of R.O.I. (1964) and R.I. Exhibited: R.A., N.E.A.C., Paris Salon.

JOICEY Richard Raylton (1925–94) 1980
Oil, watercolour. Born London, 5 October 1925. Studied at Sir John Cass College of Art. Served Royal Navy 1943–64; awarded George Medal for rescue of five victims aboard a ship under construction. Exhibited R.I., well known for his beach and low tide subjects. *Below.*

KENT Leslie Harcourt (1890–1980) (1939) + * 1946
Oil. Born near Finchley, 15 June 1890. Executive and Director of George Kent (Engineering) until 1945. Resided at Radlett, Hertfordshire, until his death. Studied art under Fred Milner at St. Ives. Elected R.B.A. (1940) Exhibited: R.A., R.B.A., R.O.I., R.S.A., N.E.A.C. and provinces. Paris Salon. *Page 166.*

✳ KING Cecil George Charles (1881–1942) (1939) +
Oil, watercolour, landscape. Born 6 August 1881. Studied engineering. Goldsmiths' College and Westminster Art School also Paris under Laurens and Steinlen. Regular contributor to *The Illustrated London News.* Official Naval Artist in the Baltic during 1914–18 war. Member of first S.M.A. Committee

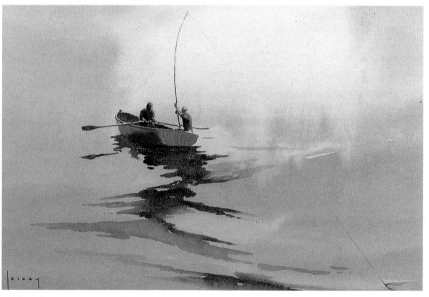

Richard Joicey, R.S.M.A. 'The Tight Line'. Watercolour, 14in x 22in. Collection: Roger Desoutter. By kind permission of Miss D. Joicey.

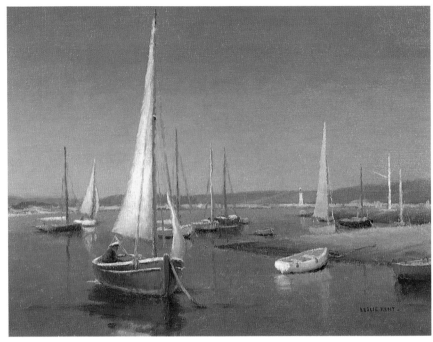

Leslie Kent, R.S.M.A., R.B.A. 'At Keyhaven, Hampshire'. Oil, 18in x 24in. R.S.M.A. Diploma collection, by kind permission of Barrie H. Kent and David H. Kent.

Wharton Lang, R.S.M.A., F.R.S.A. 'The Leaping Salmon'. Mahogany, 18in high. Collection: Frank Preston Esq.

(1939). Elected R.B.A., R.I. and R.O.I. Painter to Royal Thames Yacht Club from 1932. Exhibited: R.A. and provinces; Paris Salon, Venice. Died 9 December 1942.

KING Robert (1936–) **R.S.M.A., 1985 R.I.**
Born Leicester. Studied Leicester College of Art. Paints in oil, watercolour, gouache, pastel. Lives with wife Chrissie in coastguard cottage overlooking Solent. Member of R.I. First solo exhibition 1970 followed by success at Royal Academy. Also exhibited: U.S.A., Canada., Jersey. Now exhibits with Burlington Paintings. *Pages 106 and 107.*

LANG Wharton (1925–) **R.S.M.A., 1968 S.W.L.A., F.R.S.A.**
Sculptor in wood. Born Oberammergau, Bavaria. Studied under his father and Leonard Fuller School of Painting. Has lived at St. Ives since 1949, member of Society of Wildlife Artists, St. Ives Society of Artists. Work in various churches, Russell Cotes, Bournemouth, and Ulster Museum, Belfast. Work presented (1967) to H.M. Queen Mother ('Castle of Mey' carved in relief). Resigned R.S.M.A. 1995; elected Honorary member at A.G.M. 1995. *Above right.*

LANGMAID Rowland John Robb (1897–1956) **(1940)**
Watercolour, etching, drypoint. Born Van-

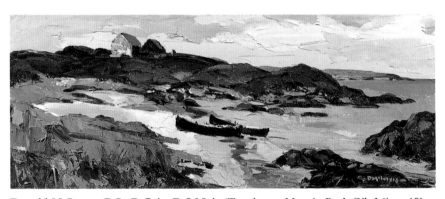

Donald McIntyre, R.I., R.C.A., R.S.M.A. 'Two boats, Mannin Bay'. Oil, 16in x 40in.

couver Island, 1 December 1897. Studied under W.L. Wyllie. Served in Royal Navy and specialised in naval subjects. Exhibited: R.A., resigned S.M.A. 1948–9. Died 11 February 1956. *Page 68.*

LEECH Raymond (1949–) **R.S.M.A. 1986**
Oil, watercolour, pastel and sculpture, depicting the endless facets of figurative life in and around the seaside. Born

Anita Mandl, A.R.W.A., A.R.B.S., R.S.M.A. 'Sealion and Cub'. Acacia, 12in

Great Yarmouth; studied Art and Design at Great Yarmouth College of Art. Co-founder of Pencil Point Design Consultancy. Work in private collections U.K., South Africa, U.S.A., Hong Kong, Jersey, Spain and Oman. Exhibited: R.O.I. and provinces; Jersey; U.SA. *Pages 108 and 109.*

LE JEUNE James George (1910–83) **1950**
Oil, watercolour, portraits, landscape, architecture. Born Saskatoon, Canada, 24 May 1910. Students Art League, New York, Heatherley's and Byam Shaw School. Work in National Gallery, Dublin and Cardiff. Exhibited: R.B.A., R.P., N.E.A.C., S.G.A., U.A.

McINTYRE Donald (1923–) **1961**
Oil, watercolour, landscape. Born York-shire. Studied under James Wright R.S.W. Member of R.I. and Royal Cambrian Academy. Work in Birkenhead A.G., Newport (Monmouthshire) A.G. and Merthyr Tydfil Gallery. Resigned R.S.M.A. (1976). Exhibited: leading London galleries. *Page 166.*

MANDL Anita (1926–) **1971**
Sculptor in soft stone, marbles and ornamental hardwoods. Born Prague, 17 May 1926. Part-time sculptor, studied at Birmingham College of Art. Reader in Reproductive Physiology at Birmingham University Medical School until 1965. Elected A.R.W.A. (1970), A.R.B.S. (1972), Member of Devon Guild of Craftsmen (1968). Specialises in simple animal forms. Resigned R.S.M.A. (1993). Exhibited: R.A., R.B.A., R.S.A., R.W.A.,

R.G.I.F.A., R.U.A., Leicester Gallery, London. *Left.*

MASON Frank Henry (1876–1965) + **1961**
Oil, watercolour, etching, illustrator, including poster design. Born Seaton Carew, Co. Durham. Educated H.M.S. *Conway*, shipbuilding and engineering. Served as Lieutenant R.N.V.R. in North Sea and Mediterranean. Elected R.I. (1929) and R.B.A. Widely repre-sented in public collections. Attended S.M.A. April 1939 meeting, elected 1961. Exhibited: R.A., R.H.A., R.I. *Page 69.*

MAYGER Chris Henry (1918–93) **1976**
Oil, gouache and pencil. Born 20 April 1918. Camberwell School of Art under Eric Fraser and Cosmo Clark. Large number of his paintings used in book cover designs by established authors. Paintings in private collections in U.K., U.S.A. and Canada. Exhibited: R.S.M.A. at Guildhall A.G. and Earls Court, Greenwich Village Workshop, U.S.A. *Page 70.*

MERRIOTT Jack (1901–68) **1954**
Oil, watercolour, landscape, portraits. Born 15 November 1901. Croydon

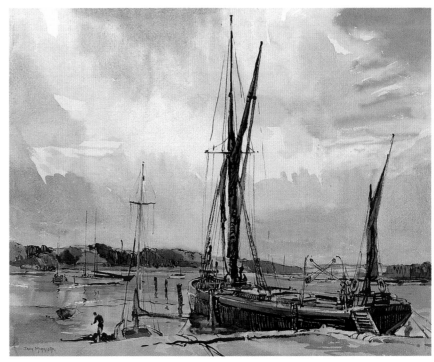

Jack Merriott, R.I., P.S., R.O.I., R.S.M.A. 'Sailing barge *Pretoria* at Wood-bridge'. Watercolour, 20in x 25in. R.S.M.A. Diploma collection, by kind permission Mrs Hilda Merriott.

School of Art. St. Martin's School of Art. Elected R.I. (1944), P.S. (1951), R.O.I. (1959). President of Wapping Group of Artists and Member of Langham Sketching Club and Croydon Art Society. Exhibited: R.A., R.B.A., R.I., R.W.A. and provinces. *Page 167.*

MITCHELL Brian (1937–) **R.S.M.A. 1990**
Born St. Ives, Cornwall. Married with one son. Grew up during St. Ives modernist heyday, studied at Art School in early 1960s, nevertheless became a figurative painter. Received Pears Award of R.S.M.A. Chairman of St. Ives Society of Artists. Paints in oil and watercolour; current work mainly acrylic. Exhibited:

Brian Mitchell, R.S.M.A. 'Wheelhouse'. Acrylic watercolour, 18in x 22½in. The *Seabien* of Newlyn, now much altered. Collection: Artist's studio.

R.W.E.A., R.W.S., R.I., R.B.A. *Page 137 and below.*

✳ **MUNCASTER Claude Grahame** (1903–74) **(1939) + 1946**
Oil, watercolour, landscapes, town scenes. Born W. Chillington, Sussex, 4 July 1903. Son of Oliver Hall R.A., adopted his new name in 1922 to avoid confusion with his father. Lieutenant-Commander, R.N.V.R. Adviser to Admiralty on camouflage of ships at sea. Elected A.R.W.S. (1931), R.W.S. (1936), R.B.A. (1940), R.O.I. (1948), Member of first (1939) S.M.A. committee. President 1958–74. Commissioned (1947) by King and Queen to paint series of works for Windsor, Sandringham and Balmoral. Exhibited: R.A. *Pages 47 and 71.*

MYERS Mark Richard (1945 -) **P.R.S.M.A., 1975 F/A.S.M.A.**
Oil, watercolour, acrylic, ink; illustrator. Born San Mateo, California 19 November 1945; self-taught artist. Wide working experience under sail. Settled in England 1971. Paintings in several U.S. and U.K. museums. Hon. Secretary R.S.M.A. (1978 - 88); Vice-President (1988 - 93); President (1993 - 1998). Founder Member: American Society of Marine Artists (1978); Fellow of A.S.M.A. (1979). Exhibited: widely in U.S.A., public and private galleries. *Pages 48 and 49*

NAYLOR Robert (1925–) **1989**
Painter in waterolour, pastel. Estuary, port and coastal subjects of eastern England and Devon. Retired to France. Resigned R.S.M.A. 1995. *Page 110.*

NORMAN Michael Radford (1933–) **R.S.M.A. 1975**
Watercolour, pen and ink on coloured papers. Born Ipswich. Regent Street Polytechnic and Bournemouth School of Art. Has spent most of his life near and on the River Orwell, where he has raced a variety of dinghies and yachts for 40 years. Award of Excellence, Mystic Maritime, U.S.A. 1988. Exhibited at R.I. and solo shows throughout East Anglia. *Pages 111 and 138.*

NORTON Charles Frank (1916–)
Born Gisborne, New Zealand, 25 April 1916, resident in Australia 1919–39. Studied at East Sydney Technical College. Appointed Official War Artist with Royal Australian Navy 1941–5; Middle East, Indian waters, S.W. Pacific and Philippines, including short periods with

R.A.A.F. Post-war teacher on staff of East Sydney Technical College. Work in the Australian National War Memorial, Canberra. Did not exhibit in 1946.

OLSSON Julius (1864–1942) **(1939) + ***
Oil, landscape. Born London, 1 February 1864. Lived in St. Ives, Cornwall for several years. Lieutenant R.N.V.R. Elected N.E.A.C. (1891), A.R.A. (1914), President R.O.I. (1919), R.A. (1920). Work in the Tate Gallery, Liverpool and Birmingham. Exhibited: R.A. Died Dalkey, Ireland, 7 September 1942.

PARKYN William Samuel (1875–1949) **(1940) (1942) * (1943) 1946**
Watercolour, pastel, landscape. Born Blackheath, London, 14 July 1875. Studied at Blackheath School, and under Louis Grier at St. Ives. Elected A.R.C.A., A.R.W.A. and P.S. Exhibited: R.A., R.I., R.H.A. .

PASCAL Leopold (1900–1958) **1953**
Landscapes. Born Morlaix, Brittany, 8 July 1900. Talents developed at young age but career interrupted by war. Appointed war correspondent and official artist to General de Gaulle, and the Free French. Continued landscape painting, seascapes, portraits. Remained in London after hostilities ceased. Exhibited: R.B.A., R.O.I., N.E.A.C. and in his native France. Died 28 December 1958. *Page 169.*

✳ **PEARS Charles** (1873–1958) *THE FOUNDER* **(1939) (1940) (1942) * (1943) 1946**
Oil, illustrator. Born Pontefract, W. Yorks, 9 September 1873. Illustrations for *Punch, The Illustrated London News,*

The Graphic. Elected R.O.I. (1913). Official War Artist 1914–18, also deviser of naval camouflage and propaganda lithographer. War artist again 1940–5. Designed posters. Works in Imperial War Museum. Keen single-handed sailor, wrote and illustrated several books on the subject, e.g., *From the Thames to the Seine* (1910) and *South Coast Cruising* (1931). Exhibited: R.A., N.E.A.C., Paris Salon. Died Truro, 28 January 1958. *Pages 2 and 72.*

PEMBERTON–LONGMAN Joanne (1918–73) 1954
Oil and tempera. Born 12 January 1918. Byam Shaw School under F.E.

Jackson. Exhibited: R.A., R.S.A., R.H.A., G.I., N.E.A.C., R.O.I., Goupil Gallery, R. Cam. A, Paris Salon. Member of Society of Wildlife Artists, Society of Painters in Tempera, St. Ives Society of Artists and United Society of Artists. *Right.*

PITCHER Neville Sotheby (fl. 1907–59) **(1940) (1942) * (1943) 1946**
Born London, 16 October 1892. School of Art under Frank Brangwyn and John M. Swan. Merchant Navy 1906–10; Naval Control Service 1939–45. Lived in London and latterly at Rye, Sussex. Exhibited: R.A., R.W.A.

Joanne Pemberton Longman, S.W.A., R.S.M.A. 'The namesakes – *Mauretania*'. Watercolour. R.S.M.A. Diploma collection.

Leopold Pascal, S.M.A. 'Plage en Normandie'. Oil, 20in x 24in. R.S.M.A. Diploma collection, by kind permission of Lucette de la Fougère.

PLATT John Edgar (1886–1967) + **(1940) * 1946**
Oil, woodcut, etching. Born Leek, Staffordshire, 10 March 1886. Formerly Principal of Leicester College. President Society of Graver Printers in Colour. Official War Artist 1939–45 war. Present at S.M.A. April 1939 meeting and resumed involvement 1946. Resigned 1954. Exhibited: R.A., N.E.A.C., I.S. Work in Victoria & Albert Museum, British Museum, Imperial War Museum, and Metropolitan Museum, N.Y. *Page 73.*

PULLIN Edgar (fl. 1946–60) **1943, 1946**

Oil, watercolour. Showed three works at 1946 S.M.A. exhibition. Elected 1943 by council alone, a postal vote being difficult to organise in wartime conditions. Exhibited: R.B.A. and leading London galleries.

RAFFAN George (1913–50) **(1939) + (1940) * (1943) 1946**
Oil, harbour and coastal scenes. Born 18 May 1913 of Australian parents. Westminster School of Art and Yellow Door Studio. Lieutenant R.N.V.R. during 1939–45 war. Member of U.A., Steward of A.G.B.I. Exhibited: R.A., R.O.I., R.B.A., N.E.A.C. and Paris Salon.

REID Nina Margaret (Winder) (1891–?) (1939) (1940) (1942) * (1943) 1946
Oil, landscapes. Born at Hove 26 May 1891. St. John's Wood Art School. Exhibited: R.C.A., R.H.A., R.O.I., S.W.A., provinces and Paris Salon. *Page 10.*

RIDGE Hugh Edward (1899–1976) 1952
Oil, watercolour. Born 20 July 1899. Barnstaple Grammar and Art Schools. Familiar with West Country scene from childhood, later settled in St. Ives, and was Committee Member and late Chairman of St. Ives Society of Artists. Noteworthy painter of Isles of Scilly.

Exhibited: R.C.A., R.H.A., R.S.A., R.W.A., R.O.I. and Paris Salon. *Page 12.*

ROBERTSON Sheila MacLeod (1927–) R.S.M.A., 1969 S.W.A.
Oil, watercolour; coastal scenes, landscape. Born London. Watford Art School and Central School of Arts and Crafts. Specialises in Scottish and Cornish subjects. Moved to Edinburgh in 1995. Work reproduced by Medici Society; Solomon & Whitehead. Member of St. Ives Society of Artists; Society of Women Artists. Exhibited: R.O.I., R.I., U.A., provinces and abroad. Solo exhibitions in London and Scotland. *Pages 112 and 113.*

ROBINSON Sonia (1927–) R.S.M.A., 1979 S.W.A.
Oil, watercolour and gouache. Landscape and harbour scenes. Born Manchester, 24 May 1927. Manchester and Hornsey School of Art. Settled in Cornwall 1965. Solo shows Guernsey and St. Ives. Exhibits regularly in London and Cornwall. Work exhibited in U.S.A., Canada, France and Australia. Member of the Society of Women Artists, and the St. Ives and Newlyn Societies of Artists. *Pages 114 and 115.*

RODMELL Harry Hudson (1896–1984) (1939) (1940) * 1946
Oil, watercolour, acrylic, inks, landscapes. Born Hull, 28 May 1896. Notable poster designer for shipping companies between the wars. Works widely reproduced, e.g., *Sphere*, *The Graphic* and *The Illustrated London News*. Retrospective 1984 at Town Docks Museum, Hull, which houses a large collection of his graphic work. Designed the R.S.M.A. emblem. Exhibited: R.A., R.B.A., R.I., S.G.A., provinces and abroad; elected R.I. (1957). Died 3 March 1984. *Page 139.*

ROGERS Stanley R.H. (1887–1961) 1943, 1946
Oil, watercolour. Born Nottingham, 7 May 1887. Goldsmiths' College School of Art, and Antwerp Académie des Beaux Arts. War propaganda posters for American government and submarine service in 1914–18 war. Naval camouflage officer, 1941–5. Elected by council alone, it being difficult to organise a postal vote under wartime conditions. Exhibited: R.I. and provinces, work reproduced in *Tatler*, *The Illustrated London News* and illustrated many books on ships and travel, e.g., *Ships and Sailors* (1928) and *The Sailing Ship, a Study in Beauty* (1950).

RUSSELL Gyrth (1892–1970) 1947
Oil, etching, landscape, illustration. Born Dartmouth, Nova Scotia, 30 April 1892. Boston, Académie Julian, and Atelier Colarossi in Paris. Official war artist with Canadian Army 1914–18 war. Royal Naval Patrol Service 1939–45 war. Works in Imperial War Museum, National Gallery of Canada and Nova Scotia Museum. Member of R.O.I. and Langham Sketching Club. Exhibited: R.I., R.O.I., R.B.A., S.M.A., G.I., R.B.C., provinces and abroad. Died 8 December 1970. *Page 140.*

SHACKLETON Keith (1923–) P.P.R.S.M.A., 1962 S.W.L.A., G.Av.A.
Painter in oil, writer and naturalist. No art schooling. RAF 1941–6, camouflage design and painted war scenes for army and navy. TV Presenter B.B.C. Natural History and *Survival*, Anglia; travelled widely in polar regions. Small-boat sailor, British International 14ft team. Founder member of S.W.L.A. and Society of Aviation Artists (Past-President); Past-President of R.S.M.A. and S.W.L.A. Chairman, Artists' League of Great Britain. Exhibited R.A., R.B.A., S.W.L.A. and galleries in U.S.A., Canada and Africa. *Pages 15 and 141.*

SHERWIN Frank (1896–1986) 1966
Oil, watercolour, landscape, illustrator. Born Derby, 19 May 1896. Derby School of Art and Heatherley's. Numerous posters for British Railway companies. Resided at Cookham. War service 1914–18 war; later painted stage scenery in Genoa. Work in Derby Museum and National Maritime Museum. Exhibited: R.A., R.I., R.B.A., elected R.I. (1950), and B.W.S. Died 1 July 1986. *Left.*

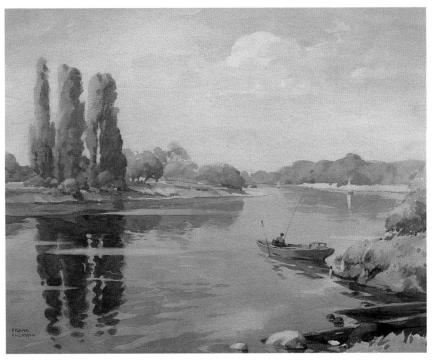

Frank Sherwin, R.I., R.S.M.A. 'The Thames at Kew'. Watercolour, 12in x 16in. Collection of Terence Storey. Reproduced by kind permission of Jinny Melville.

SIMPSON Alan (1941 -) **R.S.M.A. 1979**

Oil, watercolour, pastel, acrylic, marine and landscape. Born Basingstoke, 1941. Attended Bournemouth College of Art. Exhibited R.O.I., R.I., Mystic Seaport (U.S.A.) and Vancouver. Commissions include Bournemouth University, Poole Harbour Commissioners, Abbey National, Yorkshire Building Society, D.E.C. digital, Provident Mutual, and Barclays Bank. Also tutor organising art holidays in U.K., France, Gibraltar and Kashmir. Hon.Treasurer R.S.M.A. 1998 - 2003. *Pages 116 and 117*

SIMPSON Charles Walter (1885–1971) **1945 1946**

Oil, watercolour, tempera, landscapes. Born Camberley, Surrey, 8 May 1885. Académie Julian, Paris. Principal of St. Ives School of Painting. Author and illustrator, birds, animals and hunting scenes, as well as marines and landscapes. Work in many provincial galleries. Exhibited: R.A., G.I., Paris Salon. Resigned 1948/9. *Page 13.*

✳ **SMART R. Borlase** (1881–1947) **(1939) + (1940) (1942) 1946**

Oil, watercolour, etching, landscapes, poster designs. Born Kingsbridge, Devon, 11 February 1881. Plymouth College of Art and seascapes under Julius Olsson (*q.v.*). Works in I.W.M., Bombay, Auckland (N.Z.), and various provincial galleries. President of St. Ives Society of Artists. Member of first S.M.A. Committee (1939) and Hon. Treasurer S.M.A. Author of *The Technique of Seascape Painting* (1934). The Borlase Smart Memorial Trust bought Porthmeor Studios for artists to rent. Exhibited: R.A., R.S.A., R.Cam.A., R.H.A., U.S.A., France. Died 3 November 1947. *Page 8.*

SMITH Hely Augustus Morton (1862–1941) **(1939) + ***

Oil, watercolour, portraits, flowers. Born Wambrook, Dorset, 13 January 1862. Lincoln School of Art, Antwerp Academy. Elected R.B.A. (1901), R.B.C. (1927). Hon. Treasurer of R.B.A. and Langham Sketching Club. Showed at United Artists Exhibition (1940) as Member of R.B.A. Posthumous inclusion at Salford 1942 credits him as S.M.A. Exhibited R.A., R.H.A., R.I., R.S.A, G.I. Died 21 January 1941. *Page 50.*

STOBART John (1929–) **1956**

Oil, landscape. Born Leicester, 29 December 1929. Derby College of Art, R.A. Schools. Art Teacher in Bakewell. Initially specialised in deep-water sailing ships and ocean liners commissioned by leading shipping companies. Has lived in the U.S.A. since 1960s, where he has established himself as the leading marine painter. Owns a chain of galleries, and his company *Maritime Heritage* specialises in historical harbour scenes. Exhibited R.A., Derby, Tooth's Gallery, and Kennedy Gallery, New York. Resigned R.S.M.A. *Page 51.*

STOREY Terence (1923–) **P.P.R.S.M.A., 1972 F.R.S.A.**

Attended Sunderland Art School, Derby Art College. Chief of Art Department Rolls-Royce until 1972. Work in collection of H.R.H. Prince of Wales, Royal Burnham Yacht Club, Sultanate of Oman. Commissions: P.L.A. to record Silver Jubilee River Festival; Forth Ports to record 1995 Tall Ships gathering, and private collections worldwide. President R.S.M.A. 1988–93. Exhibited R.O.I., N.E.A.C., R.B.A., S.W.I.A., *Pages 142 and 143.*

STRAIN Euphans Hilary (Mrs Harold Wyllie) (1884–1960) **(1946) 1948**

Oil, watercolour, portraits. Born Alloway, Ayrshire. Glasgow School of Art and pupil of W.L. Wyllie. Owned and raced Z-class boat; keen supporter of training ships for young people. Exhibited: R.A., R.S.A., G.I., provinces and Paris Salon. Died 2 June 1960.

STURGEON Josiah (1919 - 1998) **R.I., R.S.M.A., F.R.I.B.A. 1970**

Oil, watercolour. Born London, 1919; brought up amidst busy Thames and east-coast shipping activities; self-taught artist until architectural training. War service 1939–46 Royal Engineers. Major role in design of Westminster Abbey annexe and decorations for Coronation 1953. Langham Sketch Club, Wapping Group of Artists (1956), Past-President. Royal Institute of Painters in Watercolours (1961). Fellow Royal Institute of British Architects 1970. *Pages 118 and 119.*

SYRETT Dennis (1932 -) **R.S.M.A., P.R.O.I. 1995**

Started painting 1966 with no formal training; taught in adult education for many years; widely travelled. Member of Wapping Group of Artists, U.A., Elected A.R.O.I. (1994). Exhibited

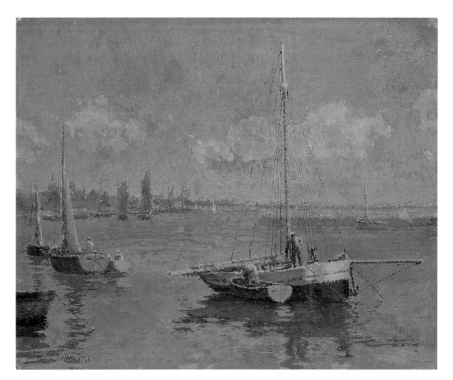

Sir Herbert Tripp, S.M.A. 'Smacks at Maldon, Essex'. Oil, 16in x 20in. Copyright J. Salmon Ltd., Sevenoaks, England ©.

R.A., Paris Salon (Gold Medal), R.B.A., R.O.I., R.P.S., P.S. *Pages 120 and 121.*

THORP William Eric (1901–93) **1958**

Oil, pastel. Born London, 27 December 1901. City of London School, studied under Herbert Dickson and Henry Schroder. Founder member and President of Wapping Group of Artists; at age 17 youngest member ever elected to Artists' Society and Langham Sketching Club. Commissioned by many shipping companies. Work in Guildhall Art Gallery and National Maritime Museum. Exhibited: R.A., P.S. and Paris Salon. *Page 52.*

TRACY Charles Dunlop OBE (1870–*c*.1947) **(1940) (1942) * (1943) 1946**

Oil, landscapes. Born Chichester, Sussex, 28 May 1870. Slade School and under W.L. Wyllie 1902–3. Works in Ipswich Art Gallery and Brooklyn U.S.A. Lived in Sussex and Ipswich. Exhibited: R.A., provinces and Metropolitan Art Gallery, New York.

TRIPP Sir Herbert Alker (1883–1954) **+ (1940) (1942) * (1943) 1946**

Oil, tempera. Born London, 23 August 1883. Long and successful career at New Scotland Yard, retiring as Assistant Commissioner. Keen yachtsman, cruising and racing. Author and illustrator, designed many railway posters. Exhibited: R.A., R.O.I., R.I., I.S. and provinces. Died 12 December 1954. *Page 171.*

TYSON Kathleen (Mrs Mawer) (1898–1983) **(1940) * (1943) 1946**

Oil, landscapes. Born Grimsby, 6 May 1898. Grimsby and Hull Schools of Art, Westminster School of Art. Works in Southampton, Hull and Lincoln. Exhibited: R.A., R.B.A., N.E.A.C., L.G., provinces and abroad. *Below left.*

VAN OSS Thomas Willem (1901–42/43)

Landscape, portrait. Born in Walberswick, Suffolk, 14 March 1901. Holland National Academy of Design (N.Y.), Paris. Sent his apologies for not being able to attend the first meeting in February 1939. Exhibited in London and abroad. Killed on active service.

VERITY Colin (1924–) **R.S.M.A., 1975 R.I.B.A.**

Oil and watercolour. Retired as Principal Architect to the Humberside County Council in 1984. Self-taught and a skilled model-maker. Demonstrates

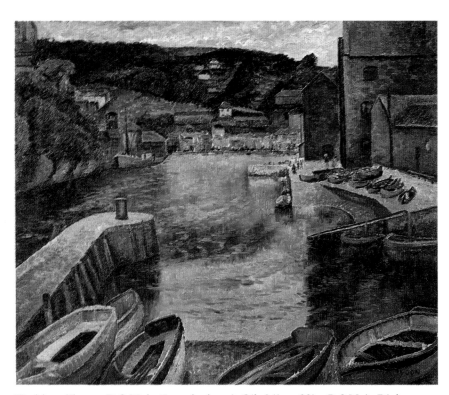

Kathleen Tyson, R.S.M.A. 'Looe harbour'. Oil, 24in x 30in. R.S.M.A. Diploma collection.

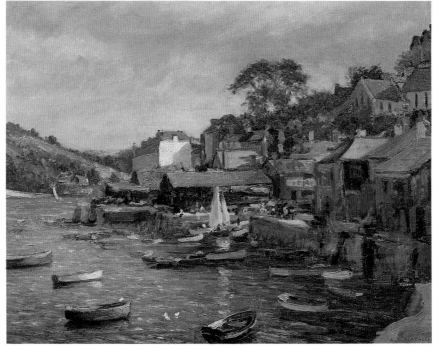

Leslie Watson. R.S.M.A. 'Salcombe'. Oil, approx. 18in x 24in. By kind permission of Mrs Helen Watson.

painting techniques thoughout the country. Member: Fylingdales Group of Artists; Yorkshire Watercolour Society; President of Hornsea Art Society. Paintings in private and corporate collections in seventeen countries. Exhibits widely in the U.K. and U.S.A. *Pages 144 and 145.*

VINALL Joseph William Topham (1873–1953) + (1940) (1942) (1943) * 1946
Oil, etching, landscape, figure and architectural. Born Liverpool 11 June 1873. R.C.A., City and Guilds of London Institute. Teacher, writer, lecturer and examiner. Exhibited: R.A., R.I., R.O.I., I.S., R.P., N.P.S., L.P.S., provinces and U.S.A. Died March 1953.

WALES (WALES–SMITH) Arthur Douglas (1888–1966) (1942) * 1946
Oil, watercolour, pastel, portraits, flowers, landscapes. Born Darjeeling, 20 January 1888. Educated H.M.S. *Britannia*. Retired from Royal Navy before 1939–45 war but returned to work in Naval Ordnance Department. Self-taught artist. Exhibited: R.A., R.I., R.O.I., R.P., P.S., Paris Salon. Died in South Africa 12 July 1966.

WATSON Leslie Joseph M.B.E. (1906–87) (1939) + (1940) 1946
Oil, watercolour, landscape. Born Harrogate, 6 July 1906. Leeds College of Art, R.C.A. Experienced Yorkshire heavy drifters and cobles in his youth; sailed a Bermudan sloop out of Ramsgate. Directorate of camouflage in 1939–45 war, particularly camouflage of airfields. For many years concerned in town and country planning and nature conservancy. Exhibited R.A., N.E.A.C., R.O.I. and London Group. *Page 172.*

WESSON Edward (1910–84) **1957**
Oil, watercolour, landscapes, architectural. Born Blackheath 29 April 1910. Self-taught artist. Tutor and demonstrator. Prolific watercolorist, numerous one-man shows. Member of R.I., R.B.A., Wapping Group of Artists. Exhibited: R.A., R.O.I. and provinces. *Right.*

WIGFULL W. Edward (fl. 1890–1944/1945) (1939) + (1940) (1942) * (1943)
One of chief illustrators for books of Percy F. Westerman, such as *The Log of a Snob* (1914), *English Illustrated Magazine, Girl's Realm, Idler, Oxford Annual.*

WILCOX Leslie Arthur (1904–82) (1939) (1946) (1947)
Oil, watercolour. Born Fulham. Self-taught artist. Camouflage officer (1941–5). Member of R.I. and Wapping Group of Artists. Work in many private collections including H.M. The Queen, for Royal Yacht *Britannia*. British Railways posters. Illustrations for maritime journals, etc. Author of *A Book of Ships*, and *Mr Pepys' Navy*, etc. Present at first meeting February 1939; elected by ballot after inaugural exhibition, not minuted until 1947. Exhibited: R.O.I., R.S.W., R.B.A. and provinces. *Page 53.*

✳ **WILKINSON Norman** (1878–1971) (1939) + 1946
Oil, watercolour, drypoint, landscapes, illustrator. Born Cambridge, 24 November 1878. Portsmouth and Southsea School of Art. Contributed to *The Illustrated London News* from 1898. Worked under Louis Grier in Cornwall, travelled widely. Inventor of 'dazzle' camouflage in 1917, and in 1939 camouflaged airfields for R.A.F. Painted 56 paintings of the 'War at Sea' (1944) now in National

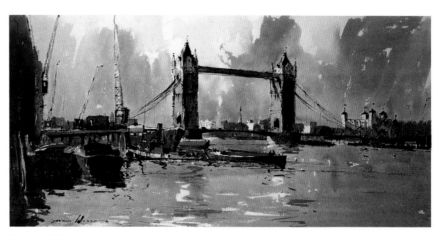

Edward Wesson, R.B.A., R.S.M.A. 'Tower Bridge'. Watercolour. Collection: Bishopsgate Police Station/Bridgeman Art Library. By kind permission of Elizabeth Wesson.

Maritime Museum. Member of first S.M.A. Committee, 1939. Elected R.I. (1906), President; Member of R.O.I. and President of Wapping Group of Artists. Hon. Marine Painter to Royal Yacht Squadron (1919). Author of *The Dardanelles* (1918), *Watercolour Sketching Out of Doors* (1953). Awarded C.B.E. (1948). Died 30 May 1971. *Pages 74 and 75.*

WILLIS John Christopher Temple (1900–69) **1961**
Watercolour. Born Weymouth, 14 May 1900. Royal Military Academy Woolwich. Reached rank of Major-General, painting in his spare time. Studied under R. Talbot Kelly and Gerald Ackerman. Exhibited: R.A., R.B.A. Died 12 October 1969. *Page 174.*

WINDER REID: *see* **REID**

WOLSELEY Garnet Ruskin (1884–1967)
Oil, landscapes, figures. Born London,

24 May 1884. Slade School. Elected A.R.W.A. (1915). Whereabouts unknown for several years and R.S.M.A. terminated membership (1947). Exhibited: R.A., N.E.A.C., in provinces and abroad.

WOOD Peter MacDonagh (1914–82) **1955**
Oil, watercolour. Born Twickenham, 30 April 1914. Southend School of Art, Slade School and Hornsey School of Art. Close to the sea from childhood, his father being Director of F. Clayden & Son, Rotherhithe. Service in R.A.O.C. during war. Technical adviser on ships for film industry, worked on replica of *Nonsuch*. Exhibited: R.A., N.E.A.C., R.I.O., R.W.S. *Page 54.*

WOOTTON Frank O.B.E. (1911 - 1998) **1957**
Oil, watercolour. Born Milford, Hants, 30 July 1911. Studied under Eric Ravilious, Eastbourne School of Art. Official artist to R.A.F. 1944 - 6. Work in

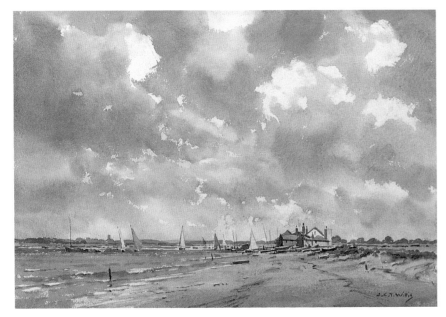

John Willis, R.S.M.A. 'Southwold'. Watercolour, 13in x 19in. R.S.M.A. Diploma collection.

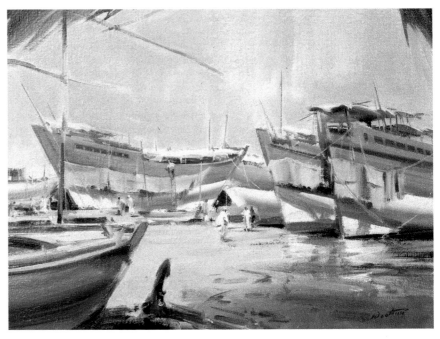

Frank Wootton, R.S.M.A. 'Arab dhows at Kuwait'.

major companies, including B.P. Work in R.A.F. Museum, Hendon, and National Museums of U.S.A., Canada, and Australia. Past-President of Guild of Aviation Artists. Exhibited: R.A., R.O.I. and abroad. Resigned R.S.M.A. *Above right.*

WORKMAN Harold (1897–1975) **1961**
Oil, watercolour. Born 30 October 1897. Oldham and Manchester Schools of Art. President of U.A. Lived at East Molesey, Surrey. Exhibited: R.A., R.B.A., R.O.I., R.C.A., N.E.A.C., provinces and abroad. *Page 175.*

WORSLEY John (1919 - 2000) **P.P.R.S.M.A. 1946**
Oil, watercolour, portrait, marine, sculpture. Royal Navy 1939. Four years in destroyers and cruiser, Lieutenant R.N.V.R. Official Naval War Artist May 1943. Taken prisoner by Germans November 1943. Created 'Albert R.N.', successful dummy naval officer escape device. Naval and military portraits for Imperial War Museum and National Maritime Museum. Work for Esso; Anglia T.V.; and book illustration. President of R.S.M.A. 1983–8. *Pages 14, 55 and 76.*

WRIGHT Bert (1930 -) **P.P.R.S.M.A., F.R.S.A. 1980**
Watercolour, oil. Initial career as illustrator, designer. Subsequently General Manager, Scenery Group; B.B.C.; President R.S.M.A. (1998 - 2003); member Wapping Group of Artists; Chelsea Art Group; President Ealing Art Group. Commissioned by major international companies U.K. and abroad. Exhibited: R.A., R.I., R.O.I., R.W.S., provinces and abroad, including annually in the U.S.A. *Pages 16 and 122*

✳ **WYLLIE Harold** (1880–1973) **(1939) + (1940) (1943) 1946**
Oil, watercolour, gouache, etching. Born London, 29 June 1880, son of W.L. Wyllie R.A. Went to New York as special artist to *The Graphic* (1898). Fought in Boer War. Served as pilot in R.F.C., before transferring to regular army: retired as lieutenant-colonel (1920). Hon. Marine Painter to Royal Yacht Squadron (1934). Member of first S.M.A. Committee (1939). Vice-President S.M.A. 1958. Exhibited: R.A., R.I. and provinces. Died 22 December 1973. *Page 56.*

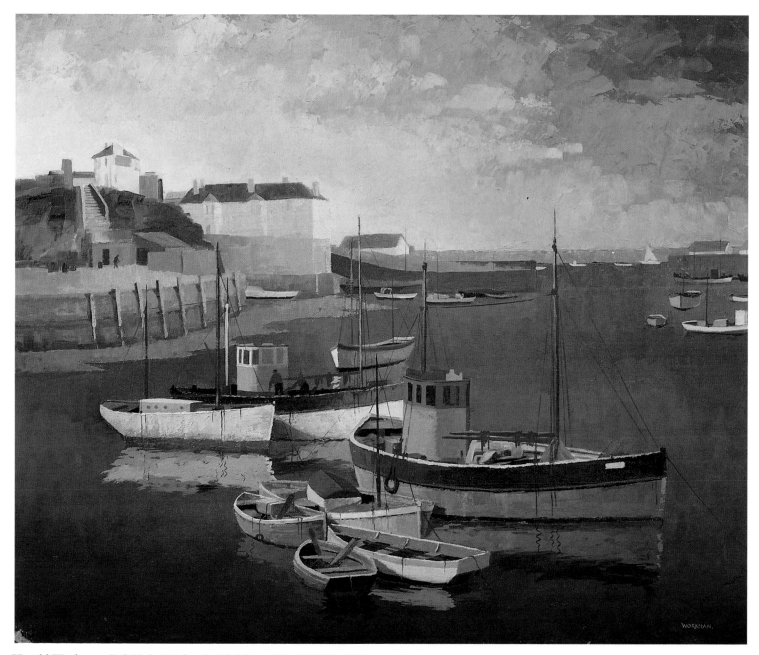

Harold Workman, R.S.M.A. 'Brixham'. Oil, 25in x 30in. R.S.M.A. Diploma collection.

Directory of Members and Associate Members of the R.S.M.A
1995 - 2005

Compiled by Lorraine Abraham, John Groves, David Howell and Geoff Hunt

The following section brings the R.S.M.A.'s story up-to-date with a record of the members and associate members who have joined the Society since 1995, together with a gallery of their work. But the story is a continuing one. The membership at any one time consists of about forty to fifty active members and associate members, though there is no limit set on numbers. Full members are elected from the associate members, who are themselves elected; both sets of elections take place at the Annual General Meeting. As always, these artists come from a far larger body of marine artists, those who regularly exhibit with the Society at its annual Exhibition, which is open to all. In thus representing this wider community of artists, the R.S.M.A. is proud to be considered as the principal focus of marine art in this country. We look forward to every new exhibition: there we shall discover new talent, new interests, new approaches, and the R.S.M.A. members of the future.

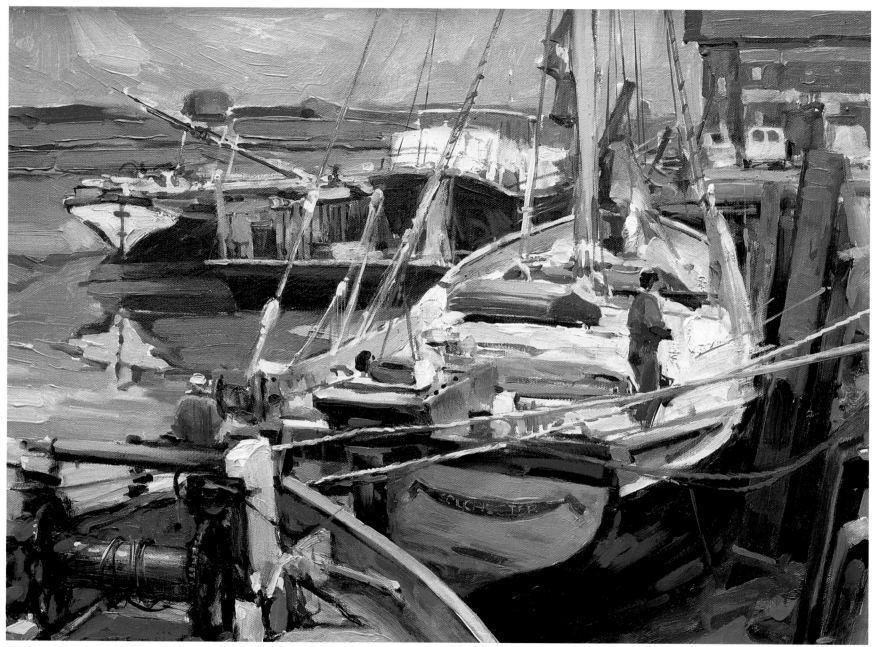

Edman O'Aivazian. 'Faversham '. Oil on canvas, 46 x 61cm.

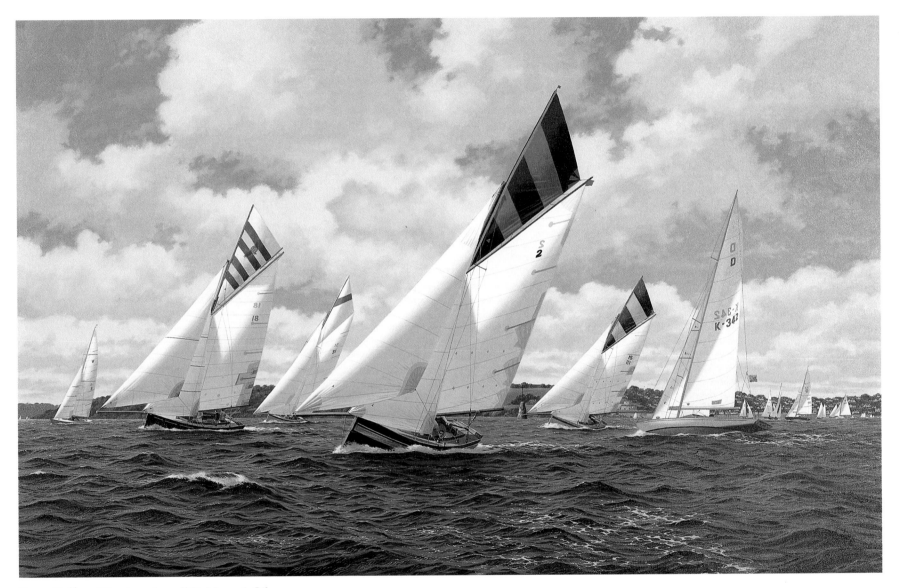

Terry Bailey. 'Classic racing off St. Mawes'. Oil.

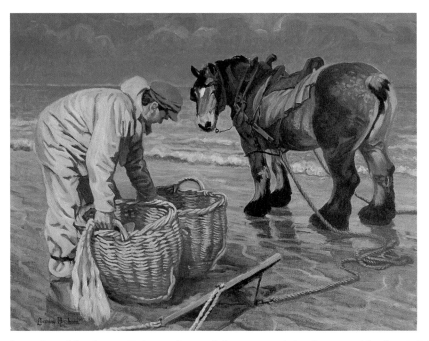

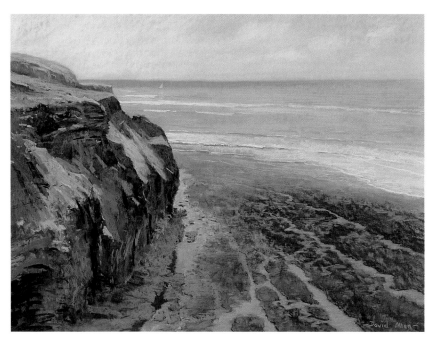

Lorraine Abraham. 'Belgian shrimp fisherman with his horse and baskets'. Oil.

David Allen. 'Low tide, Sandsend'. Pastel, 18 x 24 in. Private Collection.

ABRAHAM Lorraine (1941 -) **1998**

Oil, watercolour, scraperboard. Born Bridgend, Glamorgan, Cardiff College of Art – National Diploma in Design. University of Wales School of Education – Art Teacher's Diploma. Full time teaching until 1975, including Head of Department posts. Drawings purchased by National Museum of Wales, commissioned work for Glamorgan County Council. Resident in Brussels 1982-1984. The years spent in Belgium resulted in a special study of the Shrimp Fishing Industry at Oostduinkerke. Exhibitions include Royal National Eisteddford of Wales, House of Commons British Women's Art 1981, R.I., R.B.A., R.W.A., New York, Mystic Seaport, Connecticut. Works mainly to commission. *Page 179*

ALLEN David (1945 -) **A.R.S.M.A. 2004**

Born Harrogate N. Yorks. Pastel painter. Worked as a draughtsman and after studying at Bradford Technical College, was elected a Member of the Institution of Civil Engineers in 1973. His career was principally in the development and restoration of quarries. Became a full time painter in 1989. Much of his inspiration comes from the coast and dales of his native Yorkshire. He also demonstrates his art and exhibits widely. Member of the Fylingdales Group of Artists: winner of the Frank Herring Award at the Pastel Society in 2002. *Page 179*

ANDREWS Stanley (1932-) **1998**

Oil and watercolour. Born Surrey, 1 July 1932. Entirely self-taught. Exhibits widely in the South of England, Singer & Friedlander and abroad. Favourite subjects include harbours, estuaries, towns and cities. *Page 181*

BAILEY Terry (1941-) **2002**

Painter in oils & watercolour. Born Manchester. Mainly self taught after a brief spell at the Salford School of Art. Pursued a career as a freelance professional illustrator for UK advertising agencies. A move to the West Country in 1970 prompted an interest in marine art. Opened own Gallery shortly afterwards. Elected a full R.S.M.A member in 2002. Won the *Classic Boat* magazine prize 1999 and in 2000 at the annual R.S.M.A Exhibition, also the Conway Maritime Press Age of Sail prize in 2003. Exhibits London, USA, Jersey. Work in collections worldwide. *Page 178*

BANNING Paul (1934 -) **2004 WGA**

Born in Trinidad 1934. Trained as a furniture designer, NDD (Hons) at the West of England College of Art, taught drawing by Victor Passmore RA. Was a designer and cabinet maker until

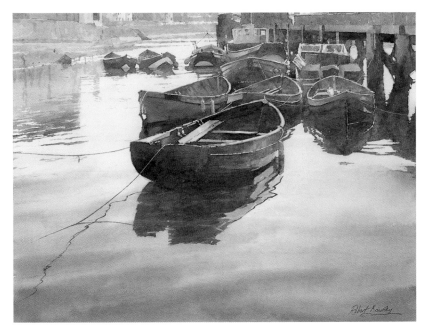

Robert Brindley. 'Cobles, Whitby Harbour'. Watercolour, 12 x 16 in.

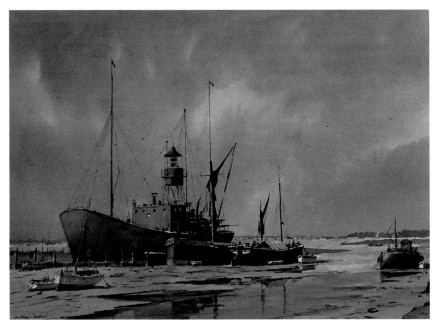

Sidney Cardew. 'Old timers at Tollesbury' Watercolour, 22 x 30in. The old lightship sits in wilderness with other boats gathering alongside, making an ideal subject.

1986. Since then has been worked as a professional painter specializing in watercolours, but also enjoys using oils. Elected to the Wapping Group of Artists 1995, and to full membership of the R.S.M.A. in 2004. Has exhibited in Dubai, Holland, USA, France, and Italy, as well as in many Galleries in the UK. Also shown in the Singer and Friedlander watercolour competition, N.E.A.C., R.W.S. C21, R.I., R.O.I. Prizes R.W.S. C21, Freshfields Prize 2000, R.I. 2002 Llewellyn Alexander Award for outstanding watercolour. *Page 181*

BRINDLEY Robert Edward (1949-) **1997**

Watercolour, oil, pastel. Born Burton-upon-Trent February 1949. Self-taught painter who worked as a computer aided design manager until 1992 when he moved to Whitby to paint professionally. Work featured on Tyne Tees Television's "A Day In The Life Of ..."series, and in *Yorkshire Life, The Dalesman* and *The Artist & Illustrator*. Exhibited: R.O.I., The Carisbrooke Gallery; The Houses Of Parliament; The Ferens Art Gallery, Hull; Melori & Rosenberg Gallery, Venice. *Page 180*

CARNEY William (1943 -) **A.R.S.M.A. 2004**

Born Stockton-on-Tees, Durham. Hornsey School of Art BA (Hons). Early experience involved textile design, and illustrating and designing overseas postage stamps. Worked for the Daily Express as an illustrator/designer, and freelance illustrator for National flower shows. Painted part-time until 1996 when he became full-time. Exhibits regularly in London including R.A. Summer Exhibition, N.E.A.C., and R.O.I. Winner of the Charles Pears prize R.S.M.A 2002. *Page 182*

CARDEW Sidney (1931 -) **1998**

Watercolour, oil, and acrylic. Born London; South East College of Arts; designer with Ford Motor Co. Self-taught artist specializing in low tide coastal and river scenes, landscape, townscape, and figure studies. Inspired by the works of Edward Seago. Member of the Wapping Group, the London Sketch Club, the Chelsea Arts Club, and the Essex Art Club. Articles on painting watercolour reproduced in the *International Artist* magazine and book. Has completed a number of commissions of larger works for London offices. Exhibitions – Mall Galleries, London R.I., R.B.A., R.W.S., and in various galleries both in the UK and abroad. Work in private collections worldwide. *Page 180*

RICHARD Dack (1944 -) **1999, RWA.**

Born Norfolk. Camberwell School of Art and Sussex University. Settled in Devon 1977 but now resident in Suffolk. Oils, acrylic, etching. Mainly

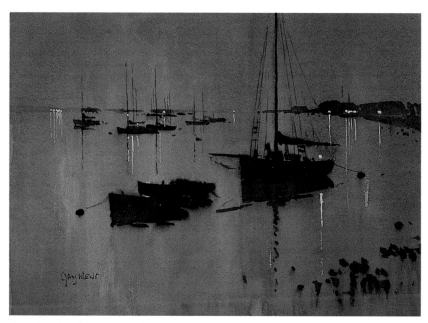

Stanley Andrews. 'Nightfall at Maldon, Essex'. Watercolour

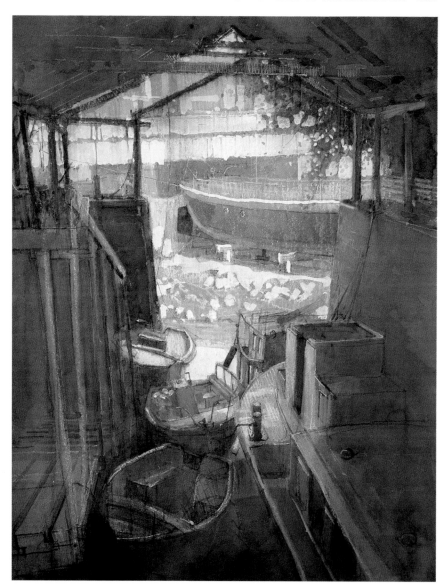

Paul Banning. 'The old boathouse, Brentford Dock'. Watercolour, approx 20 x 16 in.

maritime subjects and landscape. Exhibited R.A. Summer Exhibitions, N.E.A.C. and R.O.I. Regularly exhibits London and provinces. Maimeri Award 2000. Worshipful Company of Shipwrights Award 2000. *Page 185*

HOWELL David (1939 -)
V.P.R.S.M.A. 1997
Painter in watercolour, oil, and pastel. Marine, landscape, and equestrian. Born Markyate, Herts. Self-taught; painting full time since 1985. Lived and worked in Arabia for 9 years. Numerous one-man shows in London, UK in general, Saudi Arabia, Dubai, and Bahrain. Exhibits regularly in London, the provinces, USA, & Dubai. Work published as LE prints, book *City of the Red Sea*,

magazine articles etc. Member of the Society of Equestrian Artists. Paintings in corporate and private collections worldwide. *Page 183*

JOHANNESON Steven Thor (1948-) **2003**
Painter in watercolour, gouache and pastel; seascapes, landscapes, wildlife. Born 16 June 1948, Minneapolis, MN, USA. Studied 1970-73 Heatherley School of Fine Art, Hampstead (now in Chelsea). Worked during 1970's at McMurray's Picture Framers, London; Bajus-Jones Animation Studio, Minneapolis (background artist); full-time painter 1985 onwards. Received St. Cuthbert's Mill Award at 1999 R.S.M.A. Exhibition. Has work

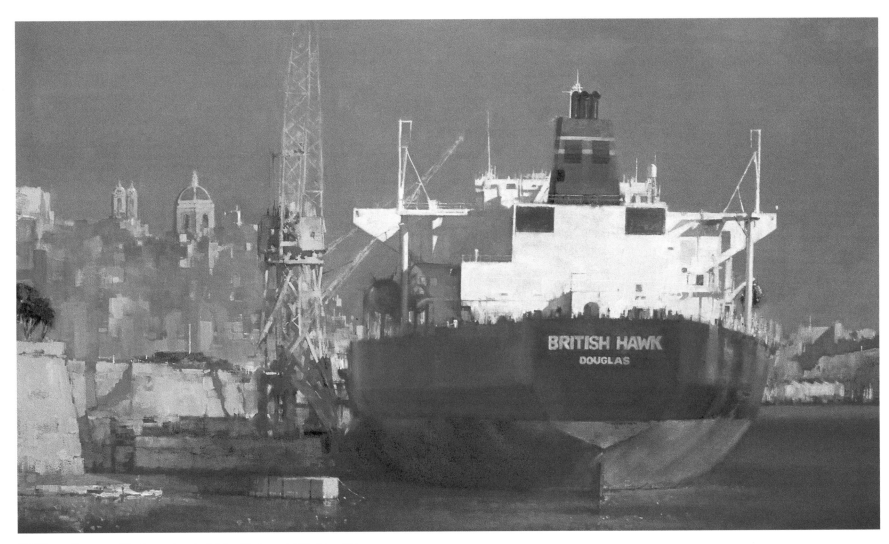

William Carney. 'Tanker at berth, Malta Harbour'. Oil, 24 x 40 in.

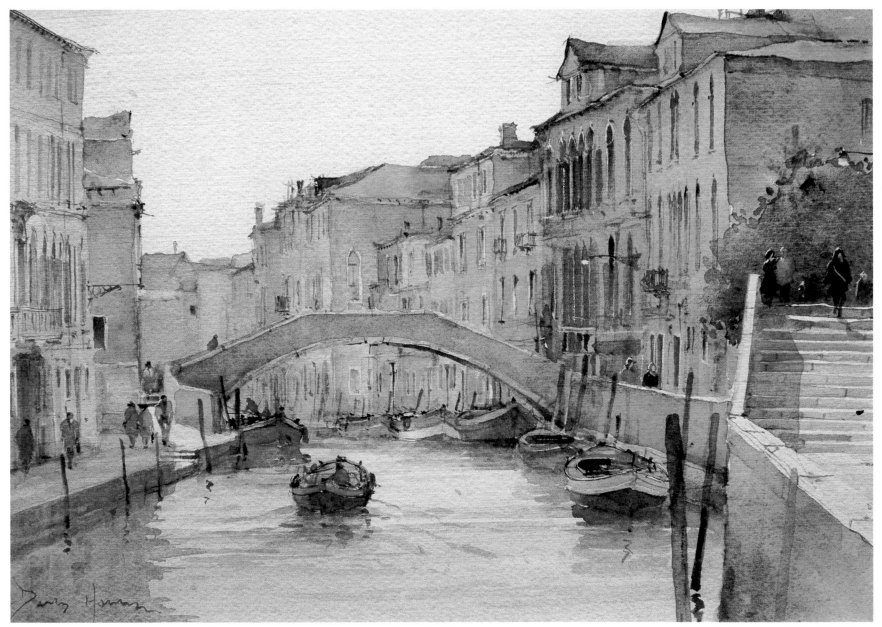

David Howell. 'Rio di Santa Margherita'. Watercolour

reproduced as greeting cards, prints and limited edition prints by various publishers. Exhibitions and work in Galleries in London, the Home Counties, the West Country and USA. In 2004, after 23 years in Cornwall, married childhood sweetheart Cynthia Maurer, and settled in Oregon in the Pacific Northwest, continuing to study Nature in all her moods. *Page 184*

LANCASTER, Brian Christy
(1931 -) **1997**
Watercolour painter: landscapes, seascapes, industrial subjects, concentrating on atmosphere and light. Illustrator. Born Atherton, Lancs. 3rd August 1931. Bolton Art School, Southport Art School. Graphic and package designer. Moved to Canada 1957 - 1963. Settled in Bristol.

Member of Bristol Savages Art Society 1969. Exhibits: R.I., R.W.S., R.B.A., R.W.A.. Work published in many books, articles for *The Artist* and *American Artist* magazines. Member of the Guild of Railway Artists. Elected Fellow R.S.A. 1995. *Page 185*

LINES John (1938 -) **2002**
Born Rugby 3 August 1938. Studied

art at Rugby Polytechnic 1957–1959, York School of Art 1961–1962. Lives and works in Hillmorton Village near Rugby. Annual exhibitions at Rugby Library. Member of R.D.A.S, R.B.S.A, G.R.A. Active demonstrator and lecturer. Travels widely in USA, Australia, Germany, India and China. Works to commissions from major shipping companies. *Page 186*

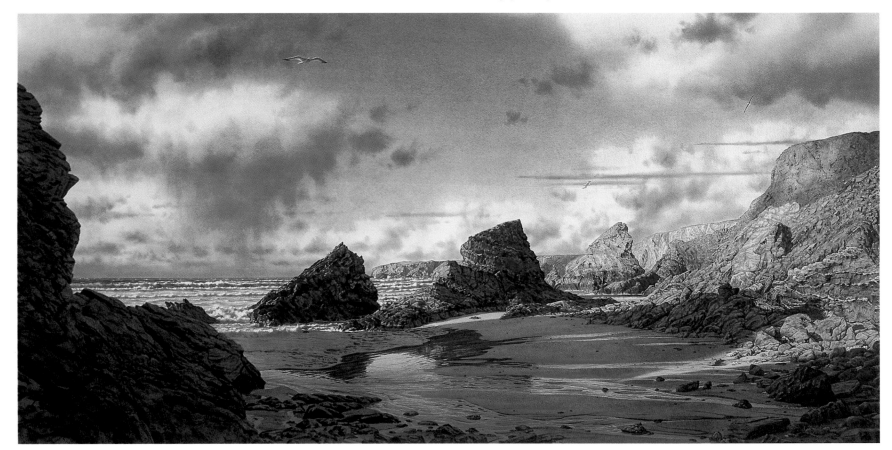

Steve Johanneson. 'November afternoon light at Bedruthan Steps, Cornwall … incoming tide'. Watercolour approx. 13 x 27.5in.

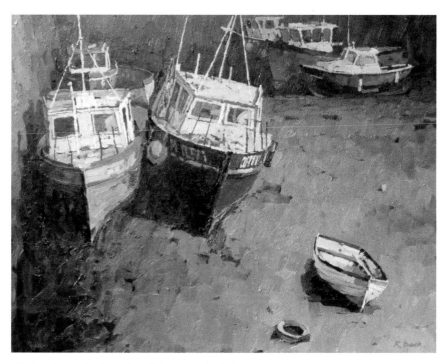

Richard Dack. 'Evening light, Sneyd'. Oil.

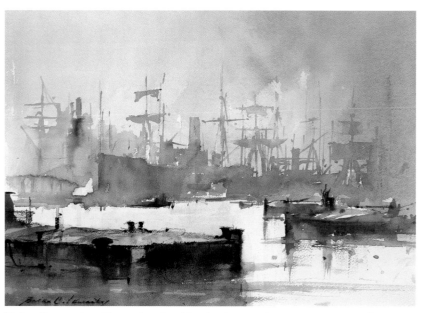

Brian Lancaster. 'December Docklands'. Watercolour, 10 x 13.75 in. The winter gloom of smog and smoke-laden air during the times of sail changing to steam in the bustling docklands at the century's turn.

MOORTGAT Ronny (1951 -)
A.R.S.M.A. 2004
Born 21st April 1951 in the village of Niel Belgium, on the River Rupel. Grew up in Schelle where the rivers Rupel and Schelde meet. Many family members were river barge men and father was involved in the shipping business. Trained as a technical draughtsman, but on completion of diploma transferred to art college for 6 years studying drawing, painting, printmaking and etching. Member of the Belgian Society of Marine Artists. Exhibited with the Maritime Artists Exhibition in Paris; included in

Archibald's *Dictionary of Sea Painters*. Works in National Maritime Museum of Antwerp; commissions include City Council of Hoboken, the port of Rotterdam, and paintings in private collections in Belgium, Germany, France, Italy, Sweden, Great Britain, and the USA. *Page 187*

MORGAN Jenny (1942 -) **N.D.D. A.R.S.M.A. 1995 - 1998**
Oil. Born Woolwich, London. Camberwell School of Art 1960s under Robert Medley, Euan Uglow, Frank Auerbach. Studied television design at the B.B.C., late 1960s. Specializes in

depicting the sea in many moods, historic shipping and yachts, especially working vessels such as pilot and fishing boats. Many years' experience sailing a gaff cutter. Exhibits: Mystic Seaport, National Maritime Museum Falmouth, Ferens Gallery, Hull, Gallerie Marin and elsewhere. Solo shows in London and Guernsey. Works in Sotheby's Marine Sales 1996, 2003. *Page 186*

O'AIVAZIAN Edman (1931 -)
2003
Started painting at the age of 13. Painter in oil, acrylic and watercolour.

Studied at the Academy of Arts in Rome. With a strong background in Architectural art and design, has lived and worked in London since 1972. Works in collections include; Museum San Lazaro, Venice. Aram Khatchaturian Museum and Museum of Modern Art, Yerevan. Aivazovsky Museum, Theodosia. Painted murals in Armenian churches, Tehran, and works in the National Museum, Riyadh. Exhibited: Biennale Venice, New York, Yerevan, Crimea. RIBA London, R.O.I. Also a Member of R.O.I. and Wapping Group of Artists. *Page 177*

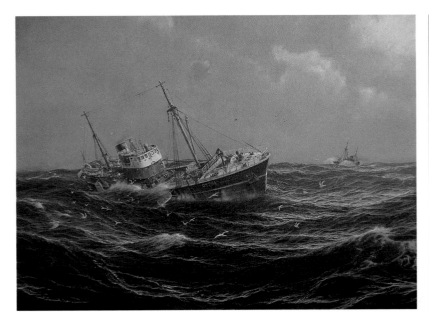

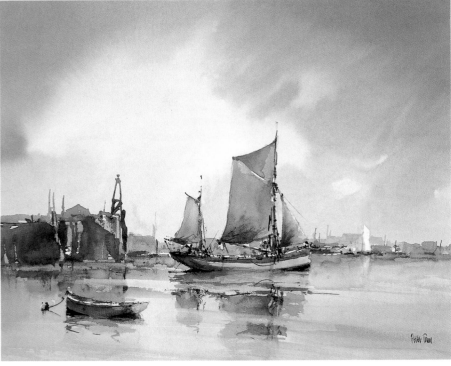

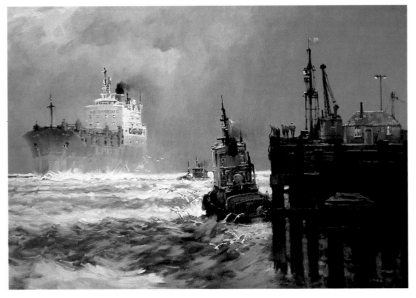

Top left: **Jenny Morgan.** 'Hauling the trawl - the Grimsby trawler *Northern Crown*'. Oil, 24 x 30 in.

Left: **John Lines.** 'Estuary business'. Oil

Above: **Peter Toms.** 'Out on the ebb'. Watercolour, 14 x 16 in.

Opposite top: **Ronny Moortgat.** 'Unloading'. Oil on canvas, 24 x 32 in.

Opposite bottom: **Martin Swan.** 'Boats leave their moorings at Cowes Aug 7th 1926'. Watercolour 20 x 30 in.

RUNAGALL Alan (1941 -) **2000**
Watercolour. Born South Essex 1941. Self-taught. Mainly coastal marine, especially East Anglia, Thames estuary, London Thames and docks. Started work for P.L.A. in 1957 in the busy West India Docks and later in Tilbury Docks. A member of the The Wapping Group of Artists and a founder member of the East Anglian Group of Marine Artists. *Page 188*

SMITH Elizabeth Anne (1950 -) **2001**
Pastel, landscape, coastal scenes, still-life, industrial. Born Hythe, Hampshire. Studied design and illustration Winchester School of Art, Bournemouth and Poole College of Art. Settled in North Yorkshire 1975. Exhibits with Pastel Society, Royal Birmingham Society of Artists and UK galleries. Winner of R.S.M.A. Charles Pears Award 1992 and many other prizes. Work commissioned by BASF, National Power, BP and South Tees Health Authority. *Page 188*

SWAN Martin (1951 -) **A.R.S.M.A. 2003**
Born Newport, Isle of Wight, April 1951. Painter in watercolour and oils. University College of Wales, Aberystwyth 1976 - 1981. BA (Hons) Philosophy, Postgraduate Cert. in Biblical Studies, PGCE. No formal art training, but has always drawn and painted. Full-time painter from 1984. Early work included botanical drawings and landscape. Designed postcards and calendars. Turned to marine painting in 1996. Exhibits regularly on the Isle of Wight, the mainland and abroad, culminating in

2002/3 with an exhibition in Auckland NZ to coincide with the America's Cup. In 1988 was featured in the BBC2 arts programme *Painters*. As well as marine and landscape, has developed an interest in Life studies. Married, lives and works on the Isle of Wight. *Page 187*

TOMS Peter (1940 -) **R.M.S., Hilliard Society, A.R.S.M.A. 1997 - 2000**
Watercolour. Twenty years in engineering industry, involved in many aspects of research and design. Full-time painter from 1982. Exhibits: R.I., R.B.A., R.M.S. 25 solo exhibitions in leading London and provincial galleries; also in France, Portugal and Belgium. Commissions include the Royal Navy, the Royal Hampshire Regiment; British Aerospace, the Astrid Trust, the Mary Rose Trust, Brittany Ferries, Vosper Thornycroft. Well-known tutor and speaker on watercolour painting techniques. *Page 186*

WEBSTER John Morrison (1932 -) **2001**
Oils, pastel, marine and landscape. Born Colombo, Sri Lanka 3 November 1932. 40 years in Royal Navy. Commanded at sea. Retired 1990 as Vice Admiral. Younger Brother of Trinity House. No formal art training but interest stimulated by requirement to illustrate midshipman's journal. First exhibited R.S.M.A. 1954. Elected Associate R.S.M.A. 1998, full member 2001. Also exhibited N.E.A.C., R.W.A., R.O.I., R.B.A., R.I. Chairman Armed Forces Art Society 1989 -1996. One man exhibitions: Art Gallery of

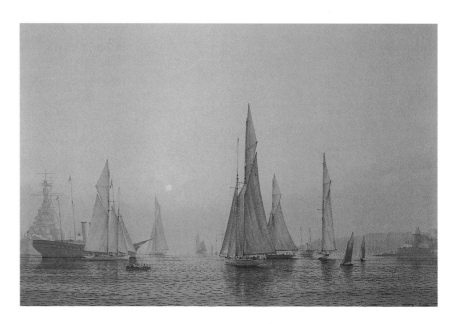

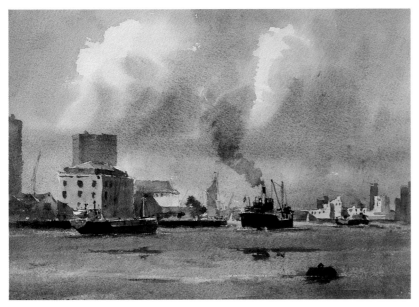

Alan Runagall. 'High water, Blackwall Reach '. Watercolour, 10.5 x 14.5 in.

Right: Elizabeth Smith. 'Beached'. Pastel, approx 67 x 45 cm.

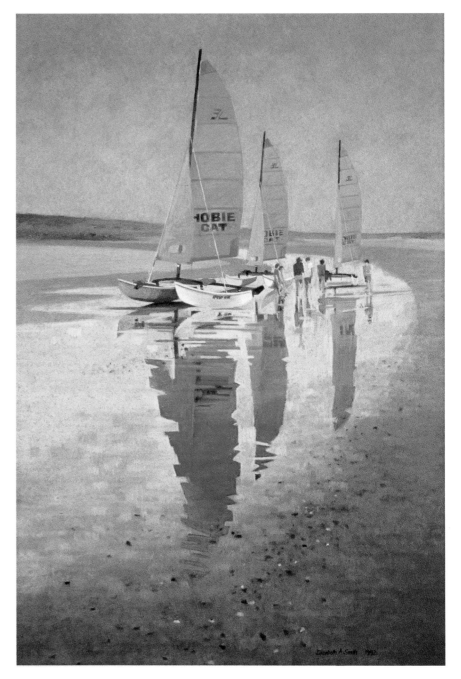

Nova Scotia 1976, Guildhall Art Gallery Winchester 1980, National Trust, Cotheile House 1988, London - King St. Oliver Swann, Tryon Galleries since 1982. Collections include HM The Queen, Corporation of Trinity House, Britannia RN College, Portland Port Ltd, Royal Cruising Club. *Page 189*

WRIGHT Rowena Sarah (1970 -) **2001**
Oil, acrylic, watercolour, pencil. Born 26 February 1970 in Berkshire. Trained at the Gemini School of Illustration near Newbury. Moved to Cowes, Isle of Wight in 1995 to become a marine artist. Volunteered for five years as a crew member on the Cowes Inshore Lifeboat. Painting subjects range from classic boats to portraits of sailors, with a particular interest in modern racing yachts. Exhibits: Galleries in London, USA, Ireland, Cowes, Dartmouth, including the Greenwich Maritime Museum, the Royal Yacht Squadron and the Royal Institute of Naval Architects. *Page 190*

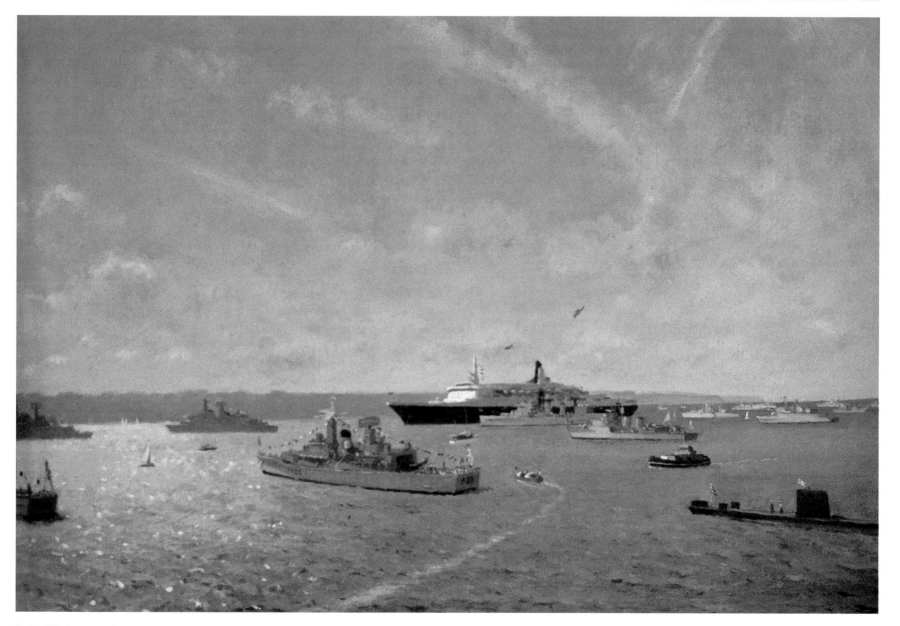

John Webster. 'The Silver Jubilee Fleet Review 1977'. Oil, 16 x 24 in. QE2 passing through the Fleet, 27 June 1977. Artist was in command of HMS *Cleopatra*, centre foreground, and the 4th Frigate Squadron. R.S.M.A. Diploma Collection.

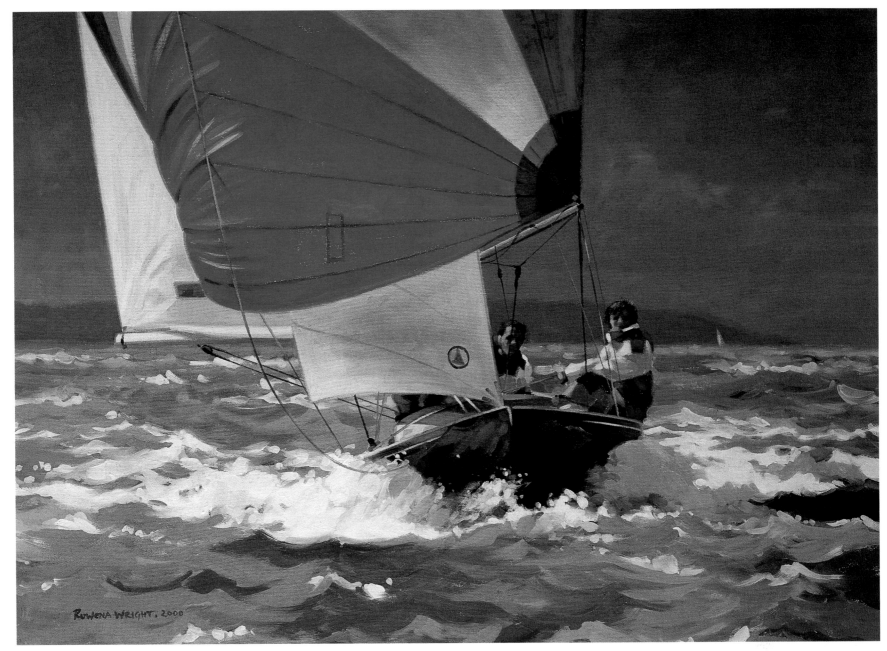

Rowena Wright. 'Dragon racing in the Solent'

Officers of the Society 1946 - 2005

President
Charles Pears (1939 -1945) 1946 -57
Claude Muncaster 1958 -74
Keith Shackleton 1974 -78
David Cobb 1978 -1983
John Worsley 1983 -1988
Terence Storey 1988 -1993
Mark Myers 1993 - 1998
Bert Wright 1998 -2003
Geoff Hunt 2003 -

Vice-President
Cecil King (1939; died 1943)
Arthur Burgess (1943 -1945) 1946 -1957
Claude Muncaster 1957-1958
Harold Wyllie 1958 -1973
Keith Shackleton was also a Vice-
President 1970 -1973, overlapping with
Harold Wyllie.
David Cobb 1973 -1978
John Worsley 1978 -1983
Terence Storey 1983 -1988
Mark Myers 1988 -1993
Bert Wright 1993 -1998
Geoff Hunt 1998 - 2003
David Howell 2003 -

Hon. Treasurer
Borlase Smart (1939 -1945) 1946 -1947
Arthur J.E.Bond 1948 -1957
(W.H.Jarvis acting Hon. Treasurer
1957)
W.Howard Jarvis 1958 -1964
Karl Hagedorn 1964 -1968; vacant 1969
Keith Shackleton 1970 -1973
David Cobb 1974
J.Sturgeon 1975 -1983
Ronald Dean 1983 -1988

Roger Fisher 1988 -1991
Geoff Hunt 1992 -1998
Alan Simpson 1998 -2003
Alan Runagall 2003 -

Hon. Secretary
P. Maurice Hill (1939 -1945) 1946 -1951
Claude Muncaster 1952 -1957
George Ayling 1957-1960
Leslie Wilcox 1960 -1974
John Worsley 1974 -1978
Mark Myers 1978 -1988
David Curtis 1989 -1994
Sonia Robinson 1994 - 1998
David Howell 1998 -2003
Elizabeth Smith 2003 -

Secretary
M .B. Bradshaw (1939 -1941)
(C.R.Chisman 1941 -1945)
M.B. Bradshaw 1946 - 1971
(Carl de Winter Asst. Secretary 1961 -
1971)
Carl de Winter 1972 -1978
Gordon Alexander 1979
M.B.Bradshaw 1980 -1982
Secretariat 1983 -

Maurice Bernard Bradshaw, O.B.E.
(1903-1991), who became an
Hon. Vice-President, was a major
figure in art administration,
Vice-Chairman Art Exhibitions
Bureau, Director of Goupil Galleries,
Director of New Burlington Galleries,
Director of Arts News Agency,
Secretary to Empire Arts Loan
Exhibitions Society. In 1929, in

partnership with C. R. Chisman, he
founded the Art Exhibition Bureau. He
was Organising Secretary of the Sea
Power Exhibition, under the patronage
of King George V1, which was a major
influence on the formation of the
S.M.A. His work as Secretary of the
Society from its inception in 1939 to
1971 and as Secretary General of the
Federation of British Artists was
crucial in the successful development
of the R.S.M.A. He retired from the
F.B.A. in 1980 although he was once
again secretary to the R.S.M.A. 1980 -
1982 before the establishment of a
secretariat in 1983.

Honorary Vice-Presidents
A single asterisk denotes the first
Honorary Vice-Presidents of the
Society; double asterisks indicate the
current holders of this office.

** Hon. Sir Desmond Ackner
Sir Max Aitken
Sir Colin Anderson
Sir Stanley Aubrey
Rt. Hon. A. S. Barnes
Air Chief Marshall Sir Frederick
Bowhill
Maurice Bradshaw
* Sir Frank Brangwyn
Air Vice Marshall Sir Geoffrey Bromet
Sir Frank G. G. Carr
Sir Robert Burton Chadwick Bt.
Sir George P. Christopher
Capt. W. H. Coombs
* Earl of Cork and Orrery

Admiral Sir John H. D. Cunningham
Capt. Sir Gerald Curteis
Sir Bernard Docker
** Maldwin Drummond
Lord Erskine of Rerrick
* Lord Essendon
Roger Fisher
Admiral of the Fleet, Lord Fraser of
North Cape
** D. G. M. Gardner
* Robertson F. Gibb
Basil Greenhill
Sir Phillip Haldin
Rt. Hon. Viscount Hall of Cynon
Valley
** George A. B. King
* Sir John Lavery
* Lord Lloyd
Rt. Hon. Lord Maclay
*J ohn Masefield
Sir Robert Micklem
Sir Arthur Morrell
Claude Muncaster
Sir Alfred Munnings
Sir Ernest Murrant
Mrs. Charles Pears
Sir Eustace Pulbrook
** Rt. Hon. Lord Riverdale
Sir Guy Ropner
Sir Alec Rose
Rt. Hon. Lord Rotherwick
* Rt. Hon. The Viscount Runciman of
Doxford
Rt. Hon. G.R.Strauss
* Sir Vernon Thomson Bt.
Commander Harry Vandervell
Commander Alan J. Villiers
(Sir Frank Brangwyn (1867 -1956) was

not an elected member of the Society. He attended some meetings and had considerable influence, which was recognised by conferring the title of Hon. Vice-President.)

R.S.M.A. PRIZE WINNERS

THE PEARS PRIZE WINNERS
(first year of award 1985)

1985 Raymond Leech "After a Shower , South Beach Lowestoft"
1986 Dennis Syrett "Mabel's Mum"
1987 Grenville Cottingham "Pacific Princess awaits P & O's Royal Celebration, 7th July 1987"
1988 Jeff Harpham "Beached Boats, Suffolk Coast"
1989 Brian Mitchell "Shoo!"
1990 Jeff Harpham
1991 Peter Johnson "After the Storm, Robberg"
1992 Elizabeth A. Smith "Beached"
1993 Derek Mynott "Dawn In Venice"
1994 Tom Wanless "Frayed ropes under the Pier"
1995 Amanda Cornish "Low Tide, Douglas, Isle of Man"
1996 Ray Denton "Incoming Tide, St. Ives"
1997 Peter Sumpter "Taking In Sail"
1998 Sheree Valentine-Daines "Disembarking, Blustery Day"
1999 Mark Rowbotham "Mackerel Fishermen, St. Ives"
2000 Rowena Wright "Dragons Racing I, Cowes Week 2000"
2001 John Lines "Ilona G Outward Bound"

2002 William Carney "Old Harry Rock"
2003 H. G. de Korte "Harbour, Rotterdam"
2004 James Bartholomew "Rising Swell, Pembrokeshire"

THE WORSHIPFUL COMPANY OF SHIPWRIGHTS' AWARD WINNERS
(first year of award 1995)

1995 Roger Dannheimer "Husbands Shipyard, Southampton"
1996 Bert Wright V.P.R.S.M.A. "Princes Boatyard, Rotherhithe"
1997 John Worsley P.P.R.S.M.A. "Boatyard, Aberdeen, Hong Kong"
1998 Richard Dack "Refitting Provident 1"
1999 John Lines "Morning Arrival"
2000 Anthony Amos "Dry dock"
2001 Edman O'Aivazian "Boatyard 11"
2002 David Curtis "Tall Ships, Charleston Bay"
2003 Ron Jobson "Tees Tugs"
2004 Geoff Hunt P.R.S.M.A. "The First Shots, HMS Victory At Trafalgar"

CLASSIC BOAT
(first year of award 1998)

1998 Jane Michaelis "Solent Gaffers"
1999 Terry Bailey "Eve To Starboard, Off Pendennis"
2000 Terry Bailey "A Freshening Wind off Falmouth"
2001 Ben Manchipp "Building The Last Hastings Lugger"

2002 Rowena Wright "Moonbeam of Fife And Tuiga"
2003 Ian Maginnis "Gaff Cutter Marigold, Profile"
2004 Tom Dack "Candida"

ST. CUTHBERTS MILL
(first year of award 1999)

1999 Steve Johannesson "Ebb Tide Reflections – Castle Rocks"
2000 Marian Forster "The Rower"
2001 Marian Forster "Waiting For The Big One"
2002 Alan Runagall "Docklands, Circa 1948"
2003 David Howell "Sidmouth"
2004 Norman Sayle "Dinghy"

CONWAY MARITIME PRESS "AGE OF SAIL"
(first year of award 2002)

2002 Geoff Hunt V.P.R.S.M.A. "H. M. Brig Sophie Leaving Port Mahon"
2003 Terry Bailey " Lutine And Panuccia Off Falmouth"
2004 Rowena Wright "Ellen MacArthur In Her Element"